THE HANDBOOK OF COLOR PHOTOGRAPHY

THE HANDBOOK OF COLOR PHOTOGRAPHY

HERWIG

AMPHOTO BOOKS
American Photographic Book Publishing
An Imprint of Watson-Guptill Publications
New York

First published 1982 in New York by AMPHOTO,
American Photographic Book Publishing,
an imprint of Watson-Guptill Publications,
a division of Billboard Publications, Inc.,
1515 Broadway, New York, N.Y. 10036

Library of Congress Cataloging in Publication Data

Herwig, Ellis.
 The handbook of color photography.

 Includes index.
 1. Color photography—Handbooks, manuals, etc.
I. Title.
TR510.H43 778.6 82-1644
ISBN 0-8174-3952-8 AACR2
ISBN 0-8174-3953-6 (pbk.)

Manufactured in Japan

First Printing, 1982
1 2 3 4 5 6 7 8 9/87 86 85 84 83 82

ACKNOWLEDGMENTS

Anyone writing in a field as well documented as color photography inevitably learns from the writings of others. Without the articles of Martin Hershenson, Ed Scully, Norman Rothschild, Al Francekevich, and other photo magazine writers, this book would have been impossible. Special thanks is due to David B. Eisendrath, Jr., longtime "Color Clinic" columnist in *Popular Photography* and a former neighbor. A source of support and information during my early photographic career, Dave was also the first person to encourage me to write.

Lincoln Russell supplied his usual workmanlike assistance with the book's black-and-white illustrations. My wife Mara was her usual tolerant self as the writing of this book monopolized the summer of 1981. Tom Maloney, Victor Keppler, Anton Bruehl, and Roger Kingston supplied illustrations and historical information for chapter 1.

Thanks to all of you.

Ellis Herwig
Cambridge, Massachusetts
December 1981

CONTENTS

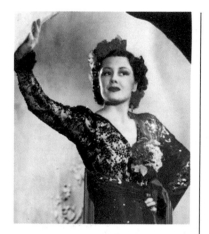

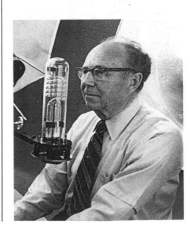

INTRODUCTION

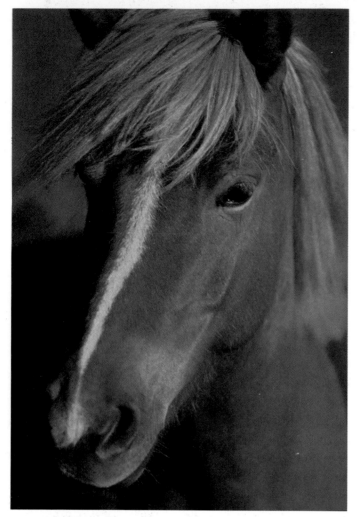

Above: Late afternoon light is often dubbed "Kodachrome time" by professional photographers, because its warm color and low angle enhance almost any subject, especially when shot on Kodachrome film, with its rich colors and low contrast. This Icelandic pony was photographed at 10:10 P.M. — "afternoon" in Iceland's summer Midnight Sun — with a 180mm lens.

Opposite page: Simple color can be very effective. The Aran Island of Inisheer was gray and colorless, and the window of this woolens shop shone by comparison.

This is a book about coexisting with color film. It's not a book about basic photographic technique. It assumes that you already know how to handle a camera and understand the capabilities of lenses and basic accessories. This isn't a book about looking for color subject matter. It's assumed that you know what you want to photograph, but would like to improve your results or tackle subjects whose photographic problems have deterred you until now. This book doesn't discuss home color processing. That subject requires a book of its own. Instead, there's a chapter on dealing with color labs and how to make the most of the services they offer.

This book supplies information useful to both amateur and professional photographers. If you plan to shoot pictures outdoors in the sunlight, there are tips on how you can improve your results. If you expect to be working under low-intensity, odd-colored light sources or to be using electronic flash units, there are tips on getting the most from these special situations as well.

A LOGICAL FIELD

Color photographic technique is logical once the basics are understood, and basic knowledge can be refined into specialized knowledge as your experience and interests grow. Film and equipment manufacturers want you to use their products successfully. They have streamlined technical problems as much as possible.

You can take color photographs with any of the hundreds of cameras and thousands of lenses available. You can use light sources ranging from faint moonlight to blazing incandescent floods to thousandth-of-a-second flash. You can make use of a multitude of filters and lens accessories to improve your results. You can photograph countless subjects under conditions impossible even to guess at until you've experienced them.

Among all these choices, there's one constant—you can't take color pictures without color film. The only reason that cameras, lenses, lights, and their myriad accessories exist is to expose film as effectively as possible.

FILM MUST BE RESPECTED

Color film is the most significant nonvariable in color photography. Cameras, lenses, and accessories can adapt to an infinite variety of photographic conditions. Not so with film. Relatively little can be done to change film's characteristics and capabilities. Beyond a few semiemergency expedients that inevitably decrease the quality of the final result, film performance cannot be altered. Color film is like a spoiled child, it only does things its own way. If color film's limitations are ignored, the result may be so poor that you won't have a usable picture at all.

Fortunately, there's a positive side.

☐ Color films are faster, more forgiving of exposure errors, and more tolerant of off-color light sources than they once were.

☐ An extensive backup network of color services is available. Most cities now have at least one custom

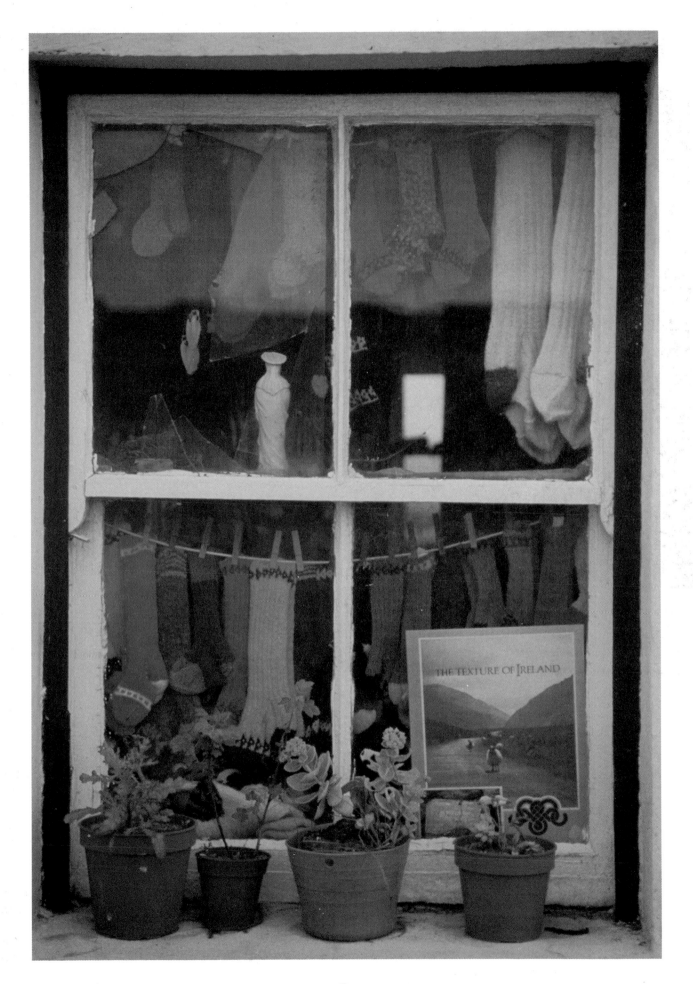

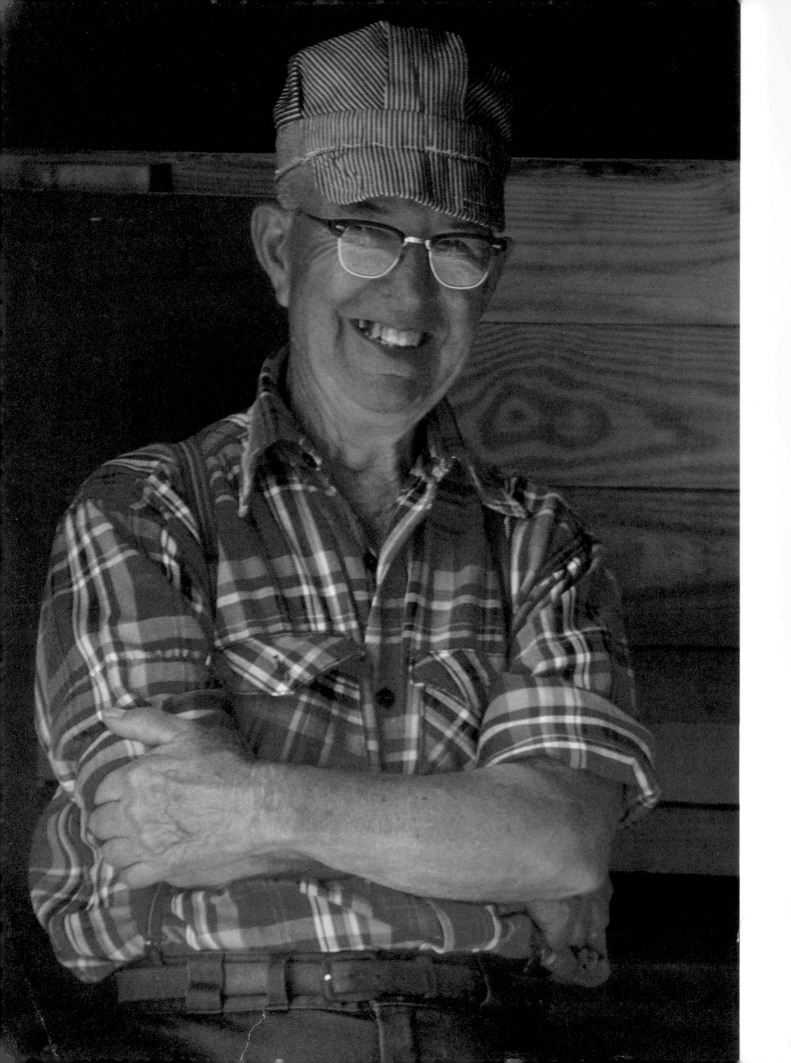

color lab to take technical drudgery off photographers' shoulders. Film speeds can be modified, slides can be duplicated, and a variety of color print processes is available. The result is more time to take better pictures. If you elect to do your color processing at home, many convenient tools and materials are available.

☐ In professional photography, color usually earns more money than black and white, both for shooting and for selling.

☐ Equipment has never been better. From color meters that can detect almost-invisible changes in the hue of a light source, to an ever-growing variety of filters and lens accessories, to microprocessor-based exposure systems reading right off the film surface of 35mm single-lens-reflex cameras (SLRs), photographers can count on more help than ever before in the struggle to humor the spoiled phototechnical brat that color film is.

In spite of these technical advances, color photography remains complicated and sometimes frustrating.

☐ Differences in light-source color that can't be seen by the human eye can make a noticeable difference in the final result.

☐ The length of exposure can have a serious effect on the performance of color film.

☐ Exposure carelessness that would be tolerable in black and white will produce worthless results in color.

☐ Temperature variations as small as one-half of one degree in certain color processing solutions may yield results that are useless.

The more you know about color films, the better color pictures you will take. Just remember that you will have to accommodate yourself to their demands before they accommodate themselves to yours.

This shot of a smiling farmer illuminated by indirect sunlight through the door of his barn required a spot meter reading off the subject's face to obtain an accurate exposure. Because of the dark surroundings, a through-the-lens meter would have overexposed the picture.

CHAPTER ONE
THE SEARCH FOR COLOR

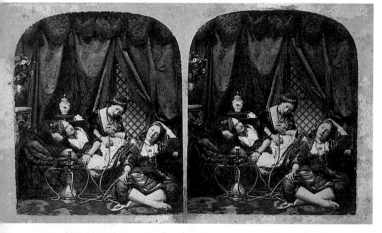

Above: Color photography was faked long before it was an accomplished fact, via hand coloring of black-and-white prints. This nineteenth-century stereoscopic duo of images showing three ladies smoking a hookah is probably of British origin. Notice how only a few colors — primarily red — have been added. The result is a colorful, rather than a color, photograph. Photo from the collection of Roger Kingston.

Opposite page, top: Dated 1877, this color photograph of Angoulême, France, was made by color photography pioneer Louis Ducos du Hauron, using a subtractive process. Three color separation negatives were shot through sharp-cutting filters, and the resulting separations were converted into translucent images, each dyed a different primary

color. The three separations were superimposed in precise register and cemented to a sheet of paper. The demonstration was classic; modern processes have only made the procedure more convenient. Photo courtesy of George Eastman House.

Opposite page, bottom: The pastel color rendition of Autochrome was appropriate for this undated study of a little girl. While colors are bland, notice how the apples in the basket and the flecks of color in the girl's sash are depicted accurately. While this famous turn-of-the-century additive color process required long exposures, it allowed color photography of live subjects, using conventional cameras. It could also be user-processed in black-and-white chemicals. Photo from the collection of Roger Kingston.

When Joseph Nicéphore Niépce produced the first black-and-white photographs in France in 1822, he wasn't satisfied for long. "I must succeed in fixing the colors," he wrote to his brother Claude,[1] believing that an emulsion could be perfected to record all colors.°

In 1850, extravagant claims were made by Levi L. Hill, a minister of Westkill, New York. To hear him tell it, he'd found a way to produce daguerreotypes in full color. The editor of the prestigious *Daguerreian Journal* certainly agreed. "Could Raphael have looked upon a Hillotype [as Hill called his process] just before completing his *Transfiguration*," said the editor, "the palette and brush would have fallen from his hand, and his picture would have remained *unfinished*."[2]

When professional photographers asked for the chemical and technical details of Hillotypes, the inventor was evasive. The photographers became insistent; their customers were putting off having portraits taken in anticipation of the marvelous color process supposedly just around the corner. Finally a "Committee of Three," appointed by the New York State Daguerrean Association, paid Hill a visit. The dream ended then and there. The committee's report ran: "Mr. Hill has deluded himself thoroughly and completely. The only thought respecting it, in which there is no delusion, is for every man to abandon any possible faith in Mr. Hill's abilities to produce natural colors in Daguerreotype."[3]

Did Hill actually produce any full-color daguerreotypes? After Hill's death in 1865, *Humphrey's Journal of Photography* wrote that "He always affirmed that he *did* take pictures in their natural colors, but it was done by an *accidental* combination of chemicals which he could not, for the life of him, again produce!"[4]

The idea of a chameleon-style direct-color-sensitive photographic emulsion remains attractive but still unfulfilled. In 1938, commercial photographer Victor Keppler wrote: "Daily we beg the scientists in the photographic laboratories, please give us a film that will take a photograph in original colors. Speed the day when we may throw away our filters and dyes. Surely science has advanced enough to take this experiment and bring it to perfection."[5]

No one has achieved this ideal. Ironically, successful color photography hinged on the advancement of black-and-white photography.

NEWTON AND SPECTRAL COLORS
Long before the invention of photography, Sir Isaac Newton demonstrated that what we perceive as "white" light is actually a combination of all the spectral colors—red, orange, yellow, green, blue, indigo, and violet. Varying the proportions of these *spectral components* produces light of different colors. In 1861, twenty-four-year-old British physicist James Clerk Maxwell performed a demonstration at London's Royal Institution to show that color photographic images could be produced by separating the spectral compo-

°Source reference will be found at the end of this chapter, page 31.

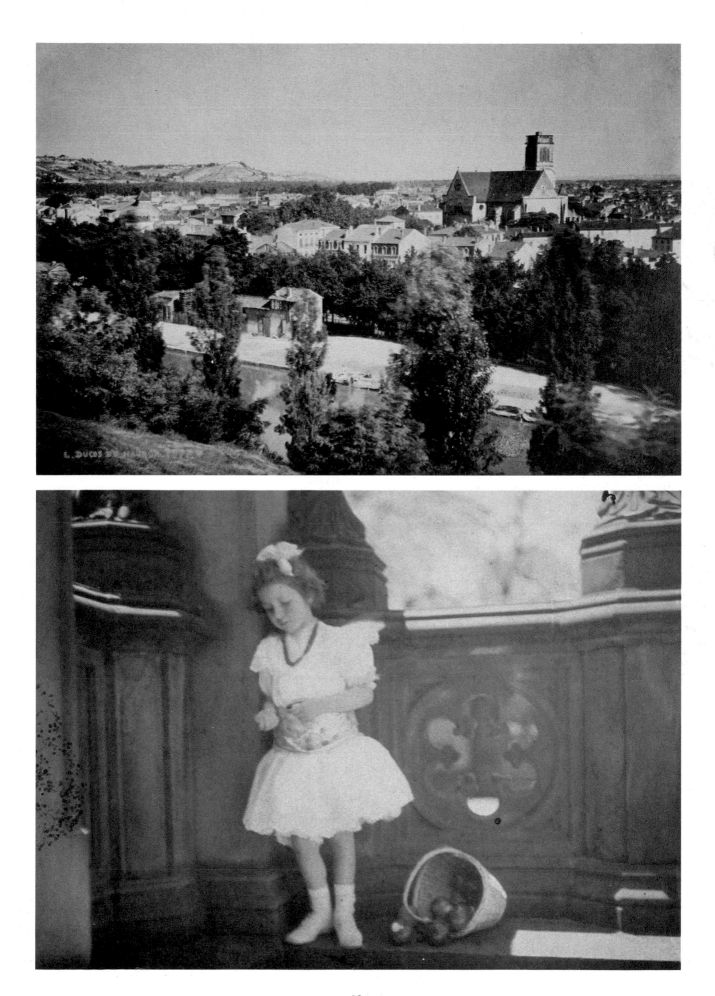

THE SEARCH FOR COLOR

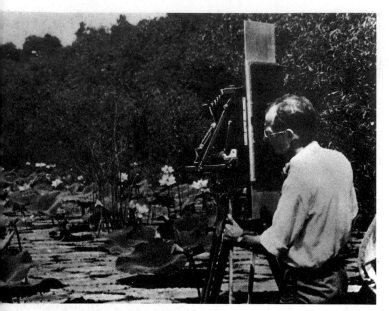

The classic method of color photography required shooting a trio of color separation images, each through a different filter. This wet photographer is up to his knees in a Wisconsin lake, shooting separations of lily pads for *The Milwaukee Journal* in 1928. The camera is a regular view camera equipped with a sliding back holding three sheets of film. While this arrangement speeded up the process of shooting separations, the procedure was still restricted to stationary subjects. Photo courtesy of *The Milwaukee Journal.*

nents of light and then recombining them. The demonstration was classic; all modern color photographic theory stems from it. Maxwell wrote:

> Let a plate of red glass be placed before the camera, and an impression taken. The positive of this will be transparent wherever the red light has been abundant in the landscape, and opaque where it has been wanting. Let it now be put in a magic lantern along with the red glass, and a red picture will be thrown on the screen. Let this operation be repeated with a violet and a green glass, and by means of three magic laterns let the three images be superimposed on the screen, and by properly adjusting the intensities of the lights, a complete copy of the landscape will be thrown on the screen.[6]

In other words, Maxwell used three primary-color filters to divide the colors of an original subject into components, recorded as positive black-and-white images. The images were recombined by projection, through the same filters that they had been photographed with. A full-color image resulted. Since Maxwell's technique called for three separate exposures of a subject, each through a different filter, photography of living subjects was impossible. Maxwell's subject was a tartan ribbon.

Panchromatic emulsions (sensitive to all colors) were unknown in Maxwell's day. Contemporary emulsions were primarily sensitive to blue light, and Maxwell's color separations were able to retain only small amounts of spectral color. Maxwell was aware of this shortcoming: "Given a suitable sensitiveness to the red and green, the reproduction would have been a truly colored representation."[7]

Maxwell did not produce a tangible photograph. All he was able to show was the superimposed image of three carefully aligned projectors. Though his theory was correct, practical color photography had a long way to go.

In 1862, Frenchman Louis Ducos du Hauron arrived independently at the same color theory as Maxwell: "The method I propose is based on the principle that the simple colors are reduced to three—red, yellow, and blue—the combinations of which in different proportions give us the infinite variety of shades we see in nature. If one could separately obtain these three images by photography and then reunite them, one would obtain an image of nature with all the tints it contains."[8]

In 1877, Ducos du Hauron produced one of the earliest known color prints. Three separations were converted into translucent gelatin images dyed in colors *complementary* to the three primaries—yellow, magenta, and cyan. These gelatin images were then carefully stripped off their support and mounted on top of each other, in exact register, on a paper support. This method of *subtractive color* (the removal of unneeded color density) is the basis of all contemporary color processes.

Ironically, almost all of Ducos du Hauron's conclusions were arrived at almost simultaneously by another Frenchman, Charles Cros. When they learned about each other's work, they became close friends.

In 1882, the discovery of aniline and eosin dyes changed the face of photographic emulsion chemistry. At last panchromatic emulsions were available and successful color separations could be made. But two basic problems remained: getting the three color separations with the minimum of effort, and combining them into a finished color photograph.

SCREEN COLOR PROCESSES

The first process allowing color photography of live subjects with a conventional camera was developed independently in 1895 by two men: John Joly and C. McDonough. A so-called "taking screen" was mounted in front of a black-and-white panchromatic photographic plate in a specifically designed holder. This screen was a glass sheet etched with orange, yellow-green, and blue alternating lines, about 230 to the inch. The screen was placed in contact with the emulsion side of the plate. Exposure was made through the screen. The screen lines functioned as tiny separation filters, allowing colors to pass in proportion to their spectral presence. After exposure, the taking screen was removed and the plate was developed to a positive image consisting of thousands of tiny lines—actually, closely grouped color separations. The transparency was bound onto a "viewing screen" similar to the taking screen but having primary-color lines. Registration was carefully adjusted so that, for example, a red line on the viewing screen covered a color-separation line put there by an orange line on the taking screen.

The result was a positive color transparency. Each secondary-color line of the black-and-white transparency was precisely matched up to an appropriate primary-color line in the taking screen. The density of the black-and-white line at that point controlled the amount of light that could pass through the colored line on the viewing screen. Thus, each group of three secondary-color lines comprised color separations of the color of the photographic image at that particular point on the plate. As long as a viewer did not look too closely, the separate spots of color would blur together. This visual mixing of three separation colors exemplified the "additive" color process.

AUTOCHROME: FIRST CONVENIENT COLOR PROCESS

Screen processes were to remain in production as late as the mid-1940s. The Joly/McDonough process was unwieldy and experimental, and other screen color materials became extremely popular. Probably the most famous was Lumière Autochrome.

Manufactured in France and first marketed in the United States in 1907, Autochrome combined the screen and the emulsion. Grains of dyed potato starch served as filters. A single-layer random pattern of starch

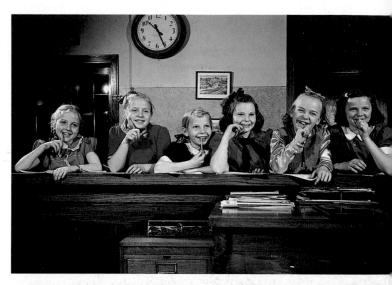

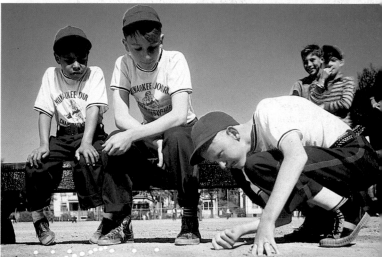

Many professionals gave Koda-chrome a try when it was introduced in sheet film sizes in 1938. Among the most successful early users were the photographers of *The Milwaukee Journal*, already famous for their Dufaycolor work. These scenes of *Journal* news-boys playing marbles and a group of little girls in a school office were shot by *Journal* staffer Edward R. Farber, using a 4×5 Speed Graphic. Photo from the collection of Edward R. Farber.

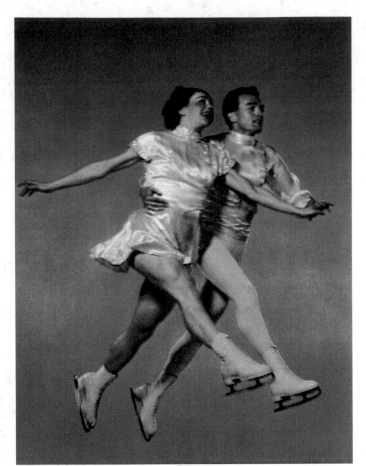

Above: Action color photography was more than a novelty in the days of one-shot cameras; it was a technical tour de force. When Victor Keppler photographed skaters Evelyn Chandler and Bruce Mapes for the March 6, 1937 cover of *The Saturday Evening Post* with a 5×7 Devin One-Shot Color Camera, he needed the blaze of 190 flash bulbs for a single exposure at 1/300 sec. The early color photographers worked hard for their pictures—there was no other way to take them. Photo courtesy of Victor Keppler.

Opposite page: The stars of impresario Mike Todd's *The Hot Mikado* posed for Anton Bruehl's one-shot camera at the New York World's Fair in 1939 for *Vogue.* This apparently spontaneous scene was actually carefully rehearsed and posed before a battery of carefully placed flash bulbs was fired to make an exposure. Since even one color shot was so hard to take using the high-quality but clumsy color processes of the day, such prominent photographers as Bruehl planned their pictures with meticulous care. The result was a standard of quality that has seldom been equaled in later days, even with more convenient equipment. Photo courtesy of Anton Bruehl.

grains (each about .015mm in diameter), dyed red, green, and blue in equal amounts, was spread on a glass plate. The spaces between the grains were filled in with lampblack, and a panchromatic emulsion was coated over the starch filter layer. Exposure of the plate was made with the filter layer facing the camera lens. Autochrome wasn't a high-speed process even by the standards of its day: Sunlight exposure was 4 seconds at $f/16$ and required a deep-yellow correction filter.

Such prominent photographers as Edward Steichen, Alfred Stieglitz, and George Bernard Shaw used Autochrome with impressive results. Victor Keppler wrote of Autochromes in 1938: "Some of the portraits I have seen have an exquisitely delicate pastel quality. Comparing them to current color photographs, vibrant with brilliant, saturated color, is like comparing a Marie Laurencin to a Gauguin. But they have a serene, modest charm entirely in keeping with the period in which they are made."[9]

In the 1930s, Dufaycolor took screen color about as far as it could go. Available in both sheet and roll-film sizes, Dufaycolor used a microscopic three-color ruled screen with a density of 23 lines per millimeter. The pattern was mathematically exact and the width of the colored lines was keyed to the sensitivity of the panchromatic emulsion. When used in large-format studio cameras, screen pattern was almost invisible.

But no matter how fine the screen color became, it was still there. Furthermore, screen color dyes that came close to the "sharp cutting" filter colors necessary for effective color separation would have made the speed of the films impossibly slow. As a result, color rendition was relatively bland. The best screen color processes still left much to be desired.

PIONEERS IN COLOR SEPARATION

In 1888 inventor Frederick Eugene Ives of Philadelphia took advantage of the growing sophistication of dye techniques to perfect panchromatic plates by adding chlorophyll to a gelatin photographic emulsion. The resulting improvement in spectral sensitivity allowed Ives to repeat Maxwell's demonstrations with superior results.

Realizing that audiences would want a more convenient method of viewing color photographs than Maxwell's three projectors provided, Ives designed the "Kromskop," a table-top viewer to combine color-separation images and filters in a convenient package that could be peeked into like a telescope. The Kromskop used two trios of separations, producing a stereo image. Results must have been impressive. After seeing a Kromskop demonstration, a London newspaper wrote: "With the Kromskop at this point of accomplishment, then bid farewell to the minor poet; his ladylove will no longer live in dreams, for he will preserve in a box the very sheen of her hair, just as in the present exhibition may be seen the gloss of the butterfly's wing, the bloom on the petal of the flower, the very tones of old ivory

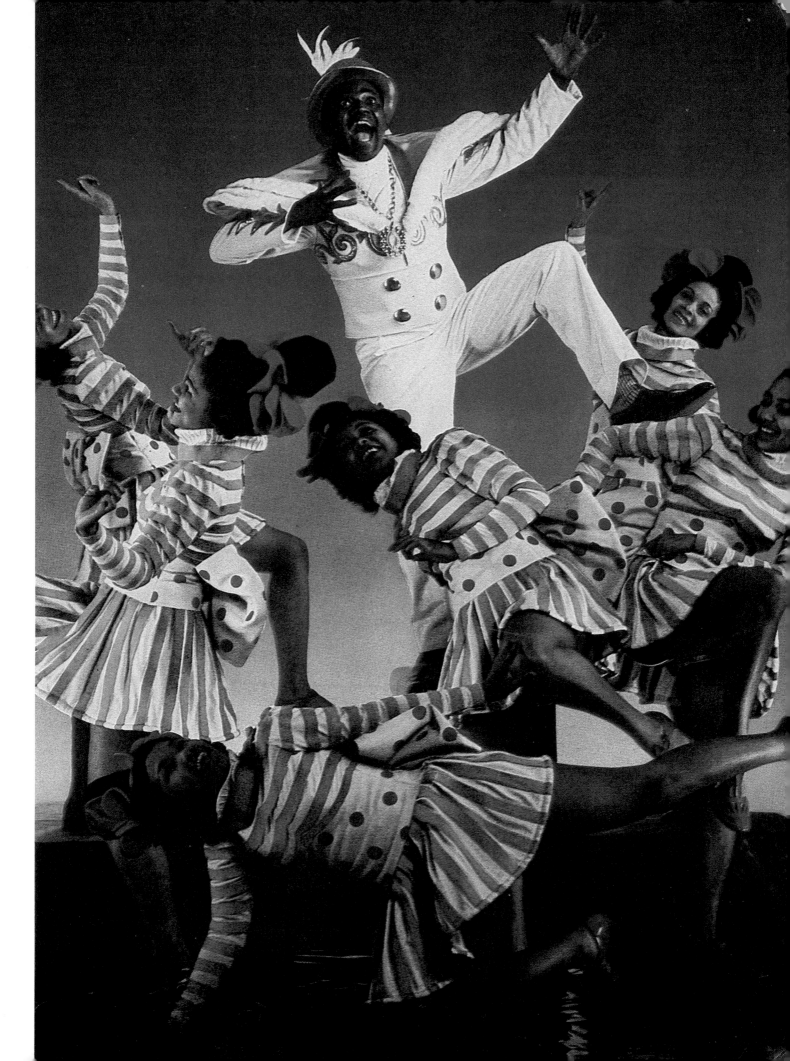

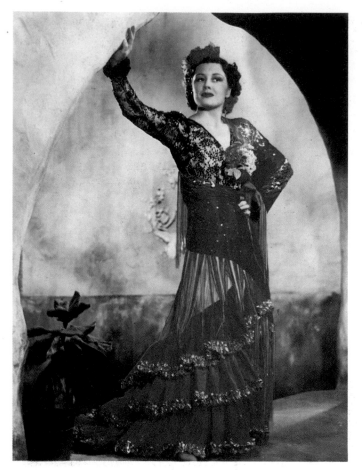

Wash-off relief was the first color print process to offer competition to the high-quality but clumsy carbro process of the 1930s. While Wash-Off Relief prints didn't have the longevity of carbros, they were easier to make and, as illustrated by the deep color saturation of this photograph of a flamenco dancer by an unknown photographer of the 1930s, gave high-quality results. Photo from the collection of Roger Kingston.

and inlaid pearl from the cabinet of the collector."[10]

Mindful that only motionless subjects could be depicted by the clumsy process of shooting three separation negatives with a conventional camera, Ives produced his Hi-Cro color camera in 1911 with backing from steel magnate Henry Hess. One of the first "one-shot" cameras, the Hi-Cro exposed three color-separation plates simultaneously. From the resulting separation negatives, one paper print was made of the blue separation, while the red and the yellow separation negatives were printed on transparent gelatin and dyed in these colors respectively. The dyed gelatin prints were then superimposed and cemented on the blue print, resulting in a subtractive color print.

The complex Hi-Cro was difficult to use and required powerful illumination to obtain an adequate exposure. Soon after the camera became available, prominent commercial photographer Lejaren à Hiller tried it:

> The subject chosen was to be a baseball player and his best girl, semi close-up. On the roof of my studio, I set up a plain background painted emerald green—roughly 8 x 8 feet. The girl had on screaming red clothes, the baseball player with his mitt had on what he should have had on.
>
> At high noon we got the models in place. Between them and the background I placed a flashpan containing four ounces of magnesium powder; on both sides of them a little further away, six ounces each and above the camera another six ounces. All were wired to go off simultaneously. Having given the proper warnings I got the models together in a tender embrace and let 'er fly. It wasn't that anyone was hurt but we had a little trouble to find our things—the background for instance. . . . I managed to grab the end of the end of the tripod while the camera was hopping away, so everything was hunky-dory. I sent the separation negatives to Mr. Hess with dispatch and in the course of time received the finished print with the suggestion that I use a trifle more light.[11]

By the end of the 1920s, a new color print process had been perfected: Carbon/bromide, or carbro. Beginning with the usual set of separation negatives, a set of separation enlargements, one from each negative, was made to the size of the final print on a special bromide paper. Each of these prints was rolled into contact with a special watercolor-pigment tissue in the appropriate primary color. The density of the bromide paper's exposures over the surface of the print was transferred to the tissues, each of which then became a pigment image of the color separation. The delicate images were placed on a temporary transparent support in careful register over each other, then transferred to a permanent paper support.

Comprising over eighty separate steps, the making of a carbro print was a long day's work for a skilled technician. The temperature of the dozens of different solu-

tions had to be precisely controlled. The pigment tissues had to be handled in a specially refrigerated, cork-lined cold room. The technician had no way of knowing if all the steps had been carried out correctly until the print was almost finished.

But once completed, carbro was the ultimate in color printing. The pigments used to form the image were stable and the colors were rich and bright. For the fortunate few able to afford the labs and staffs necessary to produce carbros in commercial quantities, the process spelled the expensive beginning of commercial color photography.

But the necessity of obtaining three color-separation negatives remained. Only still-lifes could be done by making three successive exposures. Photographers adapted to this clumsy procedure as well as they could. "We could take three shots before the hot lights could melt ice cream," recalls Frank Oberkoetter, a photographer of that era. "We used two photographers on the camera—one to change film holders, the other to change filters and trip the shutter."[12]

This clumsy procedure was useless for live subjects. While sliding-back accessories were introduced to hold all three films in a row and allow the separations to be shot as rapidly as possible, a better idea was a special camera to make all three exposures simultaneously. Ives's semiexperimental Hi-Cro was replaced by better-designed, more convenient one-shot cameras that used semisilvered internal mirrors to divide the beam from the lens into three identical images, each behind a different color-separation filter.

DEPRESSION-ERA COLOR BOOMS

The Depression of the 1930s brought hardship to millions, but big-money advertising of this era resulted in a color photography boom. Practical one-shot cameras and four-color photoengraving made color illustrations routine in the mass-circulation magazines of this pre-television era that were read weekly in millions of homes: *Vogue, Vanity Fair, Ladies' Home Journal,* and *The Saturday Evening Post.* Anton Bruehl, Victor Keppler, Valentino Sarra (who boasted that his Chicago studio could stage anything from a still-life to a mob scene), Lejaren à Hiller, H. I. Williams, Paul Outerbridge, Edward Steichen, and other prominent photographers all took the time and trouble to master one-shot cameras.

But one-shot camera photography never got easy. The cameras had serious limitations. The deep camera housings prevented the use of wide-angle lenses, and there were no camera movements for correcting vertical lines when the camera was tilted downward. "Some studios went to the extreme of constructing cockeyed room sets," recalls Frank Oberkoetter. "The sides of a fireplace would converge, for instance, so they would look parallel in a photograph shot from above without correcting movements."[13]

One-shot cameras were delicate, and refraction

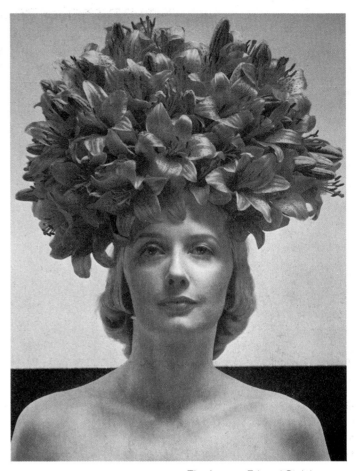

The famous Edward Steichen, then at the height of his commercial photographic fame, maintained studio color facilities in the 1930s. This offbeat portrait, taken in 1936, is amusingly titled "Heavy Lilies." It was taken with a 5×7 Devin One-Shot Color Camera. Flash bulbs were used for illumination. The picture was the lead illustration in the 1937 *U.S. Camera Annual.* Photo courtesy of Tom Maloney.

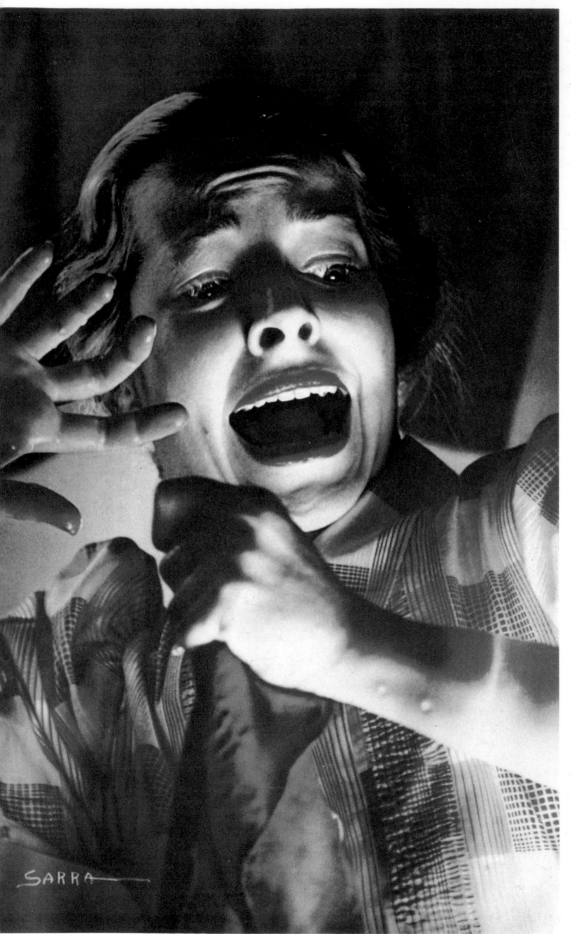

SARRA

Valentino Sarra was one of the most flamboyant and successful commercial color photographers of the 1930s, famous for his advertising illustrations. This studio re-creation of a woman's reaction to a kitchen grease fire was shot for The National Safety Council. The camera used was a 5×7 Devin, and flash bulbs furnished illumination. Notice the intentional use of green light at the left of the picture—an unnatural, unpleasant color...in keeping with the horror theme of the picture. Photo courtesy of Tom Maloney.

THE HANDBOOK OF COLOR PHOTOGRAPHY

problems made exact image registration difficult. The 5 x 7 Devin finally solved the problem in June 1936, using paper-thin "pellicle mirrors." Such a camera was only for the high-priced professional: The Devin "Precision" model cost $1,185 without lens in 1940.

One-shot color was a slow process. Paul Outerbridge's admiration for the Devin was mixed with frustration: "This is as good a single-exposure color camera as is made today, and yet it has a Weston speed of only 5 [approximately ASA 3 by today's standards]."[14]

DYE COUPLER FILMS TAKE OVER

Ironically, two months after availability of the Devin camera marked the peak of separation color, the first "dye coupler" film made color photography a game that anyone with a camera could play.

The idea of combining three color-separation emulsions on a single piece of film (referred to as a monopack film) was not new by the mid-1930s. What made monopack color film practical was the researches of a German, Dr. Rudolph Fischer. In 1912 he perfected the theory of what he called *color couplers*: chemical components that, when incorporated into a black-and-white photographic emulsion, would release colored dye during processing in proportion to the original black-and-white exposure.

From this point on, the future of color photography was in the hands of whoever could utilize such couplers in a practical monopack process. Two musicians, Leopold Mannes and Leopold Godowski, finally made it a practical reality. Through years of research, originally on their own and later at the Kodak Research Laboratories in Rochester, New York, Mannes and Godowski tackled and solved countless technical problems to produce what was finally marketed as Kodachrome film. It had three emulsions. The top emulsion was sensitive only to blue light. Below it was a layer of yellow dye to filter out any blue light that was not absorbed by the top layer. Next came an emulsion sensitive to green light only, and on the bottom a red-sensitive emulsion layer.

A single exposure produced a set of black-and-white separations in these three layers. Each layer was individually reversal-developed to produce a positive image and treated with color couplers to match the black-and-white exposure with a proportionate dye presence. The black-and-white image was then chemically bleached away, leaving only the dye image. When all three layers had been treated in this fashion, the result was a positive color transparency. In August 1936, the new film was marketed in 35mm size. Realizing that the 1" x 1½" transparencies would be difficult to handle, Kodak came up with the idea of the 2" x 2" cardboard mount—what is now known as the color slide—and marketed projectors to show the new slides on a screen. In September 1938, Kodachrome was marketed in sheet-film sizes.

Kodachrome was a vast step forward in convenient color photography, though its speed of ISO 6/9° was

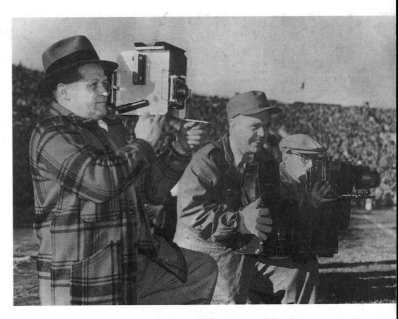

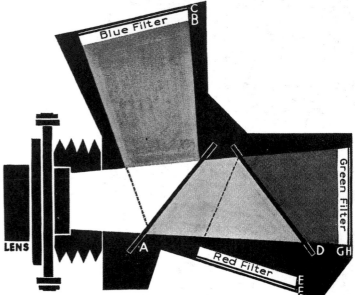

Top: The one-shot camera remained popular for certain applications even after the introduction of dye coupler color films. Shown here is *Milwaukee Journal* staff photographer Elmer Staab shooting a Packers football game with a Curtis Color Scout camera in the mid-1940s. Color engraving plates were made directly from the camera's separation negatives, allowing same-day "ROP" (run of press) color. Making separations from a color transparency would have taken more time than using a one-shot. *The Milwaukee Journal* was famous for its pioneering work in newspaper color. Photo courtesy of *The Milwaukee Journal.*

Above: This diagram of the light path of the Devin One-Shot Color Camera from a 1938 catalogue shows how complicated the camera was. A pair of paper-thin, semi-transparent "pellicle mirrors" divided the light beam from the lens into three identical images, each behind a different color separation filter. Costing over $1,000 in 1940, the Devin was strictly a tool for professional photographers.

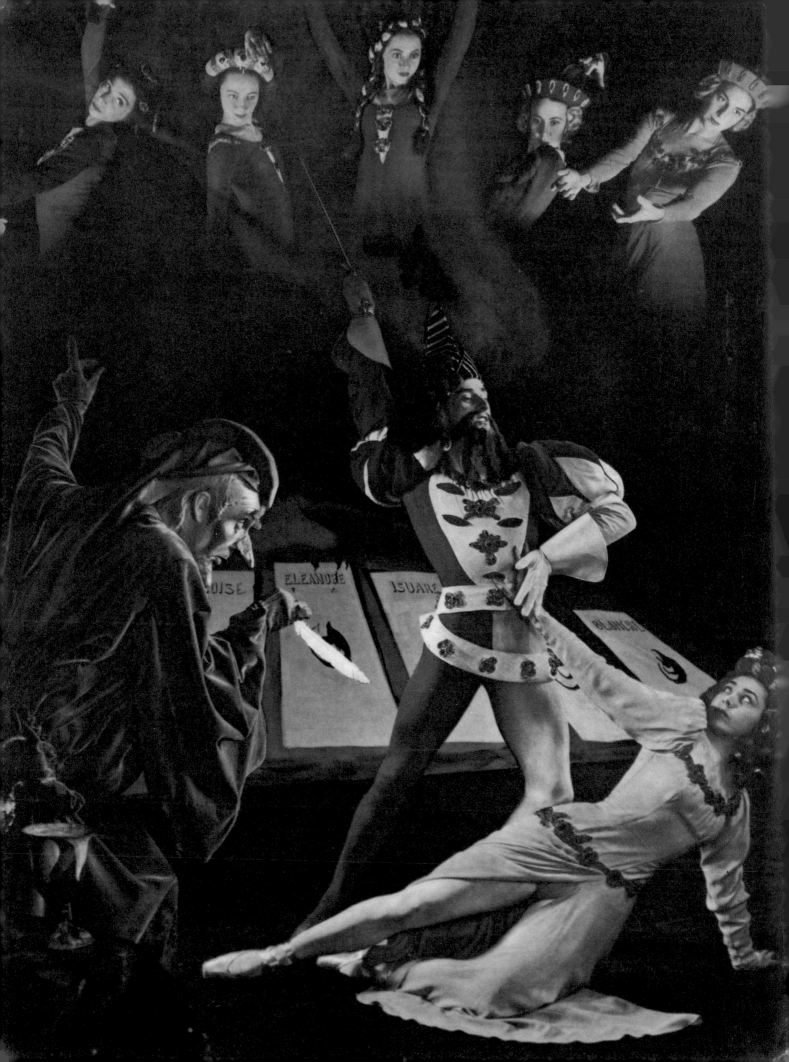

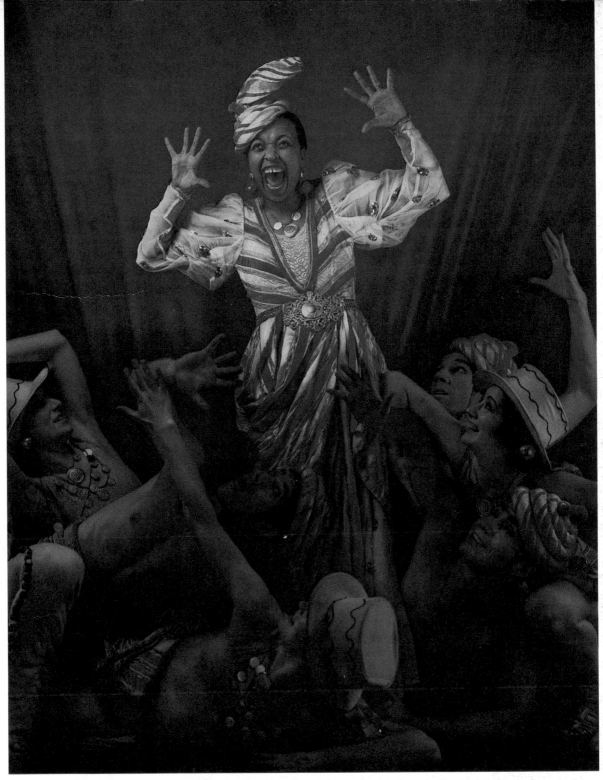

Opposite page: Barnova portrays Henry VIII complete with all his wives in this one-shot color camera montage by Anton Bruehl. Taken for a 1933 issue of *Vanity Fair* magazine, this theatrical illustration is typical of the meticulous work done by Bruehl and his technician partner Fred Bourges. Their "Bruehl-Bourges" credit was famous in the first boom years of color photography. Photo from the collection of the author.

Above: A young Ethel Waters poses for Anton Bruehl's one-shot camera in 1935, publicizing her performance in the Broadway hit *As Thousands Cheer*. The picture was taken for *Vanity Fair*, the great prestige magazine of the 1920s and '30s. Notice how carefully lighting intensity was controlled, keeping attention on Waters but retaining detail even in shadow areas. While this looks like an action shot, it was actually carefully posed and illuminated by a battery of flash bulbs.

Overleaf: A Bruehl-Bourges tour de force, this illustration of the full cast of Billy Rose's Music Hall on Broadway required over a thousand flash bulbs for a single exposure. Taken with a custom-made one-shot camera, this spectacular mid-1930s photograph was reproduced in *Vanity Fair*.

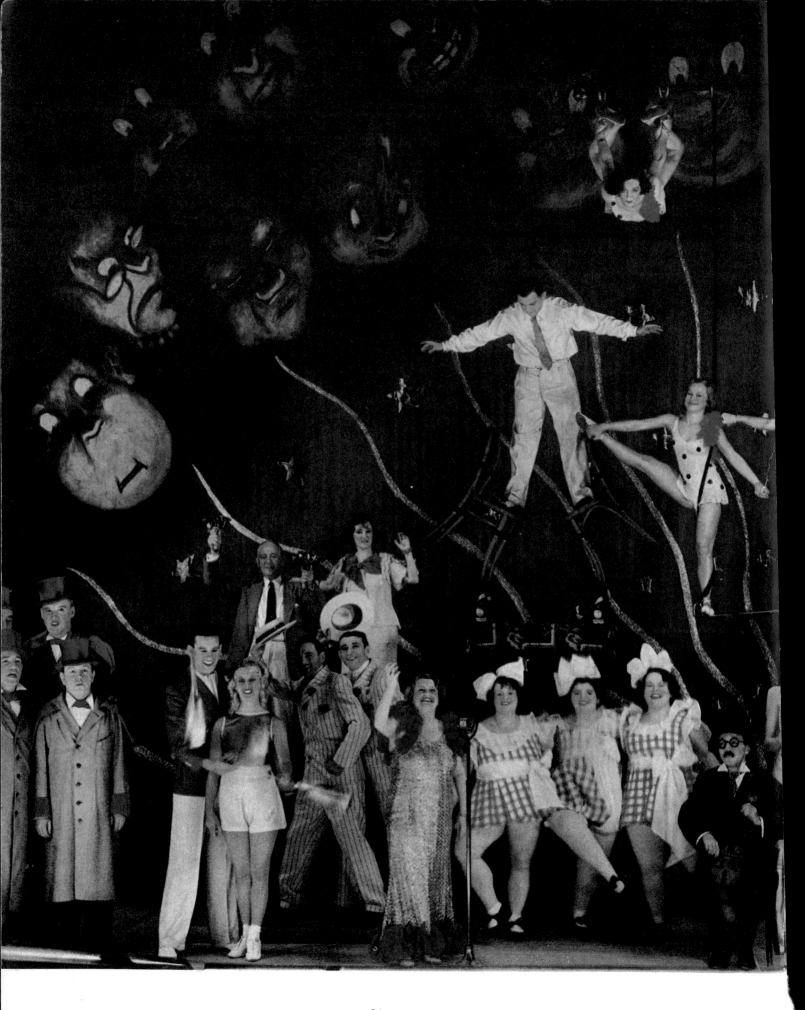

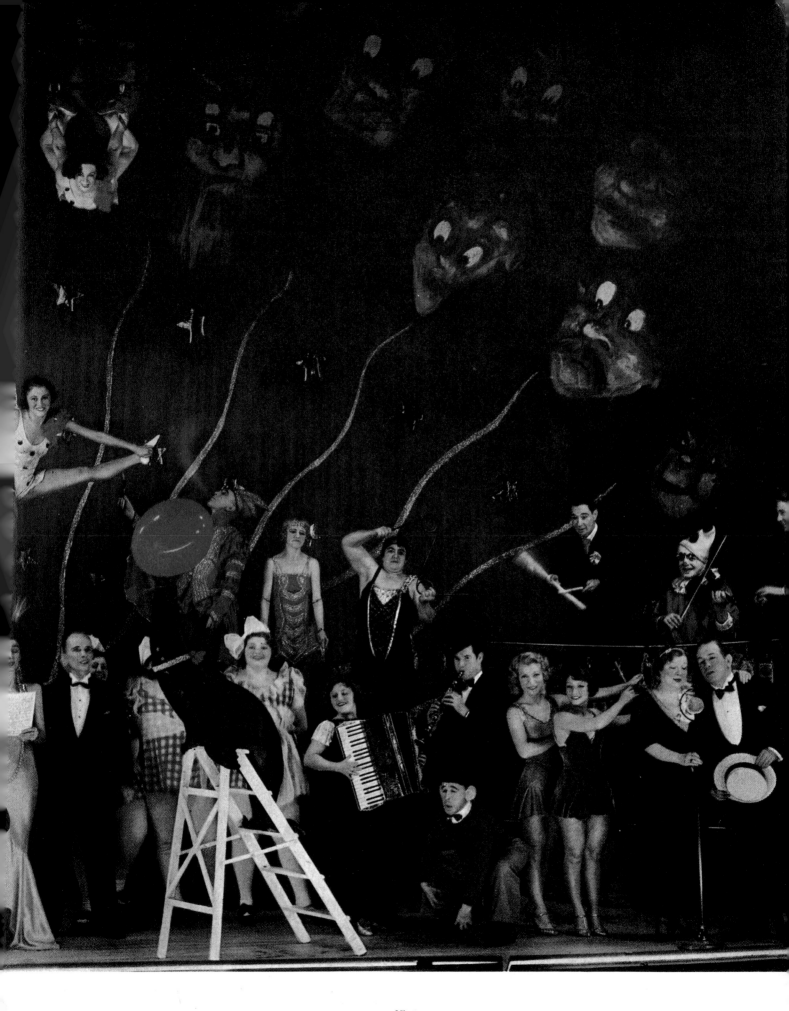

THE SEARCH FOR COLOR

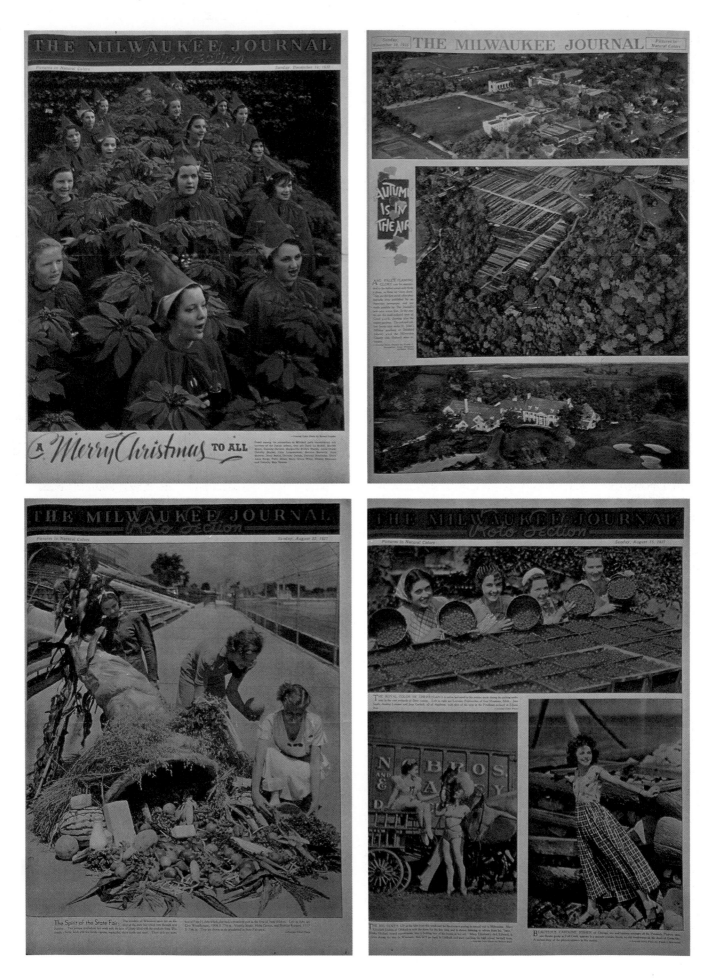

not much better than a one-shot camera. The film had to be shipped back to Kodak for processing. This shortcoming incensed some photographers. One of them was Victor Keppler, who wrote in 1938, "To have someone else interpret your picture in color is decidedly unsatisfactory. Until the developing process is simplified so that it can be performed in a studio, Kodachrome must remain a purely amateur process."[15]

Not all professionals agreed. Frank Oberkoetter described the scene at a New York studio building when one of the tenants was shooting Kodachrome:

> Grand Central Palace at 480 Lexington Avenue was a popular place to have a studio in those days. There must have been sixty photographers there, and they used to borrow each other's lights to shoot Kodachrome film. There would be electric cords running down the hallways to get enough power for the lights without blowing all the fuses. Then they would rush the film down to . . . [Grand Central] Station and get it on the train to Rochester for processing. It used to take the film two days to get back to New York.[16]

On July 23, 1942, the Ansco Company of Binghamton, New York, announced Ansco Color. Unlike Kodachrome, color couplers were incorporated in the emulsion layers. A single "color developer" activated the couplers, making user processing feasible.

In December 1941, Kodak began marketing Kodacolor roll film. It yielded a negative in which the colors were reversed. A blonde subject, for example, would have blue hair and green lips. Kodacolor was designed for positive prints via a negative emulsion on a paper base and was intended for amateur use. Processing and printing were done by Kodak.

Kodak brought out their own user-processed transparency color film, Ektachrome, in August 1946. The company soon discontinued sheet Kodachrome, a step that was not universally appreciated. Victor Keppler recalls, "My good friend Anton Bruehl got so mad when Eastman [Kodak] announced that sheet-film Kodachrome was being withdrawn that he sued them. His contention was that the new product was not as good as the old and the discontinuance of Kodachrome was affecting his livelihood."[17]

While carbro printing was to remain popular after the introduction of Kodachrome, the exacting conditions necessary to produce successful carbros had restricted the process to a small, well-paid elite. Aware of this problem, Eastman Kodak introduced the Wash-Off Relief Color printing process in October 1935. The three separation negatives were printed to size on sheets of special *matrix film*, the processed emulsion of which absorbed dyes in proportion to its degree of exposure (Wash-Off Relief was referred to as a "dye imbibition" process as a result). Each matrix was immersed in the appropriate secondary-color dye (yellow, magenta, or cyan), then squeegeed into contact with a paper base

Opposite page: In the days when color photography of any kind was still a novelty, *The Milwaukee Journal* was running regular color features, shot by staff photographers under the leadership of Frank Scherschel. While slow emulsion speeds required careful posing of most of these early color shots, they reflect the meticulous craftsmanship that made the *Journal* the most photographically progressive newspaper in the United States in the 1930s and '40s. Photo courtesy of *The Milwaukee Journal.*

Above: The introduction of Kodachrome in 1936 was a color photography milestone. At last, anyone with a 35mm camera (sheet Kodachrome was introduced two years later, for use in large-format cameras) could use this superior-quality dye-coupler film. At one stroke, all other color processes had been rendered obsolete, and Kodachrome's reputation for excellence has endured from that day to this—never equaled, never surpassed. Photo courtesy of Eastman Kodak Company.

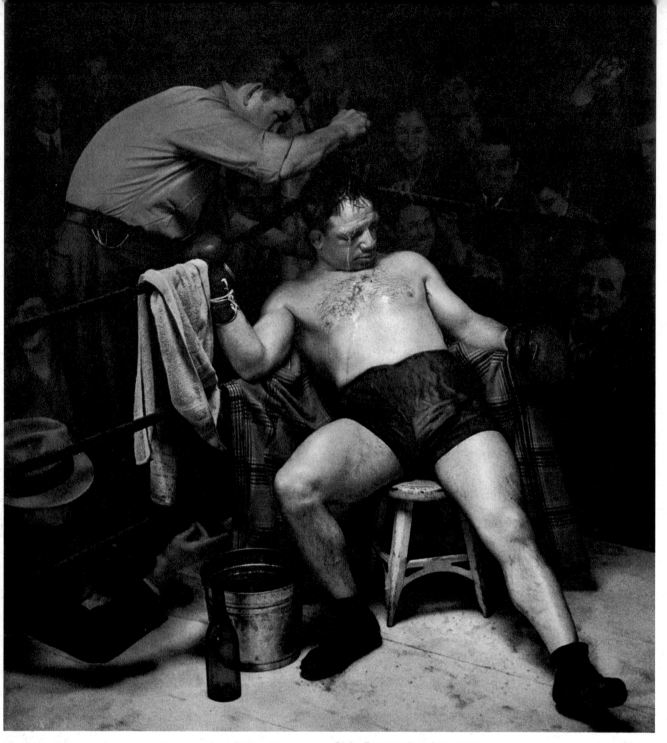

Above: "The Last Round," by Anton Bruehl and Fred Bourges, was a typical example of the carefully posed studio photographs that appeared in *Vanity Fair* magazine in the 1930s. While seemingly casual, this photograph was conceived and posed in Bruehl's studio, and dozens of flash bulbs were used to light the scene for Bourges' custom-made one-shot camera. The careful photography was backed up by top-quality photoengraving by staff engravers of Condé Nast, publishers of the famous magazine.

Right: Entitled "Ripe Corn," this offbeat nude study was shot by the great Edward Steichen in his New York studio in the mid-1930s, before Kodachrome film was available. Using a custom-built 8x10 one-shot color camera, Steichen made an open-flash exposure using four large #75 bulbs. The resulting trio of black-and-white separations of Wratten plates were combined to make a color transparency via the Kodak Wash-Off Relief process, a forerunner of today's Dye Transfer. Such complicated, expensive procedures restricted the use of color photography to professionals in this early boom era of the craft. Photo from the 1935 *U.S. Camera Annual*, courtesy of Tom J. Maloney.

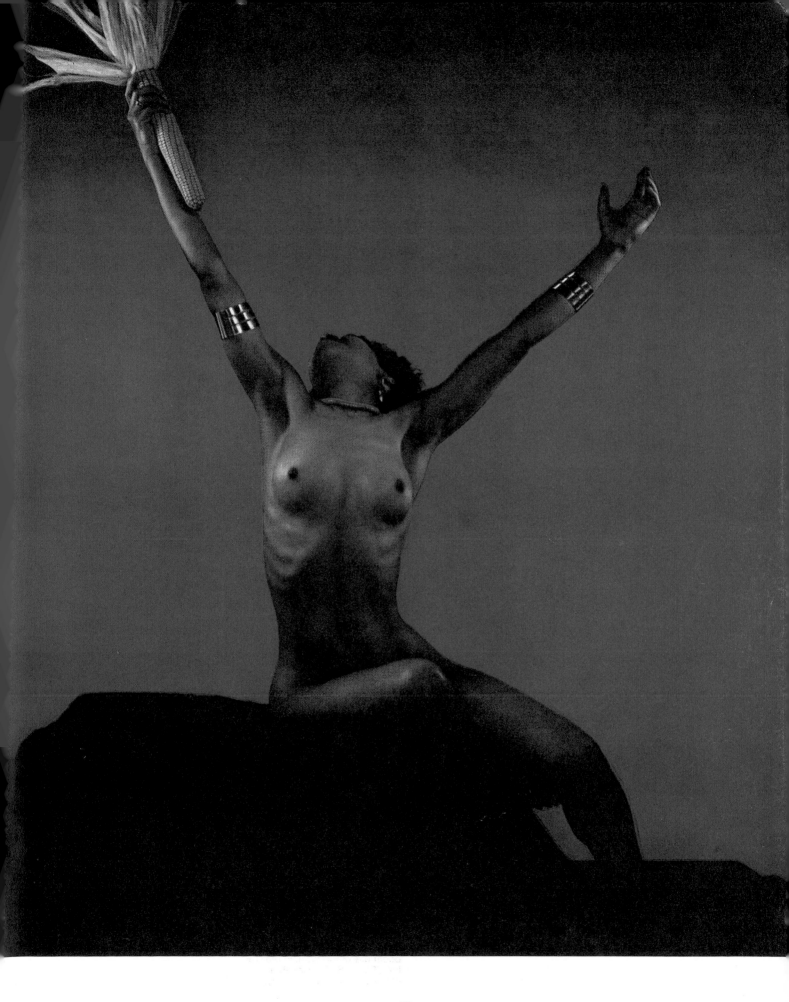

THE SEARCH FOR COLOR

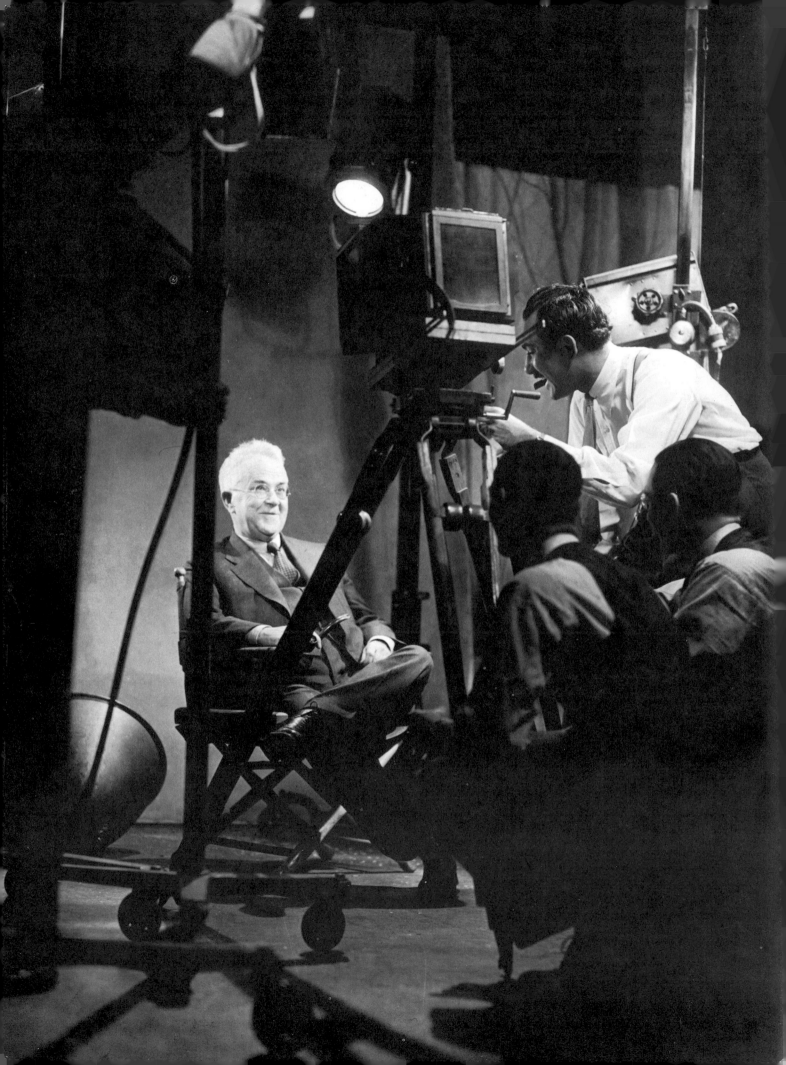

in exact register. The dyes then transferred from the matrix to the paper and a full-color image resulted. A single set of matrices functioned like a negative, allowing an infinite number of prints. Carbro's precise temperature and humidity controls were unnecessary. Dye Transfer, an improved version of Wash-Off Relief, was introduced in February 1946. Still in use, the process is regarded by many photographers as the current top-quality color printing technique.

In 1947, Kodak announced a professional-quality color negative film: Ektacolor. It could be user-processed and user-printed on Kodak's new "Type C" color print paper. Separation negatives were unnecessary and results compared favorably with Dye Transfer. Color printing had finally escaped from the professional color lab. "Color-ready" enlargers became a common sight in camera stores as thousands of amateurs and professionals took advanvage of the new printing process. At about the same time, Ansco introduced their positive-to-positive Printon process for making color prints directly from Ansco color transparencies, also with user processing.

THE MATURITY OF COLOR PHOTOGRAPHY

More than three decades have passed since the introduction of these processes. While color photographic technique has not changed significantly in these years, color has become an everyday reality for millions of photographers.

But while it's easy to load up with color film, color photographs are still not easy to take. The pioneers of color photography were more aware of their limitations than many photographers of today. Such photographers as Bruehl, Keppler, and Steichen made sure they were working under ideal conditions, even if it required firing off hundreds of flash bulbs for a single exposure, spending days to make a perfect carbro print, or working all day under blazing incandescent studio lights.

Good color photography is still enough of an exacting enterprise to make a solid grounding in color technique necessary for good results. The lesson to be learned from the pioneers of color photography is the necessity of knowing just what the color process is capable of.

NOTES

1—Beaumont Newhall, *The History of Photography*, Doubleday and Co., New York, 1964, p. 191.

2—*Daguerreian Journal*, II (New York, 1851), p. 17.

3—*1956 Color Annual*, Ziff-Davis Publishing Co., New York, 1956, p. 21.

4—*Humphrey's Journal of Photography*, XVI (1865), pp. 315–316.

5—Victor Keppler, *The Eighth Art*, William Morrow and Co., New York, 1938, p. 37.

6—Ibid., p. 38.

7—*1956 Color Annual*, p. 23.

8—Lewis Walton Sipley, *A Half Century of Color*, Macmillan Co., New York, 1951, p. 9.

9—*The Eighth Art*, p. 44.

10—*1956 Color Annual*, p. 25.

11—*A Half Century of Color*, pp. 54–55.

12—*Studio Light*, No. 1, Eastman Kodak Co., Rochester, N.Y., 1976, p. 3.

13—Ibid.

14—Paul Outerbridge, *Photographing in Color*, Random House, New York, 1940, p. 17.

15—*The Eighth Art*, p. 4.

16—*Studio Light*, p. 4.

17—Victor Keppler, *Man + Camera*, Amphoto, New York, 1970, p. 123.

Left: Victor Keppler was one of the most successful photographers during the first color boom years of the early 1930s. He is shown in his New York studio in 1937, taking a magazine cover portrait of Dr. Allan Roy Dafoe, the Canadian doctor who delivered the Dionne Quintuplets, for *The Saturday Evening Post.* On the tripod is the famous 5×7 Devin One-Shot Color Camera. Note the many powerful incandescent lights in this ultramodern studio — in the days before electronic flash units were available. Although Keppler was only shooting a portrait, he used a dozen lights, totaling 20,000 watts! Such hot lights, along with the slow emulsion speeds of early color processes, made posing an ordeal. Photo courtesy of Victor Keppler.

CHAPTER TWO
COLOR FILM BASICS

Understanding the limitations of color film is the first step toward using it successfully. Unlike the human eye, color films can't adapt to the endlessly changing colors of light we encounter every day. They perform best under light of one particular color.

Successful color photography depends on the ability to classify and control the color of a light source so as to tailor it to the needs of a particular color film. The standard method of classification is based on color temperature.

Color temperature was first determined by heating a piece of iron until it became incandescent. As the temperature rose, the color of the incandescence changed. At relatively low temperatures, the color was reddish. It got more and more blue at progressively higher temperatures. The result was that any color could be expressed in terms of the temperature necessary to reproduce it in hot iron. This temperature is measured on the Kelvin scale (which begins at absolute zero) and referred to as *color temperature*. It is expressed in thousand degrees *K*. For film to give its most accurate color rendition, the color temperature of the light source must be tailored to the film's capabilities. Color filters can be used if the film/color temperature equation doesn't match.

This method of expressing color is the opposite of the terminology used by artists. As color temperature *increases*, the color gets bluer. Artists refer to blues as "cool" colors and reds as "warm" colors. Just to make things even more confusing, photographers use the artists' style of color expression when describing the appearance of color photographs, but use color temperature terminology when talking about light sources and film capabilities.

COLOR TEMPERATURE BASICS

There are meters to determine the exact color of light sources, but in the everyday world there are only a few basics of color temperature that photographers need to know—the color temperatures of light sources necessary to obtain optimum results on various color films. These color temperatures are referred to as the films' *color balances.*

5500 K. The color balance of so-called "daylight" color films, those designed to give accurate color rendition under daylight or electronic flash, which is similar in color. Such films include Kodachrome 25 and Kodachrome 64, Ektachrome 64, 200, and 400, and Kodacolor II and Vericolor II (Type S).

The choice of 5500 K as the color temperature to which daylight color film is balanced is a generalized norm. Depending on time of day, atmospheric conditions, and geographic locale, the color of daylight can range from about 2500 K early or late in the day to over 6000 K under a noonday sun. For most photographic needs, this constant change is not a serious problem. We expect reddish light early and late in the day, just as we expect midday sun to be "white." If daylight color

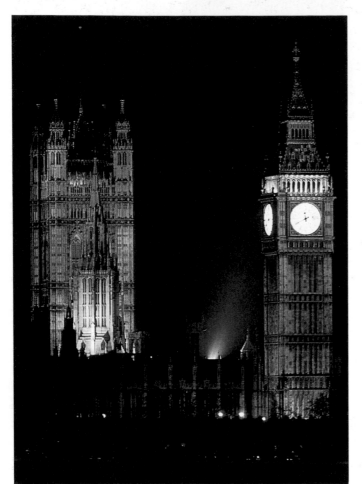

Above: Shot with a 300mm lens mounted on a tripod, this view of the Houses of Parliament in London called for a 40-second exposure on Kodachrome 25. Although rendition tends toward the yellow-orange because of the incandescent floodlights illuminating the subject, the overall look seems to be in keeping with the majestic mood of the subject. The brighter-lit clock face, however, is overexposed.

Opposite page: Type B ("tungsten") and daylight-balanced color films give different renditions under light sources of the same color temperature. Either result may be desirable. These two pictures of the Royal Military Tattoo in Edinburgh, Scotland, were shot on tungsten-balanced 3M 640-T *(top)* and daylight-balanced Ektachrome 200 *(bottom)*. Notice how the incandescent lighting is correctly depicted on tungsten-balanced film while the sky is rendered a deep blue. Ektachrome 200 renders the incandescent lights as yellow-orange and the sky as light blue. Which is the "correct" rendition? Neither one, since both incandescent and daylight are present in the scene. Like much of color photography, it's a matter of taste.

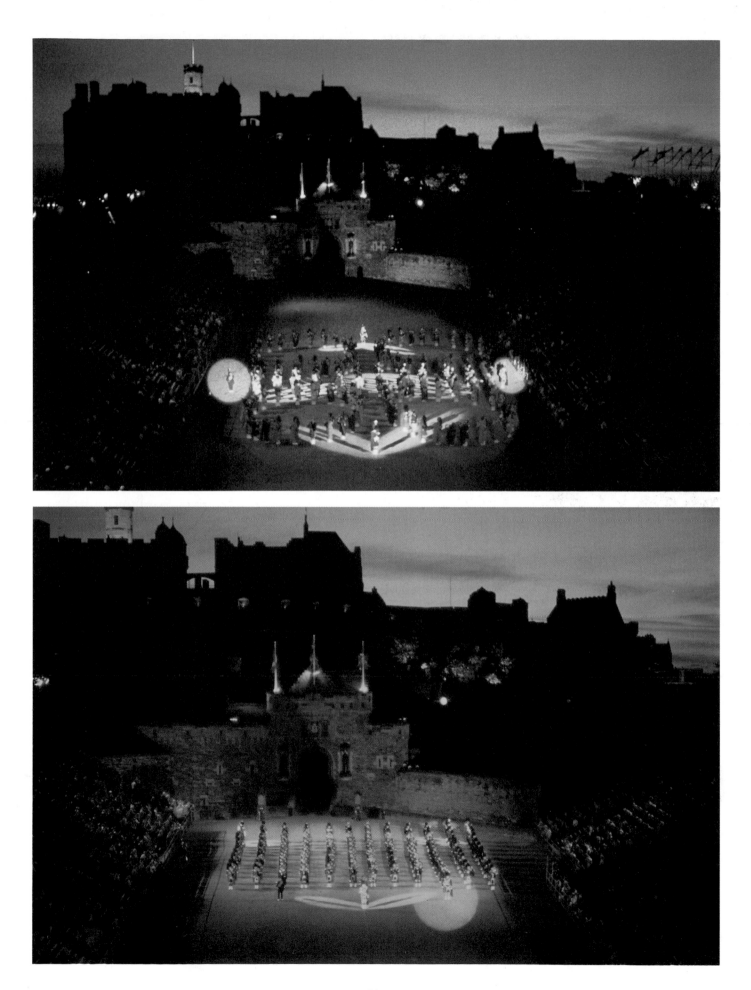

film reproduces these colors, it's mirroring reality as we see it.

3200 K. The color balance of "tungsten" or "Type B" color films. Such films are designed for exposure under incandescent light sources rated at 3200 K. Examples of these films include Kodak Ektachrome 160, Vericolor II (Type L), and 3M 640-T.

3400 K. The color balance of "Type A" color films, designed for exposure under incandescent light sources rated at 3400 K. The only such film currently on the market is Kodachrome 40. The color balances of Type B and Type A color films are only 200 K apart. Why does Kodak manufacture this close cousin of Type B? Tradition!

Light/Color Balance Mismatching. When color film is exposed under light of a *lower* color temperature than it is balanced to, colors in the final result are *warmer* than they were in the original scene. An example is daylight color film (balanced at 5500 K) exposed to 3200 K photofloods. The resulting picture has a yellow-orange "cast," or overall color tone.

When the light source is of a *higher* color temperature than that to which the film is balanced, a blue color cast results. An example is Type B color film exposed in daylight.

The degree of these off-color results varies with the gap between the color temperature for which the film was designed and the color temperature of the light. The human eye can detect a difference of about 50 K. For this reason, much professional color photography is done in studios where the color of the light can be controlled and top-quality results can be guaranteed.

COLOR POSITIVE VERSUS COLOR NEGATIVE

Color film is available in two basic types, positive and negative. Positive films yield a positive (or *reversal*) color transparency from the film that was originally exposed. Color negatives must be printed on either paper or film to provide a final positive result.

The advantages of transparencies (or slides) have made them standard with most commercial and many amateur photographers.

☐ Transparencies are finished as soon as processing is completed. No additional steps or expenses are necessary before the final result is viewed, evaluated, or utilized.

☐ Transparencies are viewed by transmitted light. This means they are as bright as the viewing light itself. Opaque color prints are viewed by light reflected off the white base they are printed on, and can be no brighter than that base. The best color print cannot have the sparkling color of a good transparency.

☐ Color prints cannot show as much detail as a transparency. Many subtleties of hue and density are lost.

☐ A color print made from a slide can be compared with the original slide to make sure it is accurate. Color negatives *must* be printed before a positive result is obtained, and color printing results are a subjective matter. Much depends on the tastes of the printer.

☐ Color transparency films have better technical quality than comparable color negative films. Many professionals who seek a high-quality color print begin with a high-quality positive film for this reason.

☐ Slides offer the convenience of projection. No color print can match the sparkle of a well-presented slide show.

☐ Positive transparency films are available in a wider variety of emulsions than color negative films.

☐ Transparency films can accommodate modified processing for film speed control. Most color negative films do not allow this option without unacceptable quality loss.

Advantages of Color Negatives. Color negative films have their advantages, too. Millions of amateur snapshooters and many professionals depend on them.

☐ Color negatives allow an infinite number of prints of equal quality to be produced. A color transparency has no negative and can be reproduced only by duplication. Although current "dupe" films often yield high-quality results, precise duplication can be difficult and expensive.

☐ The exposure latitude (that is, the degree to which you can depart from the correct exposure and still have an acceptable result) of color negative films is far greater than that of transparency films. To produce top-quality color slides, you must be constantly aware of exposure considerations. Color negatives allow compensation for many exposure mistakes in the printing stage.

☐ Controls are possible in color printing. An overexposed area in a color negative can be burned in during the printing to show more detail. An area underexposed in the negative can be dodged or held back, as is done in black-and-white printing to lighten heavy shadow areas in the print. Color casts can be introduced or eliminated. Unlike color transparencies, the image can be cropped in printing. Also, all areas of the picture do not necessarily have to be within the latitude of the film at the time of exposure. There is a second chance in the darkroom.

☐ Color negatives allow the widest choice of finished results. Both color and black-and-white prints can be made from color negatives. Transparencies can be made in a wide variety of sizes, including 35mm slides, with all the advantages of color printing.

☐ Color negatives allow you to ignore some of the precise filtration rules of color transparency shooting. In a pinch, much color correction can be done later in the darkroom.

☐ Color prints can be hung on a wall, carried in a wallet, or pasted into a designer's layout.

☐ Good-quality color negatives allow inexpensive mass color print production. Wedding and school photographers, for example, have specialized photofinishers

The subtle colors of flowers
behind the ground-glass window
of a public house in Oxford,
England made it a natural low-key
picture opportunity. If the flowers
had been brighter, the calm feeling
would have been diminished.

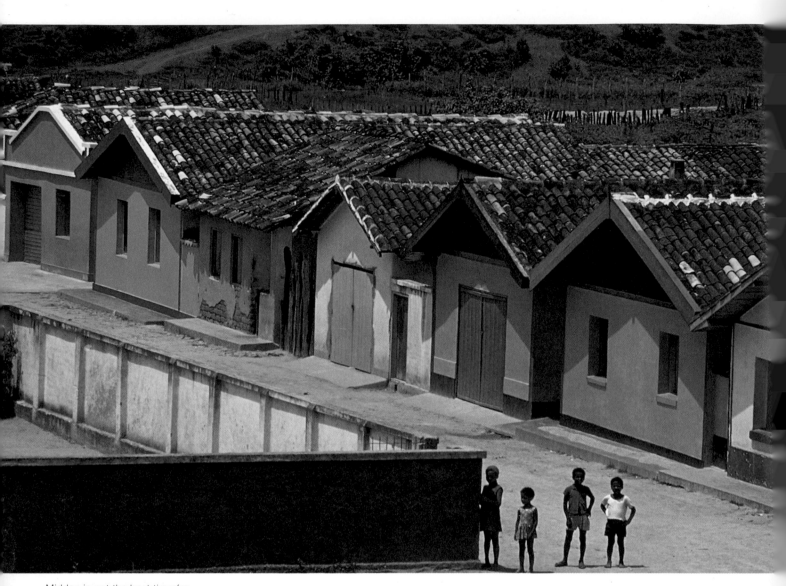

Midday is not the best time for taking pictures of any kind, but in the case of these rural Brazilian schoolboys, there was no choice. The picture was shot on Koda-chrome 25, using a 300mm lens. Fortunately, the light-colored walls of the tiny town reflected a lot of sunlight into the shadow areas, giving a better picture than usually results at this hour.

make low-price color prints by the thousand on automatic printing machines.

☐ Since color negatives can be conveniently retouched, they are a favorite of portrait photographers.

HOW ACCURATE CAN COLOR BE?

Although many advertisements for color film use such words as "natural" and "true" to describe their results, technical bulletins tell a different story. Specifically, the manufacturers say that their films are capable of giving "visually pleasing color reproductions" of scenes. Most color films do a reasonably good job of playing back a scene's original hues, but truly accurate results are impossible.

☐ For "accurate" rendition, a color photograph of a scene would have to be viewed under the identical intensity and color temperature of light present at the original scene. This is almost impossible; yet viewing the same hues under different illumination can distort our perceptions.

☐ Characteristics of some of the dyes that form the images in color films differ from the characteristics of some of the dyes and pigments found in nature. As a result, some colors found in nature cannot be accurately reproduced on color film.

☐ Color photographs are almost never prepared and viewed under consistent illumination. For example, consider the various lighting conditions for a color photograph that is exposed under incandescent light in a studio, printed in a fluorescent-illuminated color lab, and finally hung on a wall in a living room where a mixture of daylight and incandescent light is present. Under these circumstances, anyone's idea of "accurate" color will inevitably conflict with anyone else's.

☐ Color films and the human eye have different color sensitivities. Color films are more sensitive to blue and to green light than the human eye is. They are also sensitive to ultraviolet (UV) light, which is present in both sunlight and electronic flash but is invisible to us. Ultraviolet light can result in a "UV blue" tinge in color photographs.

☐ Even if films were capable of it, perfect color reproduction would be possible only under controlled laboratory conditions. In the real world there are countless vagaries of cameras, lenses, light, film emulsion, and processing to take the edge off any theoretical perfection.

Fortunately, color photographers have human predispositions on their side. For instance, even an off-red rendition of an apple in a color photograph is often acceptable. Black-and-white photographs have no color at all, yet they're accepted by millions of people every day. But very young children can only understand full-color illustrations. The ability to imagine color where it is not present comes of familiarity with the actual colors of the subjects.

Top: Keep track of the speeds of films being used. Exposure errors ruin thousands of color pictures every day, and in the case of transparency films, there's no second chance in the darkroom. The clips found on the back of many 35mm cameras to hold the end of the film box are an excellent idea. The film type, complete with ISO number, is staring the photographer in the face.

Above: The box holding a roll of 35mm Ektachrome 64 film carries important information. The emulsion number indicates the manufacturing batch of the film; the expiration date tells how long the film can be expected to produce satisfactory results under approved storage conditions. While this is not a roll of "Professional" film, the user is still advised to "Process Promptly," to decrease the chance of quality loss due to latent image decay.

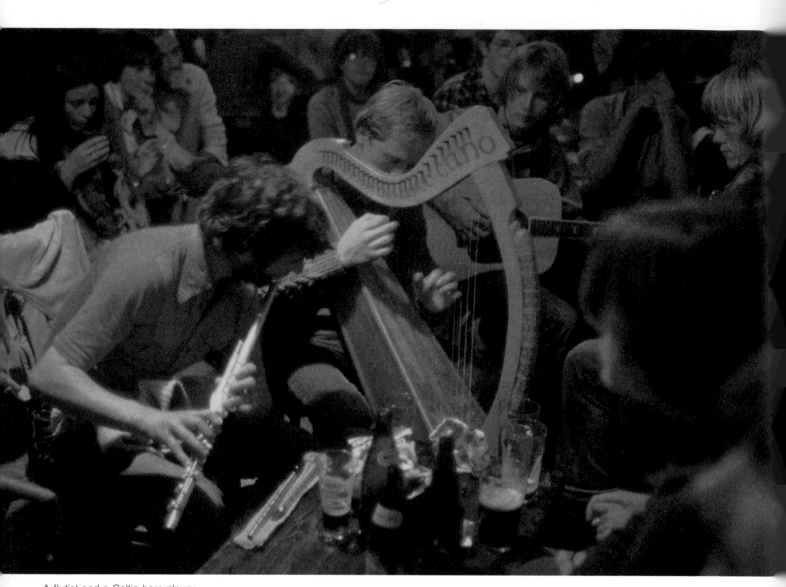

A flutist and a Celtic harp player entertain pub patrons in Doolin, Ireland. Illuminated only by dim incandescent lights, this scene required an exposure of 1/15 sec. at f/1.4 on 3M 640-T. While the film was balanced for 3200 K illumination, the color temperature of the lighting was almost 1000 K lower, resulting in warm color rendition. While use of the correct light balancing filter would have improved results, the prevalent yellow-orange tone seems appropriate for the subject matter. In addition, the added density of the LB filter would have necessitated a longer exposure of an already marginal low-light situation.

An accurate color depiction of a subject may be less satisfying to a viewer than an inaccurate but attractive one. Artists know that skin colors that look real often have nothing to do with "reality." There is a story that Renoir was once asked how he achieved the delicate flesh tones in his paintings of nude figures. "I just keep painting and painting until I feel like pinching," the artist supposedly said. "Then I know it's right."

The theoretical capabilities of color photography are less important than its ability to produce a satisfying result. Accurate color may not be desirable when inaccurate color is more attractive to a viewer.

SHOPPING FOR COLOR FILM
Many of the same criteria that apply to black-and-white film quality are also valid for color-film evaluation. The faster a film's speed (the higher the ISO number), the poorer the technical quality of the resulting pictures in either medium, particularly in the matter of the gravel-like random texture known as grain.

Grain—or, more accurately, "granularity"—is particularly noticeable in out-of-focus images because it is the sharpest detail in the picture. In addition, backlit shooting situations appear to increase the prominence of grain.

Fast color films also suffer from increased contrast and decreased exposure latitude, resulting in dark shadows and chalky highlights, while slow, fine-grain color films offer lower contrast and wider exposure latitude. Fast color films have nothing to offer but speed. In every other way, they are technical losers.

While personal taste has a lot to do with the selection of a color film, the superiority of daylight-balanced Kodachrome 25 and its Type A brother, Kodachrome 40, makes these films the standard by which all other color films are judged. Although Kodachrome is available only in 35mm size, does not offer a "Professional" emulsion (more about that soon) and must be returned to Kodak or a few big independent labs for processing, it's the color film of choice throughout the professional photographic industry. Grain is almost nonexistent, and wide exposure latitude results in superior rendition of shadow and highlight detail. Glowing "Kodachrome shadows" are instantly recognizable. The film has better-than-average resistance to ultraviolet (UV) light and many airport X-ray inspection machines (see chapter 8). The technical superiority of Kodachrome slides makes them automatically preferred by professional picture editors. If visual details are comparable, a Kodachrome will always be chosen over a slide shot on any other film.

Since most other color films can be processed in a few hours, Kodachrome's processing delay is a handicap when quick results are necessary. Two-day Kodachrome processing turnaround is standard service from Kodak dealers in most large cities. Most independent labs don't do much better.

For one-day Kodachrome processing, a customer can request Kodak's "pink bag" service. This service takes its name from the pink plastic bag used to hold these special-order rolls. It's Kodak's policy to do their best to process at least half the contents of a pink bag and have it back by the next day's shipment. If the pink bag order is small (six or eight rolls), all of it may be returned the next day.

Other Color Films. If quick processing, higher film speed, or larger-than-35mm film formats are a consideration, other color films must be chosen. Here's a rundown of available films as of 1981.

Kodachrome 64. While this high-speed version of Kodachrome 25 doesn't deliver quite the quality of the slower emulsion, it's still an excellent film. Balanced for daylight exposures, it must be sent to Kodak for processing. Kodachrome 64 is available only in 35mm.

Kodak E-6 Ektachromes. These are available in sizes from 35mm to 120/220 roll film, plus sheet film sizes up to 11 x 14. All sizes of film can be processed in Kodak E-6 chemicals by independent labs, Kodak labs, or the user.

E-6 Ektachromes are balanced for 3200 K illumination in speeds of ISO 50/18° and 160/23°, and ISO 64/19°, 200/24°, and 400/27° in 5500 K daylight color balance. These emulsions are available in both 35mm and 120 sizes. The film is available in sheet film sizes in speeds of ISO 50/18° (3200 K), 64/19°, and 200/24° (both 5500 K).

Fujichrome. Manufactured in Japan, this 35mm daylight-balanced color film is available in two speeds, ISO 100/21° and 400/27°. It can be processed in Kodak E-6 chemicals.

Agfachrome 64 and 100. These German-manufactured 35mm color films are daylight-balanced. They can only be processed in the United States by two labs—one on the East Coast, one on the West. Such mail-in processing can take anywhere from one to two weeks.

3M 640-T. This is currently the fastest color film on the market. Available only in 35mm size and in tungsten (3200 K) color balance, speed is ISO 640/29°. It is sold by camera shops and by K-Mart under their Focal brand name. Processing is done in Kodak E-6 chemicals.

Independent brands. A number of discount retailing and processing chains such as K-Mart and Fotomat offer private low-price brands of both negative and positive film, usually manufactured in Italy or Japan. In many cases, the film must be processed where it was bought.

While the choice of color negative films is smaller than that of color positive films, this restriction must be viewed in the context of color negative applications. Color negative films enjoy wide use by amateurs who use simple cameras and send their film to commercial

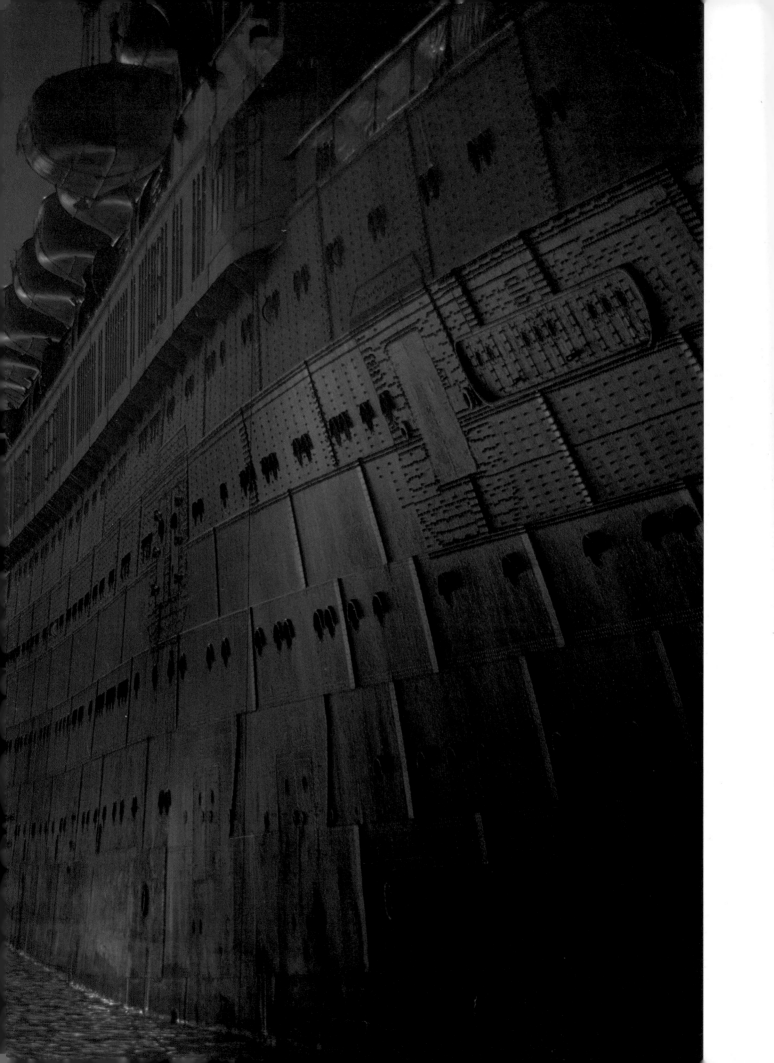

photofinishers. Wide film choice is less important than standardized, automated processing capability. Professionals who produce color prints exclusively—wedding, school, and portrait photographers—routinely shoot color negative in roll and sheet film formats that yield good sharpness and fine grain, plus ease of retouching. Since these photographers work under standardized lighting conditions, only a few film types are necessary. Color negative films also offer great flexibility in processing and printing; a few different film emulsions can accomplish more than the same number of transparency films.

All color negative films available for still camera use in the United States can be processed using Kodak C-41 chemicals, either by a lab or by the user. Kodak's color negative films include:

Kodacolor II (available in 110, 35mm, 120, and 620 sizes). This general-purpose film is balanced for 5500 K daylight exposures. Speed is ISO 100/21°.

Kodacolor 400 (available in 110, 35mm, and 120 sizes). Offering four times the speed of Kodacolor 100 with an attendant increase in grain, this 5500 K–balanced film has excellent response to unfiltered incandescent and fluorescent light.

Kodacolor has traditionally been an amateur film, designed to give acceptable results under a wider variety of light sources and exposures than Vericolor II.

Vericolor II, Kodak's professionally oriented color negative film, is available in two emulsions, each with different applications.

☐ *Vericolor II, Type S* ("short exposure"), is available in 35mm, 120/220, and sheet film sizes. The film is intended for daylight or electronic flash exposures (5500 K) of less than 1/10 second. Speed is ISO 100/21°.
☐ *Vericolor II, Type L* ("long exposure"), is available in 120/220 and sheet film sizes. Exposures must be longer than 1/10 second under 3200 K light sources. Speed is ISO 80/20°.

The Japanese Fujicolor 100 and 400 color negative films are available in 35mm. Performance is similar to Kodacolor 100 and 400 and the films are C-41 processing-compatible.

Other Japanese and Italian color negative films are available from various discount chains. Although the prices are low, the negatives must be printed by independent labs or the user; Kodak will print only color negatives shot on their own standard still picture films.

WHAT MAKES A FILM "PROFESSIONAL"?
Ektachrome in 35mm is offered in two kinds of emulsion for each film speed, "professional" and nonprofessional. The professional film costs more. What's the difference?

Professional and "amateur" Ektachromes are actually the same films. The difference is in the way the films are handled and sold. Tied into this process are the

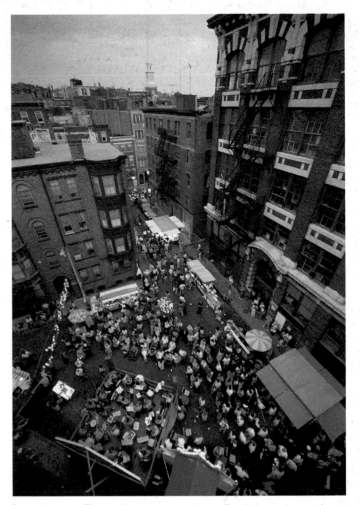

Opposite page: The setting sun on the side of an ocean liner moored at a pier on the New York City side of the Hudson River was given a dramatic boost by means of an orange filter over the lens of the camera. While the color is very exaggerated (notice that the sky is the same color), it still looks believable.

Above: Taken by early-evening twilight, this overhead view of a street fair in Boston's North End is rendered with a blue color cast on Ektachrome 400. While compensatory filtration might have eliminated the blue, it forms a desirable contrast with the bright lights of the street below. Film-light source mismatch doesn't necessarily produce bad pictures.

The red and green composition of this barn in Nova Scotia seemed tailor-made for a color shot in afternoon sun, but some human element was needed to lend depth to the scene. Fortunately, two brothers passing on bicycles agreed to pose for this picture, taken with a 21 mm lens.

calculations necessary to determine the film's *expiration date*. Immediately after manufacture, color film is too "raw" to use. Carefully supervised aging is necessary before the film can be expected to give acceptable results. Further aging brings more improvement, until a quality peak is reached, after which quality declines until performance is unacceptable. The expiration date stamped on the film box is the estimated date that the film will have aged to the point where it cannot be expected to give acceptable results.

Amateur color film is aged to the point where it just begins to give acceptable results. Then it's put on the market. These films are intended to have the longest possible life ahead of them. The assumption is that amateurs will keep unused or partially used film longer than professionals—who buy their film fresh, shoot it soon afterward, and process immediately.

Expiration dates are figured not only on the estimated "life" of the film, but also on the conditions under which the film will be stored. For amateur films, the expiration date is figured on room temperature (75 F) and average relative humidity (60 percent). High heat and humidity cause serious damage to color films (see chapter 8).

Professional color film is aged and sold under a different premise. A professional is assumed to want a film of peak quality and predictable characteristics. To achieve this, extra trouble and expense are necessary. Professional color film is aged until it reaches its peak of quality, then packed and shipped under refrigeration to keep the film at that peak. The film is stored in refrigerators at camera stores and should be kept refrigerated after purchase (55 F or lower), since the film has already reached its quality peak. If quality is not stabilized by refrigeration, it will decline. The expiration date is based on these storage conditions. Storing the film under conditions specified for amateur films will result in a shorter useful life than the expiration date predicts.

Once professional film is exposed, it must be processed as soon as possible to get the full benefit of its peak condition. Exposed but unprocessed film (both color and black-and-white) is subject to a degrading of image quality called "latent image decay" (see chapter 8).

The premise of professional color film hinges on the assumption that professional photographers work under precisely controlled conditions where the peak quality of professional films will make a noticeable difference. For studio photographers working under precisely controlled lighting conditions, this may be a valid assumption.

But most photographers are working under everyday, nonstandardized conditions where the extra quality of professional film will make almost no difference in the final result. Chances are that daylight won't be exactly 5500 K. Certain lenses impart a slight color cast. Color labs sometimes make processing errors that cause slightly off-color results. None of these factors is likely to cause serious problems (although an unlucky combi-

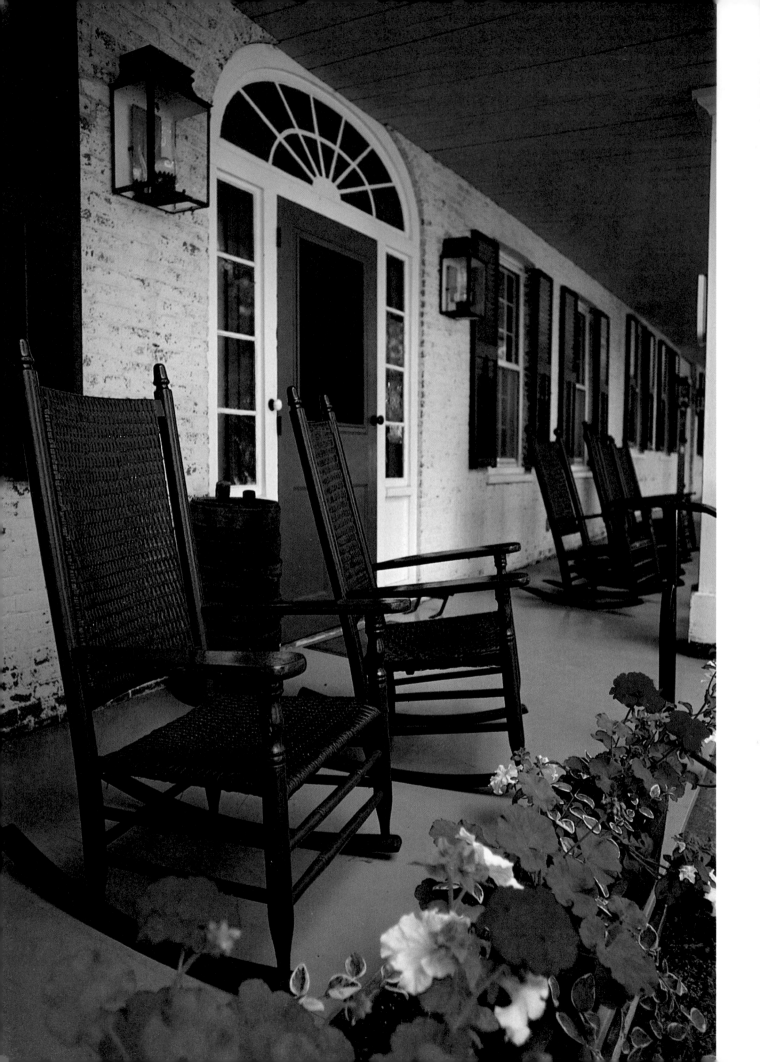

nation of them might), but they can add up to enough variables to make the use of professional film superfluous and the higher price unjustified. Few photographers are routinely in a position to make effective use of professional film's extra quality control.

Sometimes there is no choice. Kodak supplies their sheet and roll color films (excluding Kodacolor) only as professional emulsions. Oddly enough, Kodachrome 25 and 64 are regarded by their manufacturer as amateur films. They are not supplied with professional emulsions. To make things odder, Kodachrome 40 (Type A) is supplied only as a professional emulsion.

Emulsion Numbers and Consistency. The long number on the side of a film box alongside the expiration date is the emulsion number. It tells what production run of the film yielded that particular roll. Emulsion-batch awareness is significant for the same reasons that professional color film is occasionally worth paying for and using—to know exactly how the film will perform.

Color film manufacturing is as scientific as manufacturers can make it, but there are variables that can't be quality-controlled during this extremely complicated process. The result is that when a particular batch of ingredients is mixed up for a color film production run, the film will have slightly different performance than other batches.

Most photographic situations have enough real-world variables to make the slight quality differences between emulsion batches unnoticeable. But professionals who need to know exactly how their film will perform routinely buy their color film in large batches of the same emulsion number, keep performance stable under refrigeration, and shoot test pictures to determine precisely the characteristics of that emulsion batch. In some cases, they let the film age a bit to improve performance.

SAVING MONEY ON FILM

Color film is expensive and getting more so, but there are several ways to bring prices down. Most big discount stores offer film and processing at discounts of 20 to 30 percent. Buying from such mass marketers is wise because their low prices ensure rapid stock turnover. The film probably hasn't been lying on a shelf for a long time. The newer the film is, the longer its useful life.

Some 35mm color films are available in 100-foot bulk rolls. The film can be cut into lengths up to 36 exposures and loaded into cassettes in a darkroom. Savings are over 50 percent but there are some risks. Film can be scratched, either by clumsy handling or by bits of dirt embedded in the plush light traps of the film cassettes. If the darkroom isn't totally dark, light fogging may result. Sweaty fingers can leave prints on the film. For serious, convenient bulk film loading, invest in a daylight loader like the Watson (available at big camera stores for about $25). Kodak supplies Ektachrome 50, 64, 160, and 200, plus Vericolor II, Type S, in 100-foot rolls. These films are available only in the professional emulsion form.

Buy European Kodachrome. Many New York mail-order discount camera stores offer Kodachrome complete with Kodak processing at close to half list price, especially when you buy ten or more rolls. This Kodachrome is manufactured in England or France and is cheaper because high-volume dealer purchases in Europe yield bigger discounts than comparable ones in the United States. The film is sold at a package price including processing. While processing may take a day or two longer because of the extra paperwork involved, the low price should make the delay acceptable.

Cover up the red foreground flowers in this scene of a Vermont inn's front porch and the picture is little more than a black-and-white photograph. That injection of bright color makes the picture come to life.

CHAPTER THREE
COLOR FILM EXPOSURE

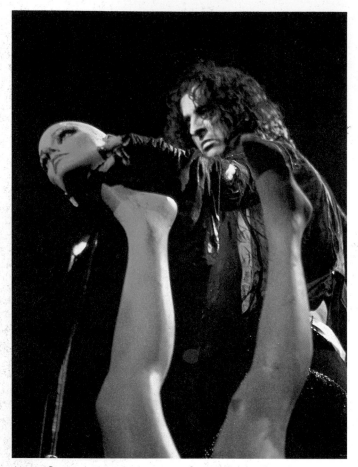

Above: Stage pictures, such as this one of macabre rocker Alice Cooper, require constant checking with a spot meter for reliable exposures. Light intensity can change every few seconds, and different-colored lights also require exposure compensation.

Opposite page: Backlit shooting situations can fool reflected-light meters, but certain scenes can "compensate" for meter error. This sunset shot of ducks swimming in Boston's Charles River would have been underexposed if the bright sun had been shining directly into the 300mm lens with its TTL meter. But the dark area of the river embankment in the middle of the composition "fooled" the meter enough to result in a correct exposure. The moral? Sometimes photographers get lucky with uninterpreted meter readings, but they can be unlucky just as easily! An understanding of exposure theory is crucial for reliable, consistent color exposures. Meters are helpful, but the *photographer* must do the thinking.

According to the advertising of most 35mm SLR camera manufacturers, exposure is simple. Set the camera's film-speed dial for the film in use and point the camera at the subject, any subject. The through-the-lens (TTL) exposure system takes over from there, delivering perfectly exposed results.

Unfortunately, exposure will never be as simple as that. To get top-quality color photographs (and save money on film that would otherwise be wasted), exposure theory must be understood. Inaccurate exposures ruin thousands of color photographs every day. The reflected-light TTL meters found in many 35mm SLR cameras are convenient to use, and in that convenience lies their biggest liability. The meters are *too* easy. Photographers often follow the meter's advice when they should know better. Meters yielding an averaged reading of light reflected off a subject overlook some real-world exposure conditions.

Correctly exposed film possesses an image density of 18 percent. In other words, exposure meters are designed to yield an exposure that renders subjects at an 18 percent density. However, only subjects that have 18 percent reflectivity to begin with yield accurate exposure readings with reflected-light meters. Relatively few subjects actually have 18 percent reflectivity. A white-painted house, for example, reflects about 80 percent of the light striking it. The average Caucasian skin reflects about 30 percent. Fresh white snow reflects close to 100 percent.

Since reflected-light meters are calibrated to render *all* tones as 18 percent gray, they give incorrect readings of subjects with *other* than 18 percent reflectivity. Subjects reflecting *more* than 18 percent of the light striking them will be underexposed, while subjects with *less* than 18 percent reflectivity will be overexposed. For example, a black wall will be overexposed as the meter tries to lighten the black to 18 percent gray. Snow scenes will come out as underexposed gray rather than sparkling white as the reflected-light meter darkens the white to 18 percent gray.

Most 35mm SLR TTL meters are also "center weighted." Light sensitivity is concentrated more in the center of the frame than at the edges. The theory runs that the area of principal interest in most pictures is in the center of the frame, and that spot is where accurate exposure is most important.

Like most simple theories, this one has limited application. Many pictures don't have their center of interest in the middle. Even if they did, that spot might not coincide with the sensitivity area of the meter and might not be even close to 18 percent gray. Camera manufacturers enjoy claiming that these center-weighted meters are more accurate than "averaging" meters that have equal sensitivity all over the frame. In fact, each type is accurate (and inaccurate) about the same percentage of the time.

INCIDENT LIGHT: THE BETTER WAY

A different approach to exposure was pioneered in 1936 by photographer Don Norwood, whose meter of the same name was the first to calculate exposures based on *incident light*. The meter itself became the subject. Readings were taken at the subject position rather than the camera position. Exposures were based on the intensity of the light falling *on* the subject, not reflected off it. The light-sensitive cell of the meter was covered by a frosted plastic sphere resembling a Ping-Pong ball that "read" light coming from a hemispherical area. While the Norwood meter was calibrated for 18 percent gray readings, it was not affected by subject reflectivity. It gave a single reading based only on the intensity of the light source and offered some impressive advantages over reflected-light meters.

☐ Holding the integrating sphere of the meter in highlight and shadow areas allowed easy calculation of light/shadow exposure differences.
☐ Since subject color and reflectivity did not affect the meter, a single standardized reading resulted.

Subject reflectivity has surprisingly little bearing on accurate exposure. While incident-light meter readings are often inaccurate with extremely dark or light subjects, the majority of exposures are accurate to within one-half *f*-stop. However, even incident-light meters have their limitations.

☐ It's not always possible to take an exposure reading at subject position, or in the same light falling on a subject.
☐ Subjects lit by transmitted light (like sunsets and similar backlit situations) don't allow incident-light readings.

SPOT METERS

Spot meters are specialized reflected-light meters that cover a very narrow angle, usually one degree. Such pinpoint sensitivity allows easy exposure readings from inaccessible or inconvenient subject areas. Spot meters are particularly useful for comparing the relative brightness of highlight and shadow areas of a particular subject. This information allows a photographer to determine whether subject brightness range matches the three *f*-stop exposure latitude of color films. If not, the decision must be made to sacrifice either shadow or highlight detail (more on this soon). Since the problem of varying subject reflectivity affects spot meters as much as it affects other reflected-light meters, readings require interpretation to arrive at a correct exposure when an 18 percent-reflective subject is unavailable.

Spot meters deal with this shortcoming in different ways. The calculator of the Pentax Spot Meter V (Pentax Corp., Englewood, CO) uses a series of reference points to be matched up with subject color. While these settings are supposed to compensate for varying subject color reflectivity, subject color may not match the color these calibrations are based on.

The adjustable light-gathering hemisphere of the Minolta Auto Meter III makes incident-light measurements easy. At top, a highlight reading is being taken; at bottom, a shadow reading. By using the meter's integral memory system, these readings can be automatically averaged to determine the most effective overall exposure.

Above: Exposure bias controls, such as this one on the Nikon F3, allow customizing the performance of the camera's reflected-light TTL meter to varying subject reflectivity. Subjects darker than 18 percent gray can be "underexposed" for accurate rendition; lighter subjects can be appropriately "overexposed." Such controls require experience to use effectively and are not as convenient, but they overcome many of the shortcomings of reflected-light meters.

Opposite page: Exposure for such transmitted-light scenes as this stained-glass window in St. Giles Cathedral, Edinburgh, Scotland cannot be handled with an incident-light meter. Using the TTL meter of a Nikon F3, an uncompensated reflected-light reading resulted in correct exposure on Kodachrome 64. However, this window does not have a lot of clear glass. If it had, such a reading might have underexposed the darker areas of colored glass. A compensatory "overexposure"— about one *f*-stop—would have been necessary to modify the meter's results.

Above: The brightly lit water behind this beachcomber on the Maine coast would have fooled a TTL meter, resulting in under-exposure of the foreground. A spot meter reading, taken off the sand behind the subject, gave the correct exposure. The circular highlights were caused by the use of a 500mm "mirror" lens.

Above: Snow scenes are classic foes of TTL meters. Their high reflectivity invariably dupes these reflected-light meters into underexposure as they try to turn the white snow gray. For this picture of a cross-country ski race in Vermont, a careful spot meter reading was taken off the faces of the skiers.

Left: Late afternoon sunlight shining on the side of this freighter on Boston's Mystic River could result in underexposure when metered with the center-weighted TTL meters found on many 35mm SLRs. The meter would be fooled by the bright patch of light. In trying to reduce it to 18 percent gray, the meter would yield too dark a result. Ideally, exposure should be made for the surface of the water, using a spot meter, or for the overall scene, using an incident-light meter with the light-gathering sphere illuminated equally by highlights and shadows.

Left: Dramatic backlit scenes like this one of wintertime sledders in Dorchester, MA, can result in underexposure with TTL meters. An incident-light meter is useless here, and it can be difficult to know just where to take a spot meter reading. The simplest expedient is to expose one *f*-stop more than the TTL meter indicates. In many cases, this extra exposure compensates for the difference between the bright sun and the darker sky area around the figures. To be on the safe side, try overexposing both one *and* two stops.

Dark-colored subjects will often fool TTL meters into overexposure. This scene of a tiny sailboat framed between Boston's Harbor Towers was brightly lit by the sun, but the water itself was dark blue. Since a center-weighted TTL meter could be expected to concentrate on the water, the exposure used was one-half f-stop below the TTL-metered setting, resulting in rich blue rendition of the water and warm-colored rendition of the buildings, illuminated by late-afternoon light.

THE HANDBOOK OF COLOR PHOTOGRAPHY

Minolta meters (Minolta Corp., Ramsey, NJ) are in a class by themselves. The Minolta Auto-Spot II Digital allows the user to program a particular exposure bias into its internal automated calculator in accordance with subject reflectivity (the meters of many 35mm SLRs, including the Nikon F3 and Minolta XD-11, offer similar capability). The Minolta Spot Meter M uses an integral microcomputer to store up to three different exposure readings in memory. These exposures are displayed on an analogue scale, and can be automatically averaged.

HAND-HELD METERS

Since reflected-light TTL meters give inaccurate readings at least as often as they give accurate ones, an incident-light meter will pay for itself very quickly in saved film. Many hand-held meters allow both incident and reflected light readings to be taken interchangeably. Such meters include the Gossen Luna-Pro SBC (Berkey Marketing Co., Woodside, NY), the Calculite X (Quantum Inst., Garden City, NY), and the Vivitar 160LX (Vivitar Corp., Santa Monica, CA). These are essentially reflected-light meters that incorporate slide-in incident-light hemispheres. Accessories that include spot metering attachments are available.

Since incident-light readings are often more useful than reflected-light readings, it may make more sense to buy a meter designed for incident-light reading. Such meters can be adapted for reflected-light use if necessary. The light-gathering hemisphere is swivel-mounted on top of the meter housing, allowing inspection of the calculator regardless of the position of the hemisphere. Choices include the Spectra Combi-II (Kollmorgen Corp., Hollywood, CA), and the Sekonic Auto Meter L-428 (Copal Corp., Woodside, NY). The most sophisticated incident-light metering is found in the Minolta Auto Meter III. Using the same microcomputer system as Minolta's Spot Meter M, the Autometer III can retain two separate light readings, displaying them on an analogue scale.

NEGATIVE VERSUS POSITIVE EXPOSURES

Meters are useless without an understanding of the different exposure approaches necessary for positive and negative color films. While all meters can be used for either application, correct exposures are seldom the same, even when the speeds of the negative and positive films are identical.

Color transparency films should generally be exposed for the highlight areas of the subject. The only exception is when highlight areas constitute an insignificant part of the picture, such as a backlit subject where most of the picture is in the shadow areas.

The opposite is true of color negative films. This is because a color print is made from a color negative, and a negative with insufficient shadow detail seldom produces a good print. Therefore, negative films should be exposed for subject shadow areas unless the shadows are

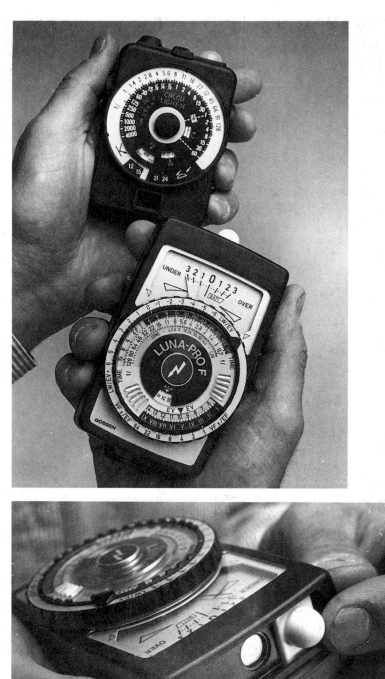

Top: A pair of hand-held exposure meters. On top is the Calcu Light-X, at bottom is the Gossen Luna-Pro F. These meters can read both constant-light and electronic-flash light sources.

Above: Using a slide-in light collector, the Gossen Luna-Pro F can be converted from a reflected- to an incident-light meter at the flick of a finger.

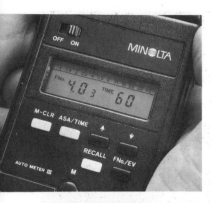

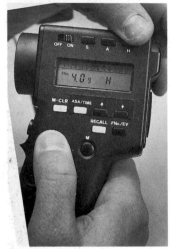

Top: The buttons on the front of the Minolta Auto Meter III may look confusing at first, but they allow unprecedented exposure control via this meter's internal microcomputer.

Above: While spot meters (in this case the Minolta Spot Meter M) are often clumsy and expensive, they allow fine exposure control unavailable from TTL camera systems and regular reflected-light meters. For reliable exposures under varying conditions, a spot meter may be well worth its price.

insignificant parts of the picture. Exceptions include subjects consisting *only* of highlights, such as sunlit landscapes.

Extremes of light and shadow pose the biggest problems for color photographers. A highlight/shadow brightness difference greater than three *f*-stops will sacrifice detail in shadows, highlights, or both, depending on the exposure used. To determine this range using an incident-light meter, use the "Ping-Pong ball" receptor to take two separate readings, one with the receptor completely in shadow and another with the receptor completely illuminated by the light source. These two readings are the difference between highlight and shadow illumination. To determine a compromise exposure, position the hemispheric receptor so half of it is illuminated by the brightest light with the other half in shadow. The resulting exposure will be an average of highlight and shadow intensity. The microcomputer of the Minolta Auto Meter III can combine and display such readings automatically.

Spot meters can also be used to determine subject brightness range. Comparison readings are taken of shadow and highlight areas and the difference noted. Just be sure that these areas incorporate subjects of equal reflectivity or the reading will not be meaningful. For fast, convenient comparison readings, the analogue scale of the Minolta Spot Meter M has many advantages.

EXPOSURE LATITUDE VERSUS COLOR SATURATION

Color slide films have a narrow but significant exposure latitude. Within that latitude lies control of color saturation. *Saturation* is an expression of the richness of colors. A light, pastel-like rendition in a color photograph exemplifies low color saturation; rich, dark color exemplifies high color saturation. Underexposure increases color saturation. Overexposure decreases it.

Before departing from the exposure norm, the norm must be determined, preferably with an incident-light meter. Suppose the "standard" metered exposure is 1/125 sec. at *f*/8. Begin by making an exposure at the recommended setting, then underexpose by one-half and one *f*-stop and overexpose by the same. The result will be four variations on the basic exposure. The overexposed slides will have lighter, more delicate color with increased shadow detail and decreased highlight detail. The underexposed slides will show richer, deeper colors with increased highlight detail and decreased shadow detail.

Color saturation control is particularly effective under low-contrast lighting such as overcast daylight. Such light increases exposure latitude (up to two full *f*-stops above and below the metered exposure), allowing a wider range of acceptable color saturation results. The color variations may be surprising, particularly with low-contrast subjects and a low-contrast film like Kodachrome 25.

Since there may be more than one desirable exposure within the latitude of the film being used, planned expo-

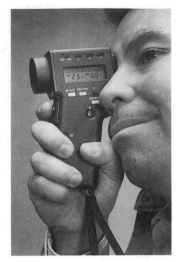

Above: Using the same micro-computer system as the Minolta Auto Meter III, the Minolta Spot Meter M allows readings from different subject areas to be automatically averaged for an overall exposure. Since the possible inaccuracy of single spot readings is one of the greatest shortcomings of spot meters, this approach is both desirable and effective.

Opposite page, top: The Royal Military Tattoo in Edinburgh, Scotland, was a no-win exposure situation. Theatrical spotlights used to illuminate the scene were so contrasty that no exposure could render both highlight and shadow detail. In addition, the lighting intensity was constantly changing, and special-effect filters on some of the lights made for an endless variety of color temperatures. Under such high-pressure situations, a combination of spot meter readings and exposure bracketing is the only way to get any kind of result. Precise color is almost impossible. This picture was taken on Ektachrome 200 film.

Opposite page, bottom: A roadside fried-clam stand on the Maine coast made for an intriguing combination of colors, the blue twilight and the glaring yellow of the fluorescent lights on the stand itself. Using a spot meter, exposure was figured for the subject area *below* the stand's lights. Since the stand is more brightly lit than the sky, the result is a moody, cool rendition, in keeping with the subject. Film was Kodachrome 25.

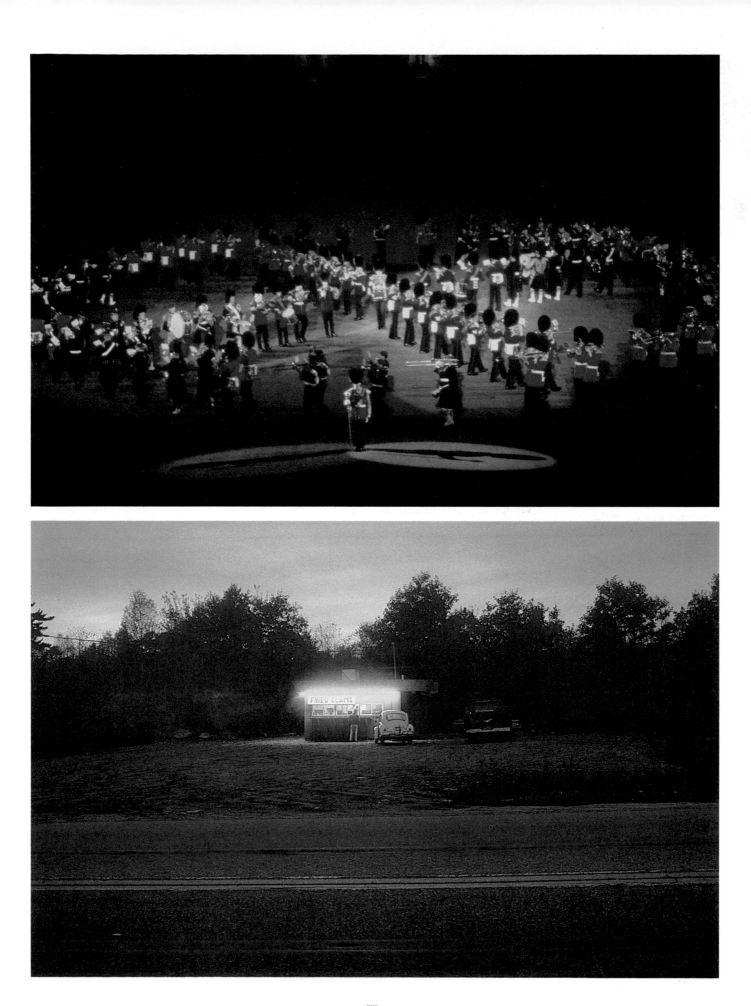

sure variations are often used by professional photographers in a technique called *bracketing*. A series of exposures above and below the meter's recommendation (about 1½ *f*-stops each way) gives a choice of exposures as well as a choice of color saturations.

LONG EXPOSURE PROBLEMS

Since short exposures are made more often than long ones, manufacturers have put their expertise into improving the short-exposure capabilities of their products at the expense of long-exposure performance. When long exposures are made, color films may run afoul of the problem known as reciprocity failure.

Reciprocity failure is the breakdown of the apparently logical correlation of exposure times versus *f*-stops: the formula $I \times t = e$ when illumination (I) multiplied by exposure time (t) equals correct exposure (e). Exposures between 1 sec. and 1/1000 sec. seldom run afoul of this phenomenon, but long exposures (5 or 10 sec. or longer) may result in unexpected film behavior.

If, for example, a meter reading indicated an exposure of 1 sec. at *f*/4 on Kodacolor II film, the same meter would indicate an exposure time of 15 sec. at *f*/16. But according to Kodak's reciprocity data, Kodacolor II loses a full *f*-stop of speed when it's exposed longer than 10 sec., making a 30-sec. exposure necessary. While it might make *logical* sense for *f*-stops and shutter speeds to be continuously reciprocal, it doesn't make *chemical* sense to the film.

Considering the combination of emulsions lying on a sheet of color film, reciprocity failure is understandable. Each of those emulsions is chemically different. The fact that they produce a good-quality color picture as often as they do is a remarkable photochemical achievement. Most photographic emulsions are subject to speed losses when they receive long exposures, and color film emulsions are no exception. What complicates the situation is the fact that the three different emulsions of color film don't suffer equal speed losses during long exposures.

Returning to the example of Kodacolor II with its 30-sec. exposure, Kodak's reciprocity failure chart also directs the photographer to add a Color Compensating 10 Cyan filter to restore the color balance of the film. But that's the easy kind of reciprocity failure color correction. Certain film/exposure combinations on Kodak's reciprocity failure chart are marked NR (Not Recommended) because these combinations lead to what Kodak calls *contrast mismatch* and what most color labs call *crossover*.

Crossover is the appearance of two opposite colors in different parts of the picture. Not-Recommended long exposures on Ektachrome 6118 (Type B E-6 sheet film) produce the following results. Magenta contrast softens, increasing magenta in highlights and increasing *green* (the opposite color to magenta) in the shadows. Right away, this is a no-win situation. Try to filter out the magenta in the highlights by adding green filtra-

Opposite page: Backlit scenes incorporating the light source—in this case, a setting sun over the East Boston docks—almost always leads to underexposure with TTL meters. The reading of a Nikon's TTL meter was modified with a one *f*-stop exposure increase for correct rendition on Kodachrome 25.

Above: The listing of necessary exposure increases on the cases of these Cokin plastic Light-Balancing filters makes accurate exposure easier. Remember that these increases apply only when the filters are *not* used in conjunction with a TTL metering system, which "reads" filter density as a matter of course.

High-key subjects like this farm
in Magillicuddy's Reeks, Ireland,
can fool reflected-light meters,
resulting in underexposure.
Using the exposure compensa-
tion dial of a Nikon F3, exposure on
Kodachrome 64 was set for two-
thirds f-stop of "overexposure."
Result was a light pastel rendition,
in keeping with the subject matter.
An incident-light meter would
have given similar results.

tion, and the presence of green in the shadows will increase. Trying to filter out the green with magenta produces the opposite effect.

At the same time the magenta contrast goes down, the yellow contrast goes up, adding blue to the highlights (which are already going magenta) and yellow to the shadows (which are already going green). Now the color's going off in four directions at once. This aggregate of wayward colors is impossible to correct.

For most 35mm photographers, reading the reciprocity failure chart is a heartening experience. Many films survive long exposure with no more than the need for still longer exposures and minimum "tweaking" with filters. Kodachrome 25 can handle 100-sec. exposures with only a slight shift to the green that may not even be noticeable. Ektachrome 400 loses 2½ f-stops at 100 seconds, but only shifts slightly to the red. Since much low-light shooting on high-speed films is done under off-color lights anyway, this slight shift may not be worth worrying about. While exposures over 10 seconds aren't recommended on any Type B (tungsten) or Type A color film, Kodak is traditionally conservative in its restrictions of long exposures. What they turn down may well be acceptable to others.

A final situation where long exposures give off-color results isn't photographic in origin. The human eye has less sensitivity to blues and greens than color film does. Long exposures of twilight subjects often result in pictures that look much bluer than the scene appeared to be. This is the difference between eyes and film. The film picks up more blue than the eye.

Below: These little boys going to school in Willemstad, Curacao, posed a tricky exposure problem. A shadow exposure would have "washed out" the background completely; a highlight would have lost detail in the boys' faces. Using a spot meter, a reading was taken off the subjects' faces. The actual exposure was one-half f-stop less, resulting in some detail in both highlight and shadow areas. While neither area is correctly exposed (the contrast range was too great for the film, Kodachrome 25), the result looks approximately the way it did to the eye.

CHAPTER FOUR
COLOR FILTRATION: PART ONE

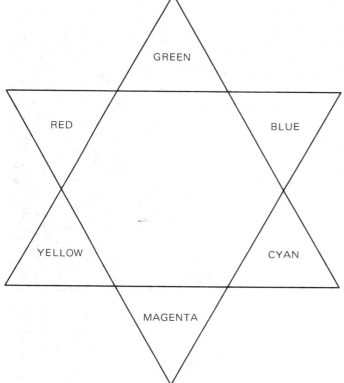

Above: Using this simple chart, antidotes to any color cast can be figured instantly. Just read off the color opposite the color to be reduced. For example, yellow is neutralized by blue.

Opposite page, top: Eilean Donan Castle in Scotland, with one light burning, was photographed at twilight with a 50mm lens and two Cokin plastic filters, a blue A21 and an A83 diffuser, to emphasize the ghostly mood of the picture. A 30-second exposure was used on Kodachrome 64.

Opposite page, bottom: The ominous look of Stonehenge on Salisbury Plain, England is emphasized by the use of a #25 red filter intended for black-and-white photography. Although the picture is not realistic, it's certainly eye-catching. Lens was a 15mm super-wide-angle.

Some photographers spend a lifetime shooting black-and-white pictures and never use a filter. This is not the case when using color films. Filters are the most versatile controls available to color photographers, and most color photographs will benefit from some kind of filtration. The possibilities are numerous.

A filter is a transparent piece of material dyed to a particular color. It will transmit its own color and absorb others. There are literally hundreds of different filters made for color photography, many varying only slightly from the others. Quality color photography often involves painstaking adjustment of light sources with filters to reconcile them with film characteristics.

Since filters always absorb some color, the rule is: Filters never add anything, they always take something away. Attempting to "warm up" a scene with a bluish color cast by adding yellow filtration (which absorbs blue) isn't adding yellow but filtering out some of the blue in the original scene, making other colors more visible. There are two interacting classifications for the six colors of filters used in photography. While many photographers may never have any further use for these classifications, they do make the photographic combining of colors easier to understand.

The additive colors are red, green, and blue. When all three are added together, the result is white light. The *subtractive* colors are yellow, magenta, and cyan (a sort of aquamarine). Each subtractive color will block an additive color. Cyan blocks red, magenta blocks green, and yellow blocks blue. When all three subtractive colors are evenly combined, they subtract all the light, making black.

Any two subtractive colors can be combined to make an additive color. Yellow plus cyan makes green, magenta plus yellow makes red, and cyan plus magenta makes blue. Any two additive colors can be combined to make a subtractive color. Green plus red makes yellow, blue plus green makes cyan, and red plus blue makes magenta.

Since filters remove some of the spectral components of the light, they reduce the intensity of that light and an exposure increase is necessary to make up for the light that never got past the filter. The TTL meters built into many 35mm SLRs read through any filters on the lens at the same time they're taking an exposure reading. Photographers using these cameras won't have to worry about figuring these increases (called filter factors) into their regular exposure-determining procedures. Simply follow the meter's reading.

Users of hand-held meters will have to allow for filter factors. They are expressed as coefficients based on the filter's density, by which metered exposure must be multiplied. A filter factor of 2, for example, requires a doubled exposure, or an increase of one *f*-stop. The Cokin plastic filters list necessary exposure increases on each filter's case, a helpful feature.

COLOR FILTRATION: PART ONE

Polarizers are routinely supplied in rotating mounts, allowing the precision control necessary to get the maximum benefit from these useful—and often abused —accessories.

SOME BASIC FILTERS

Most everyday photographic situations call for only a few basic filters. These longtime standbys will solve many problems.

Skylight Filter. The skylight filter goes by a variety of names—skylight filter, haze filter, "warming" filter, and UV filter. Only the last term is descriptive. Ultraviolet light (UV) is an invisible component of many familiar photographic light sources, including sunlight and electronic flash. It causes a blue color cast. Filtering out UV results in warmer, more accurate colors.

Two filters, available from many manufacturers, will go a long way to catching UV before it reaches the film—the 1A and the UV. They look different to the eye (the 1A has a slight pink cast; the UV appears clear), but their results are about equal. More expensive but more effective is the Singh Ray "SR-UV" filter (Tekno, Inc., Chicago, IL). Many photographers routinely equip all their lenses with a UV or 1A filter. The filters need no exposure compensation, protect the vulnerable front surface of the lens, and are always there to catch any ultraviolet light.

Polarizing Filter. This gray glass disk is supplied in a rotating mount. Properly used, polarizers decrease surface reflections on many nonmetallic objects. With the elimination of these reflections, colors photograph brighter and richer. The most common use of a polarizer is to darken blue skies on sunny days. The light from a clear sky is refracted by countless dust particles. This refraction inclines to the blue end of the spectrum, which is why the sky looks blue. A polarizing filter diminishes spectral reflections on these particles, resulting in a deeper blue sky.

For the maximum polarizing effect, the polarizer must be used at an angle perpendicular to the light source. For outdoor photography, a literal rule of thumb is to point a forefinger at your subject while extending the thumb at right angles to the forefinger. The thumb is then pointing at the spot where the sun should be for maximum polarization. Most polarizers have the axis marked on the rotating mount. This axis should be turned toward the sun. Reflections from windows are a common problem that may be solved with a polarizer, but the camera must be positioned at a 35-degree angle to the glass. No other angle will have much effect.

The sky-darkening ability of a polarizer can sometimes be at odds with the filter's effect on other parts of the picture. A seascape might be improved by a polarizer-darkened sky, but that same polarizer might kill the sky's reflection on the water, resulting in a blue sky and a dingy gray sea. There are times when reflections improve a picture.

Polarizers are useful as long as their limitations are understood. Aside from maintaining a 90-degree angle between the camera and the light source, other limitations include the following.

☐ An approximately 1½ *f*-stop exposure increase is nec-

THE HANDBOOK OF COLOR PHOTOGRAPHY

Above: While bright sunlit scenes like this one of the Staten Island Ferry in New York Harbor are colorful, they include a high content of ultraviolet light. Be sure to use a UV filter for these pictures. UV can give pictures a chilly blue color cast. The filter is also good for lens protection — an important consideration in shooting situations like this, where salt spray may be present.

Left: Realistic rendition isn't necessarily the best way to depict a subject. This shot of New York City's Brooklyn Bridge was first shot with a 15mm wide-angle lens using only a UV filter. The other version was shot with a #25 red filter intended for black-and-white photography. While the picture doesn't look "real," the semi-abstract subject matter results in a picture that may be more interesting than a straight rendition of a hackneyed subject. Then again, maybe not; it's a matter of taste.

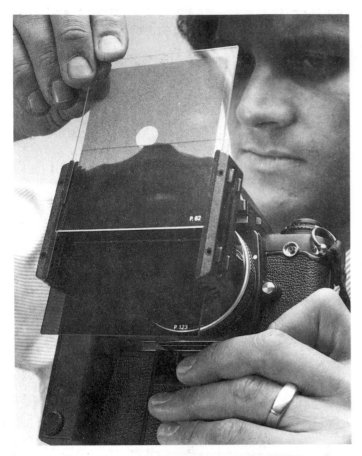

The Cokin filter mount allows simultaneous use of up to three of the plastic Cokin filters and special-effect lens attachments. While the mount is relatively deep, the large-size Cokin "P" filters permit the use of many wide-angle lenses without vignetting.

essary. While the TTL meter systems of some 35mm SLRs can "read" this density, others cannot because their meter systems use light polarization to operate. When shopping for a TTL meter-equipped camera, check with the manufacturer or importer to make sure it can meter through a polarizer. A make-do solution is to take a reflected-light reading through the polarizer, using a hand-held meter with the polarizer off the lens. The polarizer axis must be oriented the same on both the camera and the meter.

□ A shot of a wide area of sky may result in uneven polarization due to the possibility of including areas at varying angles to the sun.

□ Since polarizers can darken a sky to near-navy blue under good conditions, readings with a TTL reflected-light meter may be biased toward overexposure. Resulting color desaturation will wipe out most of the polarizer's benefits.

□ On hazy or overcast days, polarizers have almost no effect.

□ A polarizer cannot control reflections on metallic surfaces.

□ A polarizer will have no effect if the light source is directly behind or facing the camera.

Conversion Filters. Conversion filters allow the use of films under mismatched light sources with good results. While color films can be converted either way (daylight to tungsten and vice versa), the most effective conversion filter is the amber 85B, converting 3200 K–balanced color film to daylight use. The filter only loses two-thirds f-stop in speed and it gives a slightly warmer result than regular daylight color film due to the UV-filtering effect of the 85B.

While daylight-balanced color film can be converted to 3200 K tungsten illumination with a blue 80A conversion filter, full f-stops of speed are sacrificed, dropping ISO 64/19° color film down to ISO 16/13°.

An alternative to carrying conversion filters is interchanging daylight and tungsten color films as needed. On 35mm cameras, the easiest way is to note how many frames have been shot and then rewind the film, making sure that the film's leader isn't wound back into the cassette. Mark down the number of frames shot on the cassette with an indelible pen. To reload the film, cap the lens and wind the film to the frame number marked plus one more to ensure shooting on unexposed film.

Conversion filters are an easier alternative to this clumsy procedure. They only cost about as much as one roll of film and can save that much money the first time they are used.

FILTERS AND MOUNTS

Glass filters are the most common. They are generally made of dyed optical glass cemented into a metal mounting ring. While durable and resistant to fading and scratching, they are heavy and expensive. Their thickness makes using more than one filter at a time difficult.

Gelatin filters are supplied by Kodak in two-, three-, and four-inch squares. Advantages include relatively low price, wide variety of colors, and ease of combining several filters. "Gels" can be trimmed with scissors to odd sizes. Disadvantages include extreme delicacy (requiring white-glove handling) and the need for a special filter frame.

Plastic filters are newcomers. Cokin, Ambico, and Acme offer extensive ranges of colors (Cokin's is currently the largest), plus special-effect lens attachments. They snap into special mounts, supplied by the manufacturers, that allow using several filters at once for combined effects. Plastic filters are cheaper and lighter than glass and more durable than gels, but they require care to prevent scratching.

Many filter manufacturers treat the job of mounting filters on lenses as an afterthought. At the same time, the proliferation of wide-angle lenses for 35mm SLRs has made filter mounting a serious business. Many filter mounts project too far from the rim of the lens, causing image vignetting (darkening of the corners of the frame).

Some filter-mounting methods include:

Screw-in. This is the most convenient and expensive method. Glass filters are purchased already mounted in threaded rings that screw directly into lens rims. If all the lenses don't have the same diameter rims, photographers must carry the same filters in different sizes or use adapter rings to reconcile them to different lenses.

Series sizes and adapter. This earlier, less convenient but also less expensive alternative uses filters supplied in a series of approximate diameters. An adapter ring, threaded for a particular lens rim diameter and accepting a particular series filter in front, mates the filter to the lens. The combined thickness of filter and adapter ring frequently vignettes with wide-angle lenses.

Plastic multifilter mount. Supplied by manufacturers of plastic filters, these mounts accommodate three different square filters in parallel slots. While the resulting bulk requires a deep mount, the size of the large "P" Cokin filters allows the use of many wide-angle lenses without vignetting.

Quick mountings. These are designed for photographers who want to get filters and lens accessories on and off their cameras without the inconvenience of screw mountings. They consist of a receiver screwing into the lens mount and mating with a second section carrying the filter. Systems include the Kalt Quick Change System (Kalt Corp., Santa Monica, CA); the Spring Lock Mounts (Harrison and Harrison, Hollywood, CA), which accommodate wide-angle lenses without vignetting; and the Magnetic Quick-Change Mount (Laskey Studio, Grand Rapids, MI).

Gelatin filter holders. A special holder is necessary for delicate gel filters. The AF-1 and AF-2, accommodating

Top: A handful of gelatin filter holders—the Nikon AF-1 for 52mm lens diameters, the Kenko for 67mm lens diameters, and the spring-adjustable Spiratone holder. All three accept 3-inch-square "gels."

Above: Series-size filter adapters use a numbered series of approximate-sized filters that are mounted on lenses via a precisely fitted adapter with an accompanying retaining ring. Due to their bulk, series-size adapters frequently vignette when used with wide-angle lenses.

three-inch-square gels and fitting 52mm and 72mm lens rims respectively, are available from Nikon (Nikon, Inc., Garden City, NY). Similar holders are available from Kenko (Keystone Ferrule and Nut Co., Burlington, WI).

OTHER BASIC FILTERS

The filters already described cover many everyday photographic problems, but when these problems become pronounced, an increase in the strength of the basic filters becomes necessary.

High UV Levels. When the sun is very bright and the sky is very clear, even a UV filter won't prevent a blue cast in your pictures. The problem often occurs at high altitudes and when shooting aerial photographs.

On such days, distant scenes appear to be veiled in a blue atmospheric haze. While a UV or 1A filter will improve this situation somewhat, stronger UV filtration may be necessary. Kodak's 2-series filters—2A, 2B, and 2C—offer increased UV absorption and also cut out some violet and blue, resulting in apparently increased contrast.

The phenomenon of atmospheric haze is particularly noticeable when shooting with long lenses, for two reasons. With a long lens, there is a lot of atmosphere between the lens and the subject. This atmosphere functions as a blue filter. "Cold telephoto" color shots are also caused by the predisposition of certain telephoto lenses to refract an excess of blue light.

Very thick haze cannot be completely neutralized. Artists use this phenomenon to give the impression of depth in the backgrounds of paintings by adding pale blue or gray to the paints used for these areas.

Fog. Fog differs from haze. It is composed of tiny drops of water, which form a barrier between the camera and the subject. While heavy fog forms a barrier that no filter can penetrate, a slightly fog-obscured scene can be improved with one of the amber 81-series Light Balancing filters (more on these soon), such as the 81A or 81B, which impart a touch of warm color.

Open Shade. Sunny days place photographers in a double-bind situation of working under two different-colored light sources—sun and blue sky. The light from a bright blue sky has a higher color temperature than the sun itself. On sunny days, shady areas are lit with this blue light. When pictures are taken in the shade on a sunny day, the light source is not the sun but the light from the sky. Daylight-balanced film will give a chilly result alien to the warm colors associated with sunny days.

There are two ways to deal with this open-shade blue. One is to add warmer-colored light, either by using a white cardboard reflector to bounce sunlight into the shadows (a common trick of fashion and glamour photographers) or by using an electronic flash unit for "synchro-sun" fill-in light.

Cool open-shade pictures can also be warmed up

Opposite page, top: An abandoned military installation on Nantucket Island, MA, was photographed with a polarizer to darken the sky and emphasize the contrast of the yellow buildings against the blue background. Notice that the sun is almost perpendicular to the camera position (shadows are reaching to the left), illustrating the 90-degree rule of effective polarization.

Opposite page, bottom: This morning-light Kodachrome of the Clark Art Museum in Williamstown, MA did not require a UV filter. Early and late in the day, sunlight must penetrate more atmosphere than it does at midday. This extra atmospheric penetration absorbs a lot of ultraviolet light. Additionally, it warms up the color of the light. This is why photographers refer to early and late sunlight as "Kodachrome light"—the ideal time to take color pictures.

COLOR FILTRATION: PART ONE

This lighthouse and weathervane juxtaposition on Nantucket Island is actually lit by two different light sources, sunlight and blue sky. Notice how the shadow on the right side of the lighthouse is blue rather than gray. While such rendition isn't a serious problem for this picture, it can result in extremely unflattering portraits. Try using an 85B Light Balancing filter for warmer skin tones under this common shooting situation.

with filters. Here, too, the amber 81-series Light Balancing filters will help faces to photograph rosy and healthy-looking. Pros who encounter cool shadows in outdoor shooting often routinely pack along the medium-warm 81B; it is strong enough to make a difference but not so strong as to be noticeable. When shooting in open shade, beware of bright backgrounds. They can fool TTL meters, resulting in underexposed foreground subjects. A spot meter can be very helpful in this situation.

LIGHT-BALANCING AND COLOR-COMPENSATING FILTERS

Photographers often must work under light sources of the wrong color temperature for either daylight or Type B color film. If these gaps between light source and color balance are to be reconciled, precise filtration is necessary. Kodak filter classifications are used by most manufacturers. There are two main subgroups.

Light-Balancing Filters (LB). These filters are designed to change the color temperature of a light source. To lower it, LBs are available in amber. To raise color temperature, LBs are available in blue.

The LB filter classification system is confusing. There are four different series: 80 (heavy blue); 82 (mild blue); 81 (light amber); and 85 (deep amber). Within each of these classifications are letter-designated subclassifications. Density increases as filters go down the alphabet.

The 80A and 85B LB filters do double duty as conversion filters. The blue 80A filter shifts 3200 K color temperature (tungsten color film balance) to 5500 K color temperature (daylight color film balance). The 85B amber filter does the reverse, shifting 5500 K to 3200 K.

In an attempt to standardize LB filters and make them more useful for general color photography, the so-called "decamired" filter classification was introduced some years ago. Although it never became popular, it was a worthwhile attempt to straighten out the multiseries confusion of LB filters. Since some decamired filter system sets may still be available, here's the way they work.

Kelvin color temperatures are not used. Instead, color temperature is expressed in what are called micro reciprocal degrees (contracted to "mired")—color temperature divided into one million. Decamireds are mireds multiplied by 10, making for simpler numerical designation. Light-source color, filter color, and film color balances are all calibrated in terms of mireds.

Decamired filters are classfied by a number denoting density (1-13) and a letter, either R (for warm-color amber LB filters) or B (for cool-color blue LB filters). Negative numbers are used for blue filters, neutral numbers for amber.

The decamired system is a simple method of color expression for manipulating color temperature. For example, to shift the color of a 40-watt incandescent bulb (2650 K, a mired value of 377) to the 3200 K color balance of tungsten color film (312 mireds), the color temperature difference is 550 K, or 65 mireds. Checking the

THE HANDBOOK OF COLOR PHOTOGRAPHY

This aerial photograph of the
Connecticut River Valley was shot
on an overcast afternoon on Koda-
chrome 64. Since the overall
appearance of the subject was
chilly and gray, an 82C Light Bal-
ancing filter was used to warm up
the results, and the picture was shot
from a low altitude to avoid mist
that could obscure the subject.

decamired filter table, correction would require a combination of 82C (minus 45 mireds) and 82A (minus 21 mireds) LB filters, the result being close enough to 65 mireds to give a good result. Rather than looking up the color shift capabilities of various LB filters with confusing, nonsystematized number/letter designations, mired numbers need only be added or subtracted.

The unpopularity of the decamired filter system was due to a number of causes. Few manufacturers routinely supplied LB filters with additional decamired designations (though they offered decamired *sets* of LB filters as packages), preventing photographers from becoming accustomed to them. Film manufacturers never routinely offered decamired interpretations of film color balances.

Probably the main reason for the failure of the decamired system was the same reason photographers don't routinely carry full sets of LB filters. There just isn't that much use for them. A few basic LB filters give all the filtration control the average color photographer needs. The 81A or 81B (amber) filters lend warmth to a cool-colored scene, while the 82A or 82B (blue) will cool a warmly lit scene.

It's an interesting aspect of visual psychology that most viewers will accept a picture that's noticeably warm in color balance, but few seem to enjoy a picture with an unnaturally *cool* color balance.

Color Compensating Filters (CC). Available in both primary and secondary colors, CC filters are supplied in a wide variety of densities. Designated by progressive numbers, densities range from .25 (extremely pale) to 50 (strong). CC filters can also be combined for increased density. The sum of their separate densities equals the new density (a combination of 30 and 50 density CC filters makes an 80). Color and density are expressed by numbers and letters. A yellow CC filter with a density of 30 is referred to as a "CC30Y."

CC filters are used for many applications in color photography. They allow color control impossible with the two-color LB filter system. Professional color films denote any deviation of their emulsions from the norm in terms of CC filters. Fluorescent filtration (described soon) is usually handled with CC filters. They can also be used for shifting color temperature. A calculator for determining which filters are necessary for different shifts is available in the *Kodak Professional Photoguide*.

While CC filters are available in glass from several manufacturers (notably Tiffen and Bogen), most photographers buy them in the cheaper three-inch gel form, which also allows easy combining of several filters. Many pro photographers have hundreds of dollars invested in sets of CC gels, since they get scratched easily and need frequent replacement.

WHAT'S THE COLOR TEMPERATURE?

Filter-controlled shifting of the color temperature of a light source necessitates knowing its precise color temperature initially. While there are reference tables to determine the color temperature of different light sources (see the *Kodak Professional Photoguide*), these expedients are really just organized guesswork. Results are determined by the perceptions of the user. Color temperature meters (discussed in the chapter 5) tell the exact color temperature of light sources, but they are expensive and of limited value for routine photography.

In the absence of a color temperature meter, precision color control is impossible. Usually, however, it's also unnecessary. The time, trouble, and expense that many pro photographers expend on their color technique are aimed at turning out results that are as close to perfect as they can be, but such perfectionism is wasted on people who don't really care whether or not a picture's color balance is just right. Ideal photographic quality can be scientifically controlled, but whether such results are visually satisfying is a subjective matter.

Opposite page: A fake sunset. This scene of the square-rigger H.M.S. *Rose* at Newport, RI, was illuminated by a pale gray sun, but using an orange filter intended for black-and-white photography gives spectacular results. This technique can only be employed when the overall color will not render other parts of the picture in a noticeably unnatural way. Since the rest of the picture was a silhouette, this wasn't a problem.

CHAPTER FIVE
COLOR FILTRATION: PART TWO

Above: A schoolboy in a fluorescent-lit classroom in Portree, Scotland, was photographed with a Singh-Ray SR-D filter on Ektachrome 160. Notice the highlight on the back of his head caused by sun shining through a window to the right of the camera. The SR-D filter does not cause the sunlight to be rendered in an odd color.

Opposite page, top: Results of unfiltered fluorescent flash fill. The fluorescent lighting of this loading dock was filtered with a CC 40 Magenta filter, using Ektachrome 200 film. An unfiltered electronic flash unit was placed inside the truck at the right to "open up" the dark shadows inside. But since the camera, loaded with daylight-balanced color film, had a magenta filter on the lens, the daylight-colored flash took on the color of the filter. Such specialized applications require filters on the flash as well as on the lens.

Opposite page, bottom: This carefully posed computer room operator was photographed with a 16mm semi-fisheye lens, using a custom-adapted Singh-Ray SR-D filter built into the lens's internal filter wheel to correct color balance of the room's Cool White fluorescent illumination. Due to the 150-degree angle of this specialized optic, no front-mounted filter could be used. Film was Kodachrome 25. A simpler way of mounting filters on such super-wide-angle lenses is by taping a gelatin filter onto the back of the lens.

The filters covered in chapter 4 should be sufficient for general photography, but unusual shooting conditions may call for special filtration. Photographers often encounter excessively bright light sources that call for high shutter speeds and/or small *f*-stops. These can cause a number of problems.

Extremely high shutter speeds are often inaccurate. Such high speeds, as would be used in bright light, are often slower than the shutter-speed dial indicates. The result will be unintentional overexposure.

Small *f*-stops are not always desirable. Selective focus, where part of the picture is intentionally sharper than another (such as a sharp foreground and an unsharp background), works best at relatively wide *f*-stops. If the speed of a film or the brightness of a light source makes small stops obligatory, depth of field will make selective focus almost impossible. When lenses are stopped way down, depth of field increases but sharpness is lessened by an increase in refraction of light around the diaphragm blades inside the lens.

For controlling the amount, rather than the color, of light, neutral density (ND) filters are available in various densities, in gelatin squares from Kodak and in glass from many manufacturers. ND filters are calibrated in terms of filter factors. A 4X factor, for example, calls for an exposure increase of two *f*-stops (opening up one stop doubles the exposure; opening another stop doubles it again, making 4X). ND filters can also be combined. By multiplying the filter factors, the new factor can be determined (a 2X combined with a 4X makes an 8X, calling for a three *f*-stop exposure increase). Use the conversion table in the appendix to translate density designations into effective filter factors and actual *f*-stop changes.

The 2X and 4X ND filters should be enough for most applications, and they can be combined for an 8X if necessary (watch out for vignetting with wide-angle lenses). TTL meters will read the reduced exposure through the lens as a matter of course. There is no need to change the film-speed settings.

FLUORESCENT FILTRATION

Fluorescent lights have undesirably unique color characteristics. No color film gives accurate results under any but a few rare and specially manufactured fluorescents. Color characteristics must be determined and appropriate filters used when photographing under fluorescent lights.

Incandescent light and daylight are called "full-spectrum" light sources; that is, they contain components of all the spectral colors. Fluorescent lights, on the other hand, have "discontinuous" spectrums, meaning that only some of the spectral colors are present. A graph expressing such spectral components would consist of a series of vertical spikes separated by empty gaps, showing the total absence of some spectral colors and the excessive presence of others.

Fluorescent lights work on the principle of an arc

COLOR FILTRATION: PART TWO

Color where there wasn't any. Scotland's Loch Ness was attractive but bland. By using an 85C Light Balancing filter with Kodachrome 64 and a long lens, however, the look of late afternoon sun was created. A stronger filter would probably have created an effect too strong to be believable. Use effect filtration with restraint. Too little is often better than too much.

that electrochemically excites what are called *phosphors* coated on the inside of a tube, causing them to emit light. Not only do these phosphors create noncontinuous spectrum light on their own, but lamp manufacturers often use two different phosphors to give a combined result that looks more natural to the human eye. Each phosphor has different color characteristics and requires different correction.

The most common result of uncorrected shooting under fluorescent light sources is a green color cast in pictures shot on daylight film and a blue color cast in pictures shot on Type B tungsten film. Even with corrective filtration, results are often poorer than those obtained under full-spectrum light sources because color films need full-spectrum illumination for effective performance.

The first step in fluorescent correction is determining the "color" of the lights in question. This is usually a number or letter at each end of the tube. Look up the designation on the accompanying chart, or refer to *Kodak Professional Photoguide's* chart, and use the indicated filters.

Note: Most fluorescent lamp manufacturers publish "color temperature" ratings in their catalogs. These ratings are based on the way test colors look *to the eye*, not to film. As color-film filtration guides, they are useless.

For the best correction possible under varying types of fluorescent illumination, individual checking is necessary. Even if the same fluorescent lamps are used in different places, age, fixture design, and ambient colors can all cause color variations. If two kinds of fluorescent tubes are intermixed in the same location, or if fluorescents are mixed with other light sources, no chart prediction will help.

Two methods of checking fluorescent light are Polaroid's Polacolor 108/668 film for test shooting, or any of the color meters now on the market.

The Polacolor method is less expensive but more time-consuming. It requires making a series of test photographs using different filter combinations until an acceptable result is achieved. A Polaroid camera with pack-film capability and conventional shutter speed/ *f*-stop exposure control is necessary. Polaroid's folding cameras of this type (the 195 and the 180) are out of production, and the current manual-setting Polaroid (the 600SE) is expensive and bulky. Fortunately, a number of camera modifiers offer film-pack adaptation of Polaroid 110, 110A, and 110B roll-film cameras, which offer conventional exposure settings and are available inexpensively in many secondhand-camera stores. The Original Equipment Manufacturers (OEM) Relations department of The Polaroid Corporation (Cambridge, MA) can supply the names of some of these modifiers.

Here is the procedure for Polacolor fluorescent light color-checking.

☐ Select a test subject. A cooperative person at the shooting location is the best choice.

For flexible color correction capability, a selection of filters is necessary. While gelatin filters aren't cheap, they are still much less expensive than glass filters. They can also be easily combined. Just remember to handle these delicate filters with care.

While Singh-Ray filters won't solve all fluorescent filtration problems, their performance under Cool White, Daylight, and mercury vapor fluorescents is impressive. Keeping a set of three handy can ease a lot of fast-moving fluorescent shooting situations when there isn't time to carry out precise color evaluations.

Using fill-in flash under fluorescent lights can result in some odd-colored shadows if the flash unit is not correctly filtered. The Singh-Ray Flash Fluorescent Filter is designed to be teamed up with the Singh-Ray SR-D fluorescent correction filter for custom-balanced fill.

Top: The Minolta Color Meter II is expensive, but its pinpoint-accurate light-source color evaluations are extremely useful for many photographers. The meter's liquid crystal display *(left)* must be transferred to the filter table on the back *(right)* to select the appropriate Light-Balancing and Color-Compensating filters necessary for correction. This meter is a luxury that can easily turn into a necessity.

Above: The simplest way of checking out fluorescent lighting is by making test exposures on Polacolor film, using a one-second exposure. This particular camera is an old Polaroid 110A, modified to accept 100/600-Series pack film.

☐ Have the subject hold the color-chart and gray-scale page from the *Kodak Professional Photoguide* to allow checking of a wide range of color renditions.

☐ Start with an educated guess based on filtration for the most common fluorescent light, cool white: CC 50 Magenta + CC 20 Yellow.

☐ Holding the filters in front of the Polaroid's lens, make a *one-second* exposure, using a tripod.

☐ Process and evaluate the results, subtracting some filtration of any excess color or adding insufficient color. Excess of yellow, for example, is corrected by subtracting yellow or adding blue, the opposite color of yellow. Excess green is reduced by subtracting green or adding the opposite of green, magenta. The Kodak Color Print Viewing Filter Kit (chapter 7) is a convenient way of keeping a selection of filters available.

Practice makes perfect with Polacolor evaluation. Some color casts are subtle and take experience to notice. Color tinges are particularly noticeable on the gray card of the *Photoguide* included in the test picture.

☐ The filters used to obtain the best result on Polacolor should give comparable results on Kodak E-6 Daylight films. Kodachrome 25 and 64, with their warmer color balances, require subtracting 10 CC units of yellow or adding 10 units of blue.

Fluorescent filter "pack" density will affect exposure. Be sure to read exposures through the filters with a TTL meter, and bracket just to make sure.

Faster, more convenient, and potentially more accurate color evaluation is possible with either the Minolta Color Meter II (Minolta Corp., Ramsey, NJ) or the Spectra Tricolor meter (Kollmorgen Corp., Newburgh, NY). The only other color meter on the market, the Gossen Sixticolor, and its similar "Luna Color" attachment for the Gossen Luna-Pro SBC meter, can read only full-spectrum illumination.

The Spectra Tricolor takes simultaneous readings of red/blue and red/green color combinations in a light source. Resulting corrections can be made with either CC or LB filters.

Minolta's Color Meter II uses solid-state electronics to take a color reading of ambient light. Color temperature (inapplicable with discontinuous-spectrum light sources) and appropriate compensating filters are shown via a liquid crystal display. The meter offers an innovative and useful advantage over the Tricolor. An adjustable color balance setting allows accommodation of individual tastes. Warmer or cooler results are only a matter of adjusting the meter's internal microcomputer. A setting of 5350 K seems to give the best results on Daylight E-6 Ektachrome.

STANDARDIZED FILTERS EQUAL APPROXIMATE CORRECTION

A simplified, less accurate method of fluorescent color correction involves a pair of standard filters available from most filter manufacturers, the FL-D and the FL-B. Designed for daylight and Type B films respectively,

Eilean Donan Castle in Scotland looked like something out of a fairy tale. To take a picture in keeping with this mood, two Cokin effect filters were used on an 80-200 zoom lens—an A83 diffuser and the A5 "sepia" filter for a dreamy, old-time photographic look. The diffuser caused the highlight on the swan in the foreground to glow, while at the same time subduing sharp detail in the castle. Film was Kodachrome 25.

Above: Two examples of special-effect filters from Cokin. The graduated filter, available in several colors, allows tinting only part of a scene (such as the sky). The partial diffuser keeps the center of the image sharp while softening the edges; it is available in a choice of strengths.

Opposite page: When horizons are straight, graduated filters can be useful tools. This roadside mailbox in Ireland required an exposure that "burned out" the brighter sky when photographed on Kodachrome 64 *(top)*. Not much of a picture. But by using a Cokin T2 (tobacco-colored) gradual filter *(center)*, the bald sky takes on the color of a sunset. For simple darkening of the sky, Cokin's gray G2 filter *(bottom)* reveals both blue sky and clouds. Without these inexpensive special-effect filters, the picture would hardly have been worth taking.

they are better than no filter at all, but corrections are necessarily approximate.

Better "universal" fluorescent filters are the Singh-Rays (Tekno, Inc., Chicago, IL). They are available in three types: SR-D (for daylight films); SR-B (for Type B films); and the SR-L15 (for Type B film under G.E. Lucalox lamps). Utilizing special dyes, Singh-Rays respond to fluorescent light, tailoring their behavior to the characteristics of different fluorescents. SR-Ds and SR-Bs are designed for cool white, daylight, and mercury vapor fluorescents (under "warm" fluorescents, results are noticeably yellow).

Of the two series of filters, the FL-B appears to give better results. Only about half a stop is lost to filter density. Singh-Ray filters are also available on special order for custom installation in the internal filter wheels of such lenses as the 15mm and 16mm Nikkors, making fluorescent filtration as easy as turning a dial.

Fill-in flash often improves results under fluorescent light when ceiling-mounted fixtures cast shadows in the eye sockets and under the chins of subjects. However, compensating filters teamed with daylight color film would cause fill-in electronic flash to take on the color of the filter, giving odd-colored shadows. The simplest solution is to be sure that the fluorescent light is contributing *at least half* the total effective exposure. For example, if the indicated fluorescent exposure is $f/4$ at 1/30 sec., the electronic flash should be kept no brighter than $f/5.6$ or $f/8$. A flash meter or an automatic-exposure electronic flash unit (if it allows a choice of f-stops for a given film speed) makes this kind of calculation much easier. Unfiltered flash constituting a minority of the overall exposure does not cause noticeably off-color results.

A more refined way of dealing with the problem is to filter the flash with the Singh-Ray Flash/Fluorescent filter mounted over the reflector. This filter is designed for use with the Singh-Ray SR-D filter and makes the flash the same effective color as the ambient light. Both the flash illumination and the fluorescent lights are then filtered equally by the SR-D.

Filtration Chart: Approximated Results. This chart gives approximate filtrations, intended as starting points for testing. All filtrations are expressed in terms of CC filters. At best, they're just good guesses. Unless otherwise noted, they are intended for use with Kodak Ektachrome 400 film.

GENERAL ELECTRIC	
Lamp	Filtration
Warm White Deluxe Mercury	50 Magenta
Cool White	50 Magenta + 20 Yellow
Deluxe White Mercury	50 Magenta + 40 Yellow
250-watt Multivapor Phosphor-Coated	60 Magenta + 40 Yellow

G.E. ON EKTACHROME 160 TUNGSTEN

Lucalox (High-Pressure Sodium)	20 Cyan + 30 Magenta
Warm White	50 Cyan + 50 Yellow
Warm White Deluxe	20 Magenta + 10 Yellow
Cool White Deluxe	40 Magenta + 50 Yellow

SYLVANIA

Cool White Deluxe (SYL40CWX)	20 Magenta + 30 Cyan
Cool White (SYL40CW)	50 Magenta + 20 Yellow
Lifeline (F403K)	30 Cyan + 30 Magenta
Warm White (F40WW)	30 Cyan + 30 Magenta
White (F20T12W)	30 Magenta

SYLVANIA DISCHARGE LAMPS

Clear (LU150)	50 Magenta + 80 Cyan
Metal Arc (MA175/C)	30 Magenta + 10 Yellow
Mercury (H39K3-175DX)	50 Magenta + 20 Yellow

WESTINGHOUSE

F40/5000U	30 Magenta + 20 Yellow
F40/41000U	20 Magenta
F40/3000U	30 Cyan + 30 Magenta
Cool White	50 Magenta + 10 Yellow

DIFFUSION: HOW NOT TO SHOOT SHARP

For romantic or impressionistic color results, diffusion is a time-honored technique that is especially effective with color films. A diffused picture is characterized by the spreading of the glow of highlights into shadow areas and the minimizing of unimportant detail. It's not the same thing as simply shooting a picture out of focus. Diffused pictures must be focused just as carefully as sharp pictures.

When a photograph lacks sharpness, viewers' expectations change. The lack of sharp, specific detail results in a generalized message. Therefore, here are some suggested rules for diffusion.

☐ It works best with simple subjects where the lack of sharp visual detail does not confuse the viewer.
☐ Being a vague medium, diffusion works best expressing known ideas and depicting familiar subjects.
☐ Color offers greater scope for diffusion's capabilities than does black and white.
☐ Since highlights spread into shadows, low-key subjects (predominantly dark in color and lighting) with bright highlights are particularly good candidates for the diffusion technique.
☐ Pastel colors respond better to diffusion than dark or superbright ones.

Multiple-image prisms are available in a wide variety of patterns. They yield repeated images of a single subject and are most effective when used at wide apertures.

□ Diffusion can *best* be achieved on the camera when the picture is taken. If a sharp negative is diffused during printing, shadows spread into highlights, giving the picture a dingy look. The only exception is positive-to-positive printing.

□ Diffusion decreases the contrast of the original scene.

□ The degree of diffusion is determined by the subject matter. While heavy diffusion might be acceptable for a close-up portrait, it would turn the small details of a landscape into an unrecognizable blur.

□ High-contrast scenes require more diffusion than low-contrast ones.

□ Diffusion can bleed strong background colors into weak foreground colors.

The most basic diffusion involves putting something translucent in front of the lens to decrease sharpness. Classics include petroleum jelly smeared on a clear filter, wire screen, or sheer silk.

Diffusion disks that screw onto a lens like a filter are available from all filter manufacturers. While most diffusers are supplied in only two strengths, Harrison and Harrison (Hollywood, CA) supplies a set of five for precise control.

A refined diffusion technique is the so-called diffusion lens. Four lenses are available for 35mm SLRs.

□ The Portragon lens from Spiratone (Flushing, NY) offers a fixed *f*-stop (*f*/4) and single degree of diffusion.

□ The Sima SF lens (Sima Products Co., Chicago, IL) offers a single degree of diffusion, but gives the photographer a choice of *f*-stops (*f*/4 and *f*/5.6). Both the Portragon and the Sima SF are available in mounts for most 35mm SLRs.

□ The 85mm *f*/4 Fujinon SF lens (Fujinon Optical Co., Scarsdale, NY) uses perforated disks that take the place of a conventional diaphragm to control the degree of diffusion. The lens will fit Fuji SLRs.

□ The 85mm *f*/2.8 Varisoft Auto-Rokkor X lens (Minolta Corp., Ramsey, NJ) uses a selector ring to control the degree of diffusion. A sharp setting is also available. The lens fits Minolta SLRs. While the Varisoft is the most expensive diffusion lens, it is also the most convenient and versatile.

SPECIAL-EFFECT LENS ACCESSORIES

Extensive lines of plastic filters and lens accessories from Acme (Acme-Lite Mfg. Co., Skokie, IL), Ambico (Ambico, Inc., Lynbrook, NY), and Cokin (Minolta Corp., Ramsey, NJ), put special effects within the reach of all photographers. These plastic filter/accessory lines offer attractive conveniences. Full lines are available from a single manufacturer, they are listed in a single catalog, and all these items fit a common lens-mounted holder. The holder is designed to accommodate up to three filters or attachments simultaneously.

It would take a long catalog to list the full range of these accessories. Here are some highlights:

One guard at Whitehall in London becomes six guards, and one Swan Boat in the Boston Public Garden becomes a flock of swans, with the help of a multi-prism. A dark background and simple, familiar details make the use of such an accessory particularly effective in these examples. Whether they are good pictures or not is a matter of taste. Multi-image prisms are, admittedly, gimmicky.

A look inside this high-voltage industrial electrical furnace showed nothing but a spot of intense white light *(top)*. But by mounting a diffraction grating over the lens *(bottom)*, that bright spot became a rainbow of colors… not realistic, perhaps, but visually arresting.

☐ Overall diffusers are available in two strengths, plus diffusers with clear areas to allow part of the picture to remain sharp. A series of diffusers in different colors is available from Ambico.

☐ Fog filters give a misty look without affecting the sharpness of the image.

☐ Prisms allow distorted, elongated depictions of subjects, with rainbowlike color distortion.

☐ Graduated filters are partial filters. At one side, they are a particular color. Density decreases until the filter is clear about halfway across. Such filters allow controlling a *part* of the picture, such as tinting a sky while leaving the ground unaffected. A variation is a filter with a clear center and a colored periphery (gray, violet, green, orange, blue, or red).

☐ Composed of millions of prismatic grooves, diffraction gratings cause rainbowlike shimmerings of colors around bright spots of light. There are available in a choice of configurations, depending on the type of color displays desired.

☐ Star filters are clear glass disks scribed with crisscrossing lines. They make bright spots of light (such as streetlights at night) appear as multipointed stars.

☐ Multiimage prisms mount over the lens, giving repeated images in a particular pattern. Various models supply three, five, six, or more images. They are supplied in rotating mounts, allowing precise image orientation. The "Color-Multivision" prisms from Hoya (Uniphoto-Levit Corp.) have a different colored filter mounted in each facet.

Other variations on multiimage prisms include Ambico's "Action Maker" that gives a wavy, blurred-action appearance to stationary subjects. Similar effects are possible with Spiratone's "Motion Maker."

☐ The "double mask" allows combining two different exposures. An opaque mask with a central cutout is first placed in front of the lens and a picture taken. Then the first mask is replaced with a second one with a clear periphery and an opaque center, the opposite of the first mask. A second exposure of another subject is then taken without advancing the film. The result is a combination of two different pictures.

The list could go on and on. Each filter and accessory manufacturer has pet devices, and new items are constantly being introduced. The best way to cover the field is to write to *all* the filter manufacturers and importers for catalogs. Be prepared to be cynical. Many of these accessories are of very limited use and as soon as a picture looks "gimmicky," it is probably a visual or conceptual failure. Good gimmicks don't draw attention to themselves.

Variable Color Filters. A convenient way to add overall color to a picture is by the use of variable color (VC) filters, whose density can be changed just by rotating them. Available from most filter manufacturers, VC filters combine a regular polarizer with the VC color filter itself (causing an inevitable 1½ *f*-stop speed loss).

Above: Morning sunlight shining through autumn leaves in Vermont was improved on with two special-effect lens attachments. A four-point star filter turned the spot of the sun into a bright abstract of light, and a six-facet multi-image prism repeated the stars. Such contrasty subjects require the lowest-contrast color films — in this case, Kodachrome 25 — and TTL meter readings require heavy interpretation. This exposure was two full *f*-stops greater than indicated by the meter.

Left: Sealed-beam headlights on a conveyor belt were pretty dull. But by illuminating these colorless subjects with pink and yellow incandescent light, and photographing them on Type B film, the result is a rainbow of colors, including the blue rendition of the factory's fluorescent lights. A star filter caused the bright highlights to sparkle.

Rotating the polarizer causes the density of the filter to change.

Both single-color and two-color VC filters are available. The single-color filters—supplied in red, orange, green, blue, yellow, and purple—offer more subtle color choices, ranging from a pale tinge of color to an almost monochromatic intensity. Less-subtle color gradations are possible with two-color filters, but each of these filters gives a choice of two colors for the price of one.

Tricolor Exposures. Sharp-cutting filters (which pass only their own color) have an interesting application in general color photography—tricolor exposures.

Tricolor subjects must include both moving and stationary elements. The camera must be set on a solid tripod and three exposures must be made on the same piece of film, one each through #25A (red), #61 (green), and #47 (blue) sharp-cutting filters, using an exposure one f-stop greater than a normal nonfiltered exposure. In essence, each emulsion layer of the film is being exposed separately. In the resulting picture, stationary parts of the scene would be rendered normally, while parts of the picture that had been in motion would be rendered as separate red, green, and blue images. The results can be very effective.

INFRARED COLOR

Ektachrome Infrared is a film rather than a filter, but since filters play such a significant role in the use of this special-purpose film, it's included in this chapter. Ektachrome Infrared allows effects that cannot be achieved in any other way.

Ektachrome Infrared (IR) has three emulsion layers, sensitive to red, green, and IR. When processed, the green layer produces a yellow positive image, the red-sensitive layer produces a magenta positive image, and the IR-sensitive layer produces a cyan positive image.

Ektachrome Infrared is not available in an E-6 emulsion, only the previous E-4; and most color labs cannot process it. While Kodak offers E-4 processing, delivery is usually a matter of weeks. A list of other labs that still offer E-4 processing is included in the back of this book. While Kodak no longer sells E-4 home processing kits, they are still available from Freestyle Sales Co. (Los Angeles, CA).

When Ektachrome IR is exposed in sunlight without any filter at all, the result is a stark, depressing rendition running to blues and purples. Foliage comes out a cold magenta and blue skies are purple.

Use of a Kodak Wratten #15 filter renders green foliage as red or magenta (particularly under warm-colored early and late sunlight). Reds come out yellow, yellows come out bluish-white, browns come out green. Oddly enough, blue skies still come out blue. By adding a polarizer to the #15 filter, foliage is rendered an even richer red and skies are almost black.

The following list gives some idea of what effects can be expected from different filters on Ektachrome In-

Above: Magenta is an attention-getting color. Combined with suitable subjects, it can help create strong visual abstracts. In this case, a magenta "Color-flow" variable-color filter was combined with a polarizer to photograph grain loading chutes on a pier in Halifax, Nova Scotia *(top)* and the gleaming monolith of Boston's Federal Reserve Building *(bottom).* A 24mm lens was used for both pictures. Film was Koda-chrome 25.

Opposite page: A swaying branch of wind-blown autumn leaves gains added impact from a tricolor exposure. Using a 21mm lens, a Nikon F3 was mounted on a solid tripod and a triple exposure—through red, green, and blue sharp-cutting filters—was made on Kodachrome 64, using a one f-stop exposure increase over a conventional meter reading. The result is leaves in four colors—the actual yellow, plus red, green, and blue—and background trees and sky rendered normally.

Above: For specialized infrared photography, the Sunpak Nocto 480 electronic flash unit has an integral filter that passes only infrared light.

Opposite page: Boston's Park Street Church is surrounded by blue "bubbles" courtesy of a 600mm "catadioptic" (mirror) lens. The bubbles are blue Christmas lights strung through the trees of Boston Common. Out-of-focus points of light are recorded as tiny circles by a "cat" lens. The result is an unconventional Christmas-card illustration of a familiar Boston scene.

frared. The filters listed are from the same Kodak Wratten line of gels as the #15.

☐ *#1.* Exposure index: ISO 32/16°; Skies: dark blue; Trees: magenta; Skin: purple.

☐ *#16 + CC 50 Magenta.* Exposure index: ISO 32/16°; Skies: cyan; Foliage: dark red; Skin: white.

☐ *#23A + Polarizer.* Exposure index: ISO 8/10°; Skies: dark green; Foliage: bright orange; Skin: yellow/green.

☐ *#23A.* Exposure index: ISO 64/19°; Skies: green; Foliage: orange; Skin: yellow/green.

Regular exposure meters can't read IR, but since IR color only gives effective results under bright, clear sunlight (on overcast days, clouds filter out most IR), the film speed ratings on these two charts should yield reasonably accurate results. They are based on the assumption that the IR component of bright sunlight is relatively constant. Thus, an exposure reading of the overall scene brightness should give a reasonably accurate indication of the amount of IR present. Since the amount of IR transmitted varies with the filter used on the lens, different filters call for different exposures indices.

FILTER	RECOMMENDED ISO
#15 (deep yellow, also red and deep orange filters)	125/22°
#58 (green)	64/19°
#11 (light green)	100/21°

Most 35mm camera lenses have a compensatory IR focusing mark because IR focuses on a different plane from visible light. But since the Ektachrome Infrared image is produced by both IR and non-IR, regular focus settings can be used. Since IR color gives its best results in bright sunlight, small enough *f*-stops are possible to ensure sufficient depth of field to cover any focusing discrepancies. When working at very wide lens openings, focus on the front of the main subject.

Since electronic flash has a high IR content, it can be combined with different filters and IR color for offbeat results. Since Ektachrome Infrared is sensitive to both IR and visible light, the Kodak Wratten #87 filter commonly used for black-and-white IR flash photography that passes *only* IR will produce an image only on Ektachrome Infrared's IR-sensitive layer. The result is a monochrome image on a bright red background.

While Sunpak's Nocto 480 flash unit is no longer available in the United States, some dealers may still stock it (importer is Berkey Marketing Co., Woodside, NY). The unit has an IR-filtered reflector, and as long as shooting is done in dim light, there is no need for a filter on the lens. Exposure at 6 feet is approximately *f*/8 on Ektachrome Infrared, but only a monochrome result is possible with this method.

The following list is intended as a guide to different effects with Ektachrome Infrared and electronic flash,

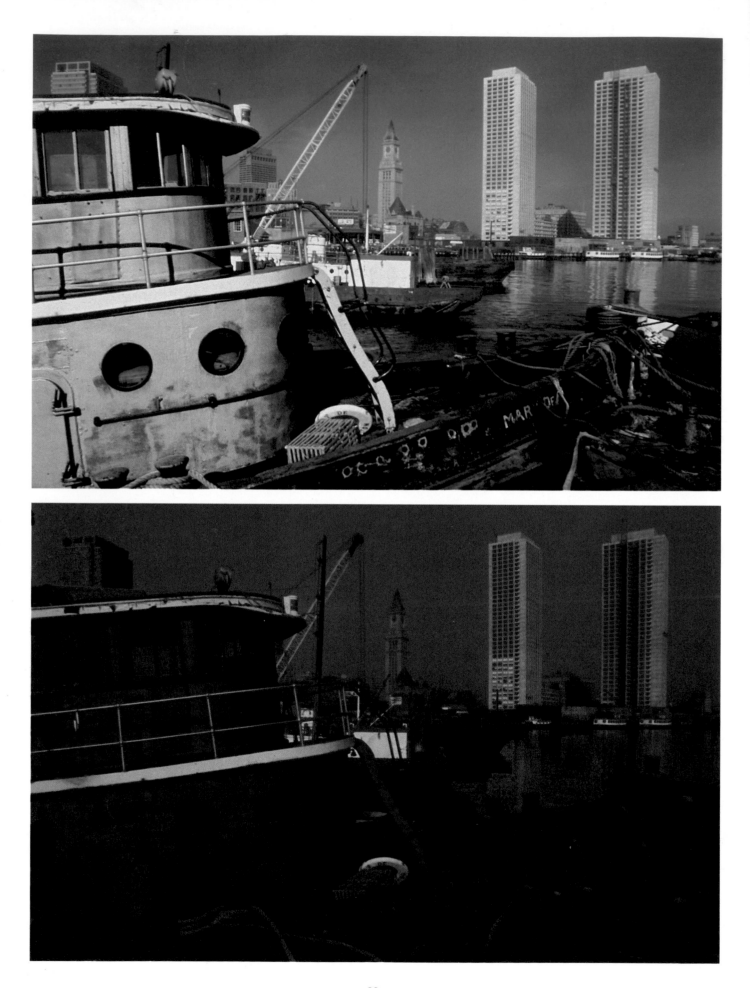

THE HANDBOOK OF COLOR PHOTOGRAPHY

using different Kodak Wratten filters on the camera lens. The listed film speeds can be programmed into an auto-exposure flash unit or flash meter. Bear in mind that this film has a narrow exposure latitude (about half an f-stop). Bracketing is the only way to make sure of good results.

□ Filter: #22 (dark orange); Effect: overall yellowish rendition; ISO 25/15°.
□ Filter: #61 (dark green); Effect: dramatic magenta rendition, pale skin tones; ISO 25/15°.
□ Filter: #25 (red); Effect: yellow-orange rendition, background details subordinated; ISO 100/21°.
□ Filter: #36 (dark violet); Effect; magenta-red rendition, pale skin tones; ISO 10/11°.

IR color can be abused as easily as special-effect lens attachments. Gratuitously weird pictures may be momentarily entertaining, but novelties become irritating very quickly. Photographers whose work with IR color has risen above the gimmick category have taken the time to become familiar with its capabilities. They use IR color only for specific effects that make visual sense.

People are inclined to believe what they see in a photograph ("The camera doesn't lie"). When the contents of a photograph turn out to be totally unbelievable, viewers are more likely to feel irritated and cheated than fascinated. No one likes a showoff.

Opposite page: Ektachrome Infrared film can produce a wide variety of spectacular, if not always believable, color effects, depending on which filters are used on the lens. These two scenes at Boston Harbor were shot with the standard green *(top)* and blue *(bottom)* filters used for black-and-white photography. Since conventional meters are of little help in gauging infrared exposures and color effects cannot be accurately previsualized, experience is the only way to master this special-purpose emulsion.

CHAPTER SIX
COLOR FILM AND ARTIFICIAL LIGHT

Above: Pure fantasy lighting. Few things are less interesting than the innards of a tape recorder, but by illuminating the subject with red and blue lights, the tangle of wires and components becomes a high-technology abstract. Film was Kodachrome 40, though daylight film would probably have given acceptable results. No one's trying to be "realistic" here.

Opposite page: Widows praying at a shrine in Rio de Janeiro, Brazil were photographed on Ektachrome 200. Exposure was determined with a spot meter. While the candlelight at the scene resulted in deep orange color rendition, it gave a fair approximation of the way the subject appeared to the eye. In situations like this, where the *actual* color is anybody's guess, both daylight and Type B color films will give different but equally acceptable results. Neither rendition will be "correct," but both may look right.

Although most color photographs are taken under daylight, it is probably the least desirable light source. Color temperature is constantly changing, and it almost never matches the color balance of daylight film. Daylight isn't portable or controllable. It must be used on its own terms.

On the other hand, artificial light sources can be precisely matched to a film's color balance. Intensity and direction are controllable. Multiple light sources can create pictures that would be impossible outdoors. Most commercial photography is done in studios under controlled lighting because professionals can't rely on the sun; they have to deliver top-quality results on schedule. Such reliability is possible only in a studio.

ELECTRONIC FLASH

There are two types of artificial lighting: incandescent lights and electronic flash. Of the two, electronic flash is the more common nowadays. Flash bulbs have lost their popularity to the more convenient electronic flash, though they are still used for extremely powerful lighting needs. Electronic flash units range from pocket-sized portables all the way to high-power studio installations.

There are good reasons why electronic flash (EF) is so popular with both amateurs and professionals.

☐ The light from EF is similar to daylight. It can be paired with daylight color film without the use of extensive filtration.
☐ The brief duration of the flash, usually 1/1000 sec. or less, virtually guarantees a sharp picture.
☐ Most small EF units are conveniently battery powered and self-contained.
☐ EF color and intensity are consistent and predictable to use.
☐ EF units are available with many conveniences and accessories, from beam spreaders and "barn doors" to automatic exposure control.

This rosy picture has a few flaws as well.

☐ Flash contains a heavy component of ultraviolet light (UV). Unless UV is filtered out, the result is a bluish color cast. While some EF units have a UV-absorbing coating on their flash tubes, such coatings may deteriorate with time and not all of them are effective.
☐ EF units emit only a finite amount of light, allowing only a single *f*-stop in a given situation. Smaller stops require faster film (with attendant quality loss) or a more powerful unit. Time exposures are impossible.
☐ The brief flash gives *only* sharp pictures. Controlled blurs are impossible.
☐ There is no opportunity to observe the effect of the light on a subject. The only exceptions are studio electronic flash units (and a few portables) incorporating "modeling lights" in their reflectors.
☐ The extremely short exposures of certain automatic exposure (AE) units can cause film reciprocity failure.

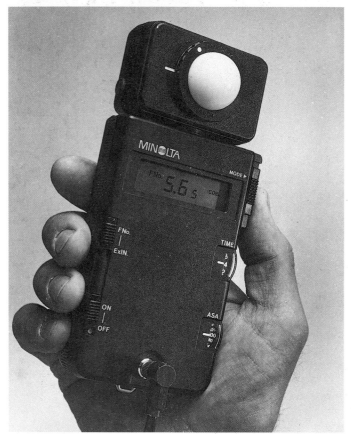

Top: The ultraviolet-light content of electronic flash can cause bluish color results with many subjects, as well as occasional unexpected fluorescence. Some flash units, including this Vivitar Zoom Thyristor 3500, accept UV reflector filters. If available, these inexpensive accessories should be used routinely.

Above: Electronic flash cannot be measured with constant-light meters. The computerized Minolta Flash Meter III is specially designed for flash measurements. It can evaluate both single and repeated bursts of flash illumination, as well as constant light. The meter also accepts a line of application-multiplying attachments.

☐ Intensity can only be measured with a special meter.
☐ Many small EF units are designed only for on-camera use, the least-effective lighting technique.

Living With Electronic Flash. While many of these problems are simply part of the price that must be paid for EF's conveniences, there are a few cures. UV can be filtered with a UV or 1A filter. Stronger correction is possible with Kodak's 2A or 2B filters or the Singh-Ray SR-UV. With experience, flash results can often be anticipated. Using a manual-setting Polaroid camera, results can be previewed and exposures can be verified.

Unexpected Colors. The UV content of EF can cause unusual problems due to the phenomenon of fluorescence. Many subjects, such as white shirts, bridal dresses, and "super white" studio seamless background paper, are impregnated with chemical whiteners. UV in flash can cause these whiteners to fluoresce momentarily, glowing with a blue color that the film will record. Sometimes a pink polyester dress will photograph bright blue or a green synthetic fabric dress comes out brown, due to the tendency of certain synthetics to absorb UV and re-emit it as a different color.

A UV filter on the lens won't solve this problem because the UV from the flash causes fluorescence before the image reaches the lens. To rule out the possibility of UV excitation, the UV must be stopped at the flash. In their E-73 pamphlet, "Why a Color May Not Photograph Correctly," Kodak recommends filtering UV with "Clear Lumar Polyester with UV Inhibitor" (available from Sears, Roebuck) taped over the flash reflector. For small flash units, a reflector-sized Kodak Wratten 2B filter may be used instead.

Ready-made UV flash filters include Tekno, Inc.'s "Singh-Ray Electronic Flash UV Filter," claimed to absorb 96 percent of the flash unit's UV before it leaves the reflector. Available in sizes up to 12 inches square, the filter also eliminates the possibility of color crossover due to reciprocity failure. The manufacturers of several small flash units (including Vivitar) supply snap-on UV reflector filters.

The Singh-Ray flash filter is also available as the SR-UV filter for use on lenses. While a lens-mounted filter cannot prevent UV fluorescence, it can correct much of the resulting blue shift. While more expensive than the usual 1A and UV filters, the SR-UV is a more effective UV barrier.

Another problem in flash photography is color casts caused by reflective surroundings. The color of "bounced" flash (reflected off a wall or ceiling instead of directed at the subject) is often contaminated by surroundings that add some of their own color to the picture when illuminated by the flash. A bounce-flash picture in a room with blue walls, for example, would pick up some reflected blue even if neither the subject nor the flash had any excess of blue.

Most off-color surroundings aren't so obvious. Some paint manufacturers tint their "white" paint with yel-

Above: This scene was photographed with electronic flash bounced off the bedroom's white ceiling. While the illumination is reasonably even from foreground to background, notice the deep shadows thrown under the down-turned face of the girl reading the book, because of light that was reflected directly down from the ceiling. While bounce flash often gives better results than straight, on-camera flash, it can throw shadows in undesirable places, as well as picking up unwanted color from nonwhite surfaces.

Left: This computer repairman was photographed with three electronic flash units on Kodachrome 25. One light above and to the right of the camera illuminated the foreground and the man's face. A second light to the left of the camera gave a sharp "rim light" on the technician's profile. A third light, equipped with a yellow filter, was directed at the background. Exposures were calculated with a flash meter and checked with a Polaroid camera.

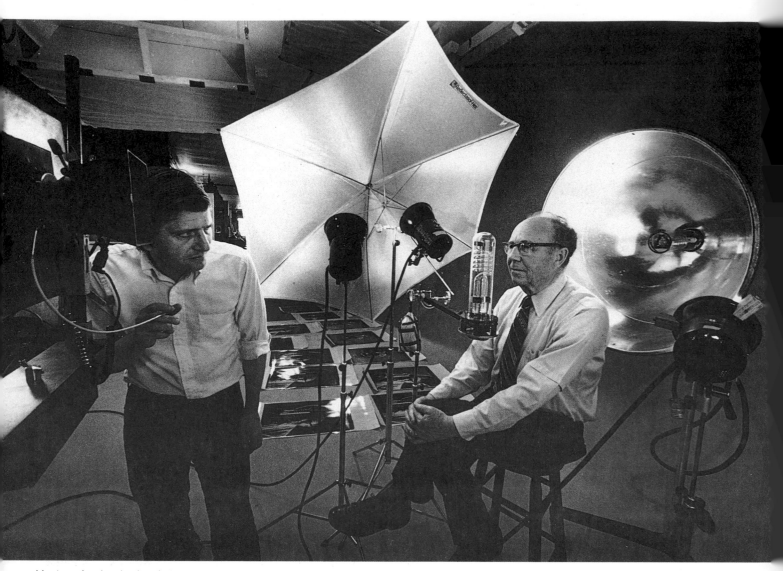

Much professional color photography is done in studios, where the precise color and behavior of light can be controlled. In this picture, Dr. Harold Edgerton, inventor of the electronic flash, poses for his portrait in the electronic-flash-equipped studio of Boston commercial photographer Steve Grohe *(left)*. Notice the flash units that are "bounced" off the reflective umbrella in the center. The result is low-contrast light.

low. It may be too faint to notice, but the result can be a yellow color cast to bounce-flash pictures. *Dirty* white paint can also warm up bounce-flash results unexpectedly.

Color contamination can also occur with direct (on-camera) flash. Color casts will be present in some pictures and absent in others, depending on flash-to-subject distance. Close up, only the light from the flash is lighting the subject, but when flash shots are taken at a greater distance, the light bounces around the room, picking up color tinges from surfaces that did not have a chance to reflect light when the flash was very close to the subject.

INCANDESCENT LIGHTS

EF offers convenience and short exposures, but incandescent lights have attractions of their own.

☐ They are often cheaper than flash units.
☐ Since incandescent lights are constantly burning, effects are easy to observe.
☐ Exposures can be determined with a conventional meter.
☐ They are designed for use on stands, encouraging experimentation with off-camera lighting.
☐ Incandescent lights are mechanically and electrically much simpler than electronic flash. They're easier to set up and maintain.
☐ Time exposures are possible.

Incandescent lights have their problems, too.

☐ They get dangerously hot (operating temperatures can run as high as 1000 F). A falling light can cause serious damage if it lands in the wrong place.
☐ AC household current is necessary for operation. The resulting wires are inconvenient, and overloaded circuits can cause blown fuses.
☐ There may not be enough light for high shutter speeds.

The cheapest incandescent light is the photoflood. Although they look like big household bulbs, photofloods have overloaded filaments that give bright light for a short time (their usual life is about six hours). Photofloods are supplied in several strengths, designated by numbers: #1 consumes about 250 watts; #2 about 500 watts. Both of these sizes will screw into a regular household light-bulb socket. The more powerful #4 photoflood requires an extralarge "mogul" socket. Photofloods are available in both 3400 K and 3200 K color temperature, for use with Type A or Type B color films respectively. A #2 photoflood shouldn't cost more than three dollars.

The #1 and #2 photofloods are available in blue glass for use with daylight-balanced color films. Color temperature is 4800 K, making for warmish results. Blue floods are intended for use as fill-in lights with indoor subjects lit by window light, which often gives slightly blue results on daylight color film. The warmth of blue floods gives interiors an attractive appearance.

Photofloods must be used in appropriate lighting units. While close to a dozen manufacturers supply such equipment, Smith-Victor Co. (Griffith, IN) offers one of the most complete lines on the market of sockets, reflectors, light stands, and complete units accepting photofloods.

A variation on the regular photoflood is the reflector flood. This mushroom-shaped bulb incorporates a built-in reflector and can be used in simple fixtures. A particularly useful example of such a fixture is the "Lowel-Light," from Lowel-Light Mfg. Co. (New York, NY). The Lowel-Light consists of a heavy porcelain socket fastened by a hinged mount to a flat metal plate that can be hung, propped, or taped to anything from a wall or ceiling to a light stand. A set of accessory "barn doors" clips directly onto the bulb, providing additional lighting control. The whole assembly is functional and inexpensive.

While photofloods are cheap, their shortcomings may disqualify them for use by many photographers. They are very fragile. Pack photofloods carefully and carry spares. The longer photofloods burn, the more their color temperature changes. Tungsten molecules evaporate from the hot filament, migrating to the inner surface of the glass and causing it to discolor. Users of large studio floods make it a rule to burn all their bulbs for the same length of time. This ensures that color temperature will change consistently, allowing compensatory filtration.

Quartz Lights. Another type of incandescent light goes by many names—quartz-halogen, quartz-iodine, or just quartz light. It offers compactness and durability and avoids the color changes affecting photofloods. When a quartz light is turned on, evaporating tungsten molecules combine with iodine vapor in the quartz envelope and are attracted back to the filament, preventing discoloration, extending filament life, and allowing higher operating temperatures for increased light output (which is why quartz envelopes are necessary: glass can't handle the heat).

While quartz lights are much more expensive than photofloods, they offer advantages impressive enough to make them the current top sellers among incandescent lights.

☐ Consistent color temperature makes quartz lights a logical choice for color photography.
☐ Quartz lights can be very small. Some are only an inch or two long. As a result, lighting units can also be smaller. Some Smith-Victor, Acme, and Lowel quartz lights can literally fit into a pocket. These manufacturers offer convenient "lighting kits," combining two or three lights, stands, light control accessories, and cords in a single case.
☐ Quartz lights are more durable than photofloods.
☐ The envelope is a particularly effective filter of UV light.

Above: A resort condominium development conference room was lit with photofloods to balance the bright windows in the background. Film was Kodachrome 40, whose Type A color balance caused the window light to be rendered with a blue color cast, allowing a color contrast with the warm-colored wood interior.

Right: While photoflood bulbs are delicate and subject to color changes, they are inexpensive and convenient for occasional photography. A wide range of reflectors gives a choice of light coverage.

Above: Quartz lights, like these Lowell Tota-Lights being used with polarizing screens for copying an oil painting, are much more expensive than photofloods, but compactness and constant light color make them preferable for many busy photographers.

Left: Grandmother and big brother help little brother get dressed after his nap in this incandescent-lit interior photograph. A single quartz light was mounted on a stand to the right of the camera, directed at a white wall. Its intense illumination was reflected all over the small room, allowing a 1/125 sec. exposure on Ektachrome 160. Since the walls were pure white, this bounce lighting did not encounter any color contamination.

Re-creating British military bands of yesteryear, these soldiers are marching in the Royal Military Tattoo in Edinburgh, Scotland. The picture was shot with an 85mm *f*/1.8 lens, wide open at 1/125 sec. on Ektachrome 200. While the color rendition under the outdoor theatrical spotlights runs toward yellow, similar pictures shot on Type B film turned out too blue. The moral? Not all lighting situations fall neatly into the capabilities of daylight *or* Type B color films.

Incandescent Tips.

Incandescent Tips. When using photofloods or quartz lights, apply some basic rules for good performance.

☐ Incandescent lights are under a great strain when they are first switched on and current hits the cold filament. To get the longest life out of their lights, many pros use a "hi-lo" switch, available at most electrical supply houses. The switch allows burning the lamps on low voltage for focusing and composition, then stepping up to full voltage for the actual exposure.

☐ Photofloods and quartz lights all have rated voltages for correct color temperature. A variation of 1 volt in the electric service results in a 10 K color temperature shift. This can make a noticeable difference when shooting copies or doing portraits against a white background. In both cases, a color temperature shift would be both noticeable and objectionable. Current fluctuations are particularly prevalent in summertime when everyone turns on air conditioners. A 5-volt current drop isn't so unusual under such circumstances, resulting in a 50 K color temperature shift.

Volt meters, available at large hardware stores, allow checking of incoming voltage. If it is below the lamp's rated voltage, multiply the shortfall number of volts by 10 to get the resulting color temperature shift, then check the color temperature correction calculator in the *Kodak Professional Photoguide*. It tells which LB filters are necessary for compensatory filtration.

☐ Stand-mounted incandescent lights can be easily knocked over, so use heavy stands that are more likely to stay on their feet. The extra weight is worth tolerating when working around people, especially in busy places. A falling hot light is very dangerous. Two of the heavier stands on the market come from Acme-Lite and Smith-Victor.

☐ Always start with just one light. Add a second one *only* when the first is doing as much as possible. The same goes for a third light, etc. Overlighting a subject causes more problems than it solves.

☐ Use the least amount of light possible. Few subjects appreciate being under hot light. The more consideration shown to subjects, the better the resulting pictures will be.

☐ Don't overload electrical circuits. The result will be blown fuses and no pictures. While most home circuits can accommodate up to three #2 photofloods, be sure to carry some extra fuses.

Household Incandescents. Household Incandescent lights are not designed for photographic purposes. These lights have a lower color temperature than photofloods, resulting in excessively warm color results with Type B color films. The following chart will help fine-tune household tungstens for more accurate results. The lower the lamp wattage, the lower the color temperature.

Much "artificial light" that photographers encounter is actually household incandescent lights, often mixed with lighting of a different color temperature. This conversation in Deacon Brodie's Pub on The Royal Mile in Edinburgh, Scotland, was shot with an 85mm lens on 3M 640-T film. Due to the incandescent lighting, an unnaturally warm color rendition results, with a blue foreground where window light was shining on some glasses on the bar. While filtration would have improved the picture, candid situations seldom allow such technical embellishments.

This twilight scene at Grafton, Vermont's Old Tavern was taken on Kodachrome 25. The weak daylight is rendered as deep blue, while the incandescent-lit windows are yellow-orange. While neither rendition is "correct," this color combination is a classic for cozy-looking scenics.

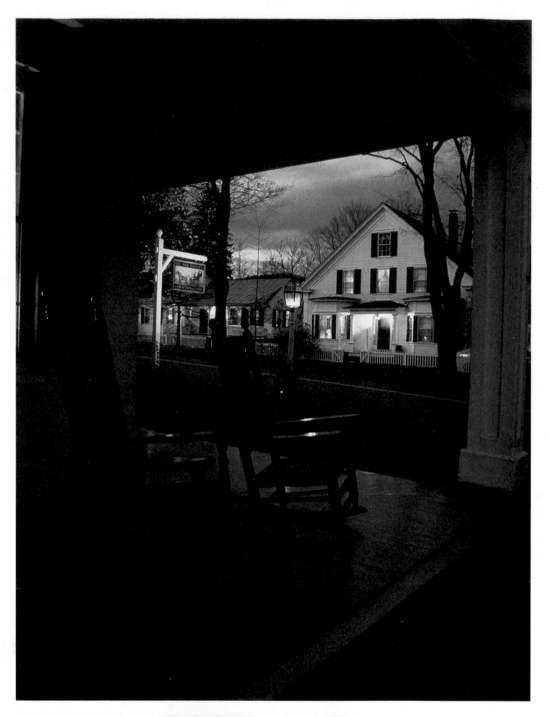

A sales conference was photographed on Kodachrome 25 using three electronic flash units — one above the camera, one to the left, and one on the right directed at the background. Such multiple lighting must be built up, light by light. While such procedures are time-consuming, the results are well worth the effort when the job is done right. No single light source can produce such even foreground-to-background lighting, and the narrow exposure latitude of color slide films makes careless lighting more noticeable. Before shooting, an even exposure was verified with a flash meter and Polaroid test shots.

LIGHT BALANCING FILTER CORRECTIONS
for Type B (Tungsten) Color under Household Incandescents

200-watt lamp (2980 K)	82A
100-watt lamp (2900 K)	82B
75-watt lamp (2820 K)	82C
40-watt lamp (2650 K)	82C + 82A

A classic "available light" technique is to replace household bulbs with #1 photofloods. The resulting lighting looks natural but is brighter as well as being the correct color temperature for Type A or Type B films, depending on the bulbs used. Be careful not to overload fuses or burn lampshades while using this technique of boosting and correcting light without altering its appearance.

MIXED LIGHTS

Photographers sometimes encounter mixed lighting conditions, lights of different color temperatures in the same picture. This is a classic double bind, for no filter can make everything correctly balanced. A common situation might be a room with bright windows and interior incandescent light. On daylight film, areas lit by window light would be rendered accurately while areas lit by incandescent light would have a red-orange color cast. On Type B film, the opposite would occur. While there's no cure for this problem short of waiting until dark and using Type B film, or filling in a daylight-filled room with electronic flash or blue floods, some pictures may be improved by film/light mismatch. An example might be an early evening shot of an incandescent-lit window on daylight color film. The exterior looks cool and blue while the window looks warm and inviting.

Photographers working indoors under mixed light sources can sometimes filter each source separately, if the light sources can be independently controlled and if there are no moving subjects. The camera is mounted on a solid tripod and two exposures are made, one for each light source while the other one is turned off, each with appropriate filtration. For certain industrial and technical applications, it's the only way to get an acceptable result.

LIGHTING AND CONTRAST

The rules of lighting contrast applying to outdoor photography are also valid for artificial-light color photography. But while sunlight cannot be controlled, artificial light can be custom-tailored to film capabilities. A common studio technique is to use two lights, one as the main light and a second, weaker light for shadow fill-in. A third light is used to illuminate the background.

The easiest method of controlling the intensity of artificial lights is to vary their distance from the subject. Using an incident-light meter at subject position, make comparison readings of highlights and shadows, adjusting lamp-to-subject distance until the highlight-shadow exposure difference is within the three *f*-stop range of color film exposure latitude. The easiest way to check this range is by using the calculators of the Minolta Auto Meter III and Spot Meter M. Such careful control will retain detail in both highlights and shadows that would be lost with harsher lighting contrast. If lighting intensity can't be controlled easily by moving the lamps, try using bulbs of different intensity, or one of the diffusers available for many incandescent and flash units. These accessories decrease both the intensity and the contrast of the light output.

These four basic rules should simplify the lighting of many subjects.

☐ Completely black areas are seldom of any interest. People look at photographs because they are looking for information. A dead-black area conveys no information. It's just a hole in the picture.

☐ Avoid bright areas without detail (overexposed highlights, for example). A viewer instinctively looks at light areas first. If these areas contain no information, the viewer feels cheated.

☐ The brightest light should fall on the area of greatest interest. Two main lights or two areas of equal lighting emphasis are confusing. One area of primary interest is about all most photographs can accommodate.

☐ One light must predominate. No matter how many lights are used, one must be brighter than all the others. If several separate areas are lit equally, confusion results. People are accustomed to the single light source of the sun.

Unnecessarily complex lighting is as bad as using too many special-effect lens attachments or the weird color of Ektachrome Infrared for no real purpose. Such pictures show that the photographer didn't know how much of a good thing was too much. Too little lighting is often preferable to too much.

CHAPTER SEVEN
COLOR LABS

Above: Like the desk personnel of Boston's Master Color Service Inc., pictured here, most color lab staffs do their very best to fulfill reasonable customer needs. But like all professionals, they expect professionalism on the part of their customers, too. The more a customer knows about color lab capabilities, the better results he or she will get from a custom lab.

Opposite page: Molten glass dripping out of a factory furnace was a dramatic yellow-orange color; a blue background makes it even more dramatic. A small electronic flash unit with a blue-gel-covered reflector was directed at the background, and then a series of tests was made with a Polaroid camera until the flash exposure on the background was matched to the brightness of the molten glass.

There are good reasons why many photographers have their film processed and printed by professional color labs. A "pro lab" can afford the specialized equipment and skilled staff necessary to process and print color to manufacturers' standards. The result is not only better quality than home color darkrooms can deliver, but more free time for photographers to take pictures and gain experience. Given this quality/time differential, lab services are often cost-competitive with home processing. Since offering more services means more business to color labs, they routinely supply a wider range of processing choices than most home darkrooms can handle.

Finally, association with a color lab can improve a photographer's technique. Lab staffs evaluate the work of hundreds of photographers every day. As a result, they are an excellent source of technical critiques and suggestions.

CUSTOMER RESPONSIBILITY

Professional color labs are just that—professional. Customers who get their money's worth out of such labs deal with them in a professional manner. Services must be ordered in correct terminology. It's not good enough to say that a print is "too blue," for example. How much blue is too much? Lab personnel need precise instructions.

Out-of-focus slides or scratched color negatives cannot produce good results from any lab. Labs routinely complain that customers expect top-quality results from substandard originals.

Anyone who goes shopping for a color lab will find many differences in the prices and services available from competing labs. Choice is dictated by technical needs versus the price a customer is willing to pay for quality work. For example, a $5 mail-order color print can't be expected to compete with a $40 job from a top custom lab, but both types of lab can expect to have some satisfied customers. This chapter should help decide what degree of lab expertise is necessary.

COLOR LAB SERVICES

While full-service color labs offer a wide choice of often specialized services, their most common functions are processing color film and making color prints.

Film Processing. There are two processing procedures, both from Kodak: E-6, for Ektachrome and films with compatible processing (3M, Fuji); and C-41, for Kodacolor, Vericolor II, and other compatible-processing color negative films (3M and Fuji again).

Color Printing. Where film processing is a precise, nonvariable procedure, color printing is much more subjective and controllable. Color prints are made using enlargers with infinitely variable filtration capabilities. The result is that there is seldom an "ideal" print. The tastes of both the printer and the customer have a bearing on finished results. So does the intended use of a

The automated E-6 processing equipment *(right)* of the Master Color Service is designed to produce the consistent quality that's expected from any professional-level color lab. Chemical solutions are automatically replenished to maintain precise film response, film is dried in special dust-free drying cabinets *(bottom left),* and transparencies are handled only with gloves as they are evaluated before being mounted *(bottom right).*

print. Some reproduction processes call for a particular print density or color balance; exhibition prints may call for a different "look." This is why there are so many custom color labs. Color prints tailored to precise customer needs are in great demand.

Depending on customer needs, tastes, and means, there are five choices in color printing.

Ektacolor 74. This process yields color prints from a customer-supplied color negative. Prints can also be made from color transparencies if the original is copied onto special low-contrast color negative film to produce an *internegative*, from which the Ektacolor print is actually made. A new development in internegatives by PEC LaserColor Labs (West Palm Beach, FL) uses laser beams instead of an optical system. Computer-generated color abstract versions of the original are also possible.

While it sounds illogical to divert a transparency through the internegative step when there are positive-to-positive print processes available (Ektachrome 2203, Cibachrome II, and Dye Transfer, see below), there is a compelling reason to do so.

Color print materials are supplied only in a single contrast grade. Prints will be of poor quality if the contrast of the original doesn't happen to dovetail with the contrast capabilities of the print material. Internegatives constitute a control step that allows contrast and exposure of the original transparency to be fine-tuned to the capabilities of the print material, depending on how the internegative is exposed and processed. Ektacolor 74 paper is also sensitive to small filter variations, allowing it to be "tweaked" for precise color control. The resulting print quality makes up for some of the inconveniences of internegatives—extra expense, extra time, and a slight loss of sharpness.

Some mass-production labs offer extremely low prices on bulk Ektacolor prints as long as the photographer sticks to carefully defined rules: a standard film format (usually 120 square or 6 x 7 cm), no cropping (or standardized cropping via special masks), accurate exposures, and a standard light source (electronic flash). Wedding, portrait, school, and other photographers whose working procedures allow this kind of approach use such services routinely.

Ektacolor 74 prints (sometimes referred to as "C-prints") constitute the bulk of most labs' color printing. Some labs offer different grades of C-print quality at prices governed by the number of remakes that the lab is willing to provide before a customer is satisfied.

Ektachrome 14. This positive-to-positive process allows prints to be made directly from color transparencies. No internegative is required. The result is faster printing and better sharpness than Ektacolor 74 prints from internegatives. Bright colors reproduce with a strong "poster" quality. Since this is a reversal process, print borders come out black instead of white.

While Ektachrome 14 has obvious advantages over

Slides should be viewed on a 5000 K "light box" for accurate color appraisal. Professional color labs *(top)* routinely maintain such facilities, and all serious photographers should have one of their own. Shown here *(bottom)* is the inexpensive "Idealite" from Richards Manufacturing Company.

THE HANDBOOK OF COLOR PHOTOGRAPHY

Ektacolor 74 for prints from transparencies, it does not offer the fine color control available from an internegative. Contrast and exposure vagaries in the original can result in poor quality. The process gives good prints only from perfect-quality originals whose contrast characteristics precisely match the material's capabilities. Compared to Ektacolor 74, Ektachrome 14 prints (called "R-prints") have a garish color rendition which may be inappropriate for some subjects. The only contrast control available is highlight masking (see below), the cost of which can wipe out any savings over an Ektacolor 74 print with its more flexible internegative control. Ektachrome 14 paper also offers less-fine color control than Ektacolor 74 prints, requiring massive filtration changes to produce noticeably different results.

Cibachrome II. This competing positive-to-positive process is from Ilford. Many photographers like the bright color rendition of "Cibas," though the material sometimes has difficulty rendering pastel colors effectively without masking. Cibachrome is coated on a white plastic base that gives prints a brilliant, snappy appearance.

Cibachrome II is among the most permanent color processes. Its dyes appear to resist fading more than Ektacolor 74 RC or Ektachrome 2203 RC prints, making Cibas a good choice for exhibition printing. Cibas are usually more expensive than comparable Ektacolor or Ektachrome prints.

Dye Transfer. Usable with either color transparencies or color negatives, the Kodak Dye Transfer process offers premium quality at an extremely high price (often over $300 for an 8 x 10 print) that restricts its use to a demanding, well-heeled clientele. Images are more permanent than Ektacolor or Ektachrome prints. Once the first print is made, additional prints cost less because they are made from the same set of separation matrices.

Panalure. This panchromatic enlarging paper allows black-and-white prints to be made from color negatives with grain and sharpness identical to comparable color prints.

All color print processes offer a choice of paper surfaces, glossy and matte. Glossy prints tend to look sharper and snappier than identical prints on nonshiny matte surfaces, but the mirror effect of glossy prints quickly picks up fingerprints and may make exhibition prints difficult to view comfortably. Most labs keep sample comparison prints available in both surfaces. Give the choice some serious consideration. Glossy prints are initially impressive, but their delicacy and shiny surface may make them a poor choice in the long run.

Masking. This contrast-reducing method for negatives and transparencies requires making a contact print from the original on special low-contrast masking film. The resulting image is bound in precise register with

Opposite page, top: An illuminated display was turned into a kaleidoscopic abstract with a time exposure and a zoom lens. During a tripod-mounted 10-second exposure, the lens was zoomed backwards and forwards over its 35-85mm range, turning every bright light into a colorful streak. Film was Kodachrome 40.

Opposite page, bottom: This electrical switch test console was a dull metallic gray, no color at all. Using three lights, each covered with a different-colored gel (red, blue, and green), resulted in this abstract. It doesn't look much like the original subject, but no one has complained. Photographs carry an implication of reality, even when they don't actually reflect it.

Above: Large-scale slide duplication is a common color lab service. This technician at ASAP Photolab, Inc. in New York City is using a special long-roll duplicating camera with a precisely controlled light source for predictable, consistent results.

the original before printing or duplication, adding selective density that serves to narrow the original's contrast range. Cibachrome II, Ektachrome 74 and duplicate transparencies sometimes require masking of the original to maintain highlight and shadow detail.

Transparency Duplication. Big labs routinely "dupe" thousands of transparencies. Dupes can be color-corrected and cropped, and enlarged transparencies can be made by printing on large sheets of transparency film. Slide duplication is explained in detail in the next chapter.

Less commonly utilized color lab services include combining color transparencies into film strips, making prints from motion picture film frames, color "stats" (rush color prints of specific size for graphic designers' layouts), "super size contact sheets" (either 11 x 14 or 16 x 20) made from a roll of 35mm or 120 color negatives on an 8 x 10 enlarger, negative filing, and retouching services that can result in flawless color prints from badly scratched negatives. Distracting details can be airbrushed. Transparencies can be retouched. Separate images can be combined on a single sheet of film.

MAIL-ORDER COLOR LABS

The high cost of quality color printing has led to the growth of dozens of low-priced mail-order color labs. Their quoted prices in photo magazine advertising are much lower than "custom" labs with walk-in, personalized service.

Mail-order labs' advertising often makes extravagant claims: "Hand printed," "Custom lab quality," "We treat your negatives like our own," etc. What kind of quality do these labs actually deliver? Basically, customers get what they pay for. Many mail-order lab customers have never seen a custom color print and will often accept quality that a more sophisticated photographer would reject. While most mail-order labs will remake a print if it is returned with reprinting instructions, such labs often take weeks to return an order. Sending a print back two or three times for reprinting before results are acceptable can take months. Considering that most custom labs have two- or three-day print turnaround, it becomes understandable why busy pros are willing to pay custom lab prices for fast, reliable service.

This is not to denigrate mail-order labs. Considering the prices they charge ($3 for an 8 x 10 print is not uncommon), their quality is appropriate and reasonable. Since all labs pay about the same prices for equipment and materials, savings have to come out of wages and reject prints.

Custom color labs rely heavily on the expertise of their color printers. These well-paid craftspeople routinely reject several prints before coming up with a combination of color balance and exposure that meets their standards. Custom labs routinely carry out customer requests regarding color rendition, cropping, print density, etc. Reject prints in the trash and skilled

printers' salaries are a big part of the high prices custom labs charge (8 x 10 Ektacolor 74 prints can cost anywhere from $15 to $40 as of this writing).

Mail-order labs can't afford such procedures and still make money at the prices they charge. As a result, these labs rely heavily on semiskilled personnel who use electronic negative analyzers to determine print filtrations. This mass-production technique results in some good prints, a few completely unacceptable prints, and many marginal-quality prints that are seldom remade unless a customer returns the print with a specific complaint. Custom printing requests are seldom carried out. Prints ordered from 35mm negatives or slides are often cropped to fill the 8 x 10 paper. Uneven slide and negative exposures can fool the analyzer and print quality will suffer. Sometimes a customer will luck out and get a perfect print; other times, results will be enraging.

Considering their low prices, more-refined techniques would be financial suicide for mail-order labs. Most customers find the results acceptable, and only a few request reprinting. The service can't be compared to high-priced color labs. Each serves a different clientele with different standards.

Getting the Most from Mail-Order Labs. Since mail-order labs *are* so inexpensive, it makes sense to take advantage of their prices as often as possible. Here are some tips to improve results.

Expose film correctly. Match the light source precisely to the film's color balance. Expose with care. Electronic analyzers at most labs are set to the standard of correctly exposed film. A Kodacolor II negative exposed under incandescent light, for example, would result in a print with a yellow-orange color cast. A custom-lab printer would correct such a color imbalance routinely, but such a print could easily cost five or ten times as much as the mail-order print.

Pick recognizable subjects. A portrait, for example, incorporates skin tone, a widely accepted standard that allows off-color results to be spotted easily by a quality control inspector. Unfamiliar subjects do not offer such convenient references.

Avoid "subject failure" negatives. These are negatives with a predominance of some strong color at odds with the rest of the picture. Electronic negative analyzers will be fooled by this strong jolt of color, coming up with filtration that distorts colors in the rest of the picture. An example would be a portrait subject in a bright orange jacket with a neutral brown-gray background. The bright orange would cause the analyzer to add too much cyan filtration, coming up with a bright orange jacket but a gray-green tinge to both the subject's face and the background. This kind of negative requires custom printing.

Make logical requests. While mail-order labs seldom pay attention to special printing directions, there's no harm in trying. The most common failing of mail-order

People standing on the tops of buildings? No, this is a 20-minute time exposure of atomic fuel cells glowing in the bottom of a deep water tank. All the light in the picture came from the energy of the cells themselves, resulting in a dramatic monochrome effect.

The shore of Cape Cod was photo-
graphed from the air at sunset
with an 85mm lens on Ektachrome
200. A very short exposure was
necessary to avoid ''burning out''
the backlit water, and the result
is a visual abstract of silhouetted
land and orange water.

THE HANDBOOK OF COLOR PHOTOGRAPHY

prints is that they're too light. Routinely requesting that they be made extra dark may improve results.

Don't be impatient. Mail-order print prices are lower than custom-lab prices. Part of the difference is made up by the time customers spend waiting for the work and sending it back to be redone. Accept this shortcoming to save money. Custom-lab service doesn't come at mail-order prices.

All mail-order color labs are not created equal. The huge Meisel Photochrome operation, for example, offers a full range of sophisticated color services. Prices are often lower than big-city custom labs. Discounting the extra time involved, such a lab can be a desirable intermediate-price supplier of top-quality work.

Through their dealers, Kodak offers in-house color services at reasonable prices. The list includes film processing (of Kodak films), color printing, transparencies from color negatives, copy negatives, photographic business and greeting cards, and mail-in/mail-back processing via prepaid processing mailers for both E-6 and C-41 process films (except Vericolor II Professional, Type L). Unacceptable results are reprinted at no additional cost. Turnaround time is usually faster than mail-order lab service.

COLOR SLIDE PROCESSING

Since E-6 film processing costs about the same everywhere, a local lab is a logical convenience. Requesting that 35mm slides be returned unmounted can almost halve the processing cost. Unless every slide on the roll is acceptable (seldom the case), the price of the mount is wasted every time a reject slide is thrown away.

While large camera stores carry a wide variety of plastic, metal, and cardboard 35mm slide mounts complete with instructions for use, a particularly useful mount is the Erie No. 1 (Erie Color Slide Club, Erie, PA). It is the only readymade mount showing the full area of a 35mm transparency. Most slide mounts (including Kodak's) have "windows" that are slightly smaller than the dimensions of a 35mm slide (24 x 36 mm), resulting in peripheral image loss.

Hand slide mounting saves money, but color transparencies are extremely delicate. Always wear cotton "editing gloves," and follow mounting instructions carefully.

MODIFIED PROCESSING

Modified processing is an attempt to increase or decrease ISO speeds of color transparency films. Speed is actually a photochemical characteristic of each film and can't be changed, but modified processing can *partially* compensate for incorrect exposure. The key word is partially. Most custom color labs offer this service at a premium price. While "push" or "pull" processing inevitably sacrifices image quality, there are good reasons for resorting to it.

☐ The wrong ISO speed may have been inadvertently entered on a meter's calculator.

Top: The heart of any color printing operation is the adjustable filtration capability of a color enlarger like this one at ASAP Color Photolab, Inc., in New York City. Such equipment makes color printing an infinitely variable as well as infinitely subjective procedure, since color casts can be introduced, varied, or eliminated.

Above: A printer at Master Color Service, Inc. inspects an 11×14 enlarged contact sheet made from a roll of 35mm color negatives mounted in the negative carrier of an 8×10 enlarger. Such "supersize" prints allow easier evaluation. Note that the printer is wearing gloves to avoid leaving fingerprints on negatives and sensitized material. In the background, a dry print is emerging from the lab's automatic processing machine for Ektacolor 74 paper.

☐ When shooting in poor light, increased film speed may be a reasonable tradeoff with decreased quality if there is no other way to take a picture.

☐ Pull processing (where ISO speed is decreased) lowers image contrast, sometimes useful when shooting under harsh lighting conditions.

☐ A photographer may be stuck with film that's too fast or too slow for prevailing light conditions.

Kodak endorses a one f-stop push for E-6 (and even offers a special "ESP-1" processing mailer for the purpose), but warns that further pushing will result in serious quality loss. A two-stop push is accompanied by greatly increased grain and contrast, a green color cast, and blacks that come out gray. A three-stop push is strictly an emergency expedient. Ektachrome 160 Tungsten seems to suffer more than daylight-balanced E-6 films. Custom labs will push film as far as a customer asks—with the proviso that they are not responsible for the results.

E-6 films from other manufacturers have mixed reactions to pushing. 3M's 640T allows a one-stop push, while any attempt to push Fujichrome E-6 films results in unacceptable quality loss.

Color films are "pulled" less often than they are pushed, but sometimes film is inadvertently overexposed or ambient light is too bright for correct exposure. Modified processing can drop speed by up to one f-stop, with an attendant decrease in image contrast.

While E-6 films are routinely pushed and pulled, C-41 color negative processing is another matter. While some custom labs are willing to try a one-stop push if the customer will tolerate some quality loss, most labs regard C-41 films as unpushable due to serious color crossover. Some color technicians questioned point out that the exposure latitude of Kodacolor 400 is so great that two-stop underexposure will still produce printable negatives. Attendant quality loss from underexposure is about equal to quality losses from push processing.

Pushing Kodachrome. Kodachrome 25 and 64 must be processed by Kodak or a few independent labs, but these high-quality emulsions can also be push processed. Three services are available.

☐ Underexposed Kodachrome sent to Kodak processing labs with *specific* exposure information and a written request for special processing (including acceptance of responsibility for results) will receive a modified processing run. A surcharge of $36 is added (as of this writing), plus the regular per-roll processing charge. Different underexposures require different processing and cost another $36. Up to one-stop underexposure is not regarded as requiring special processing, two-stop underexposure is specially processed, and pushing to higher speeds is discouraged.

☐ Dynacolor Labs (Los Angeles, CA) offers up to five-stop push and one-stop pull processing of Kodachrome, though both Kodachrome 25 and 64 show quality loss

beyond a two-stop push. As of this writing, Dynacolor charges $12 extra per roll for this service.

☐ New York Color Works, Inc. (New York, NY) offers one-stop pull and three-stop push Kodachrome processing, plus 90-minute "clip test" processing (described below). As of this writing, price is $12 per roll.

The availability of modified processing has led some photographers to rely on it for processing custom-matched to their exposures via one of the following procedures.

Test roll. A careful exposure reading is taken and a "throw away" roll is shot at that exposure. The roll is kept separate from the rest of the film that is shot. All of the pictures are shot at the same exposure as the test roll, assuming that lighting conditions remain constant. The test roll is processed first. If the resulting transparencies indicate that the exposure was off, the rest of the film is pushed or pulled accordingly.

Clip test. All the film is given the same exposure and the lab is instructed to clip off the first six frames of a roll for test processing. Depending on results, modified processing is used for the rest of the film if necessary.

Split holder. This method is used for sheet-film applications. Both sides of a film holder are given the same exposure. One is processed first as a guide to processing for the second sheet.

Except for Kodachrome and Agfachrome, customers have the choice of having their film processed either by a manufacturer's or a local lab. Each has advantages and disadvantages. With E-6 and C-41 processing, local labs offer speed. Film dropped off first thing in the morning can often be processed by lunchtime. Many processing modifications are available. Film sent off to Kodak usually takes at least two days. Push-processing options are minimal.

The other side of the story is that even the most meticulous color lab can occasionally foul up a processing run. While manufacturers' labs make mistakes too, the huge volume of work they handle lessens the odds of any one customer's film being ruined by processing errors.

Therefore, if speed or special processing is important, opt for a local (preferably familiar) lab with the understanding that processing errors may occur. Labs routinely refuse to accept responsibility for film processing beyond replacement with fresh, unexposed film if a mishap occurs. If neither time nor special processing is a significant factor, manufacturer processing probably offers more reliable service.

SLIDES FROM MOVIE NEGATIVES
Some mail-order color labs offer package deals including a roll of ISO 100/21° color negative film, processing, and a set of slides made from the negatives. Prices are well below comparable Kodak service of slides from color negatives. Some labs charge only mailing costs for

A nun crocheting in the morning sun in Lisdoonvarna, Ireland called for a ''standard'' sunlight exposure of 1/250 sec. at f/8 on Kodachrome 64, using a 300mm lens to avoid disturbing the subject.

Sometimes a picture is nothing
but bright color. This picture of
Indian corn was purposely shot as
an extreme closeup, concen-
trating on color and texture. Film
was Kodachrome 64, used with a
"macro" 55mm closeup lens.

an introductory roll and include a fresh roll with each completed order. The film is claimed to be usable under both daylight and incandescent light without filtration. Two-stop film speed pushing is also offered. This mystery film is Kodak's 5247 color negative film, intended for motion picture use.

Since most movie productions leave unused film stock, specialized labs buy up 5247 for sale to still photographers. Unfortunately, some of its characteristics may not appeal to these customers.

☐ 5247 is balanced for 3200 K illumination and has wider variations between emulsion batches than still-camera films. Cinematographers routinely buy film for a production in a single emulsion number and test it carefully. A still photographer might wind up with several rolls for 5247, each of a different emulsion number with noticeably different color characteristics.

☐ Since motion pictures are all shot at 1/50 sec., 5247 gives its best performance at this exposure. Deviations may run into reciprocity failure.

☐ Only labs that sell 5247 will process it. While they will print the negatives, Kodak labs will not. Mail-order and "drug store" printers may accept them, but results are seldom good. The 5247 negatives do not have frame numbers, and so similar negatives may be difficult to distinguish and designate for printing.

This 5247 is a good film, with excellent push-processing capabilities (it will go up to ISO 400/27° with results comparing favorably with Ektachrome 400), but the difficulty of printing makes it of questionable benefit to color print shooters who do not do their own darkroom work. Color slide photographers will gain few advantages over more common films with local processing. Whatever price saving the film offer is off-set by the inconvenience of returning the film to a specialized lab.

EVALUATING A COLOR LAB

Before entrusting work to any color lab, comparison testing is indicated. Here are some areas to check.

☐ Don't go by the samples of finished prints that most labs display. No lab owner shows bad samples. Look for capabilities that fill your particular needs.

☐ Check out film processing. One of the most crucial aspects is cleanliness. Processing errors resulting in off-color pictures may be correctable in printing or duplication, but negatives and slides with dried-in dirt from unclean processing solutions are irretrievably ruined.

Take a roll each of color slide and color negative film. Pull the film out of the cassette, completely fogging it. Then rewind the film and have the lab process it. A black roll of negative film and a clear roll of slide film will be the result. Slide the processed film between two fingers, feeling for any roughness. One spot of dirt often indicates the presence of others. Avoid labs with dirty processing; they're probably sloppy in other ways as well.

☐ Send identical negatives or slides to different labs for comparison prints. How do the prints compare with each other? With the original subject? Look at the gray areas in particular. If color printing filtration or the processing chemicals impart some color of their own, it will show up most readily here.

☐ The Macbeth Color Checker (Kollmorgen Corp., Hollywood, CA) is handy for evaluation of print and slide processing. It is a 35mm-proportioned color chart that includes a scale of gray tones. Shoot a picture of this chart (being careful to match film color balance and lighting color temperature) and have it processed. The original chart is a standard for instant comparison.

How amenable is the lab to redoing the print, at no additional expense, until it comes up to standard? The better labs will do so willingly and, assuming that requested changes are reasonable and correctly explained, they should get things right the second time around. If the second print is just as bad, or wrong in some other way, try another lab. Everyone makes mistakes; the best people correct them.

When dealing with a mail-order lab, the order will have to be mailed in with reprinting instructions. With a local lab, reprinting requests must be explained to counter personnel. Either way, before requesting print quality changes it's important to understand what to ask for and how.

Logical Printing Instructions. The most obvious characteristic of a print is its color balance. Does it match the subject, or the slide that was printed? Is there a tinge of unwanted color present? This can happen with the best labs. Precise color rendition is a matter of the personal taste of the printer as much as one of scientific precision. But if the results don't look right to you, the error must be explained in technically meaningful language before a change can be made in the darkroom.

Correction for a color cast in a print can be determined by inspecting the print through a filter of the opposite color in a variety of densities to get an idea of what that print will look like if the color cast is lessened. Correction for the lack of an overall color can be determined by inspecting the prints through a filter of the desired color.

This isn't as complicated as it sounds. Most color labs have a Kodak Color Print Viewing Filter Kit available. It consists of six sets of filters, one for each of the six primary/secondary colors. Each set consists of a card with cutouts for filters in densities of 10, 20, and 40. Inspecting a print or slide through the appropriate filter will quickly indicate just what corrective filtration is necessary. The kit is inexpensive and is also helpful for evaluating Polacolor test prints when checking fluorescent lights.

If the print looks too blue, for example, it should be inspected through different densities of yellow, the opposite color to blue, until a density that just cancels out the blue color cast is found. If a CC 20 yellow filtration

does the job, the lab would be instructed to add CC 20 yellow or subtract CC 20 blue. It's actually enough just to say that the print has a CC 20 blue excess and let the lab correct it any way they choose. Color corrections for slide duplicates can be handled in the same way.

Checking Density. Now look at how dark or light the print looks. This is an evaluation of density. Density corrections should be requested in terms of *f*-stops: To order a print to be remade twice as dark, ask for a one-stop density increase. For a print twice as light, ask for a one-stop density decrease. Half- or quarter-stop increases or decreases (or more than one stop) can also be requested. This is not the same as asking for an *exposure* increase or decrease. Positive-to-negative and positive-to-positive print processes work in opposite ways—one uses more exposure to darken a print, the other uses less. It's easier to explain the density desired than to tell the printer how to do the job.

Check out these other print attributes.

☐ Was the enlarger correctly focused? (Look for sharp reproduction of grain.)

☐ Were any specks from emulsion dirt correctly spotted out with colored dyes? Some labs offer "economy" grade processing that leaves the spotting to the customer. Others just don't bother to spot.

☐ Are borders even and neat? Remember that full-negative prints from 35mm frames don't fit the proportions of 8 x 10 paper. Most custom labs will center the image, leaving two wide borders on the long dimensions of the image.

☐ If cropping was requested, was it done correctly? Did the lab ignore instructions, or weren't they given accurately?

REASONABLE EXPECTATIONS

The best labs can't get good results from bad originals, just as they can't do good work without correct instructions. The sloppier photographers are about shooting pictures, the more work will be left in the hands of the lab. The moral is simple: Carelessness costs money. Bad negatives and slides require more expensive processing than good ones. It's no secret that good prints depend on shooting good negatives or slides.

Don't take some manufacturers' claims too seriously. One of the classics is that color negative film can be shot anywhere, without compensatory filtration, and corrections can be made when the negatives are printed. While acceptable results may be obtained from carelessly shot color negatives, correctly filtered film gives the best results. It's as simple as that. All those filtration recommendations are there for a good reason.

Minor mistakes can often be compensated for in printing, such as "warming up" the color balance of a print or slide. But other filtration problems can't be repaired in the darkroom. Take the omission of the use of a polarizer in photographing a tan house against a blue sky. Without a polarizer, spectral reflections would give a cool result. A polarizer might decrease those reflections, resulting in improved color saturation. Attempting to improve the colors of the non-polarized negative in the darkroom by adding warm filtration to the print would distort the other colors, giving highlights a reddish hue. This lack of a polarizer could never be compensated for in the laboratory.

Similar problems arise when attempting to use filters to improve pictures taken under misty or foggy conditions that obscure the subject. Filters cannot add color. If there's no color in a subject to begin with, a filter can't put it there.

Another misconception about color correction is that the strong presence of one color can be canceled out by an equal addition of the opposite. In other words, a heavy green cast from unfiltered fluorescent lights could be "cleaned up" by a similar dose of magenta. Such heavy color juxtapositions will indeed cancel each other out, but their density will remain. The result is dull, degraded image quality.

Another example of color failure occurs when daylight color negative film is shot under household tungsten illumination. Since this light contains far less blue than daylight, the film's red-sensitive layer will predominate so strongly in the processed negative that no amount of blue filtration in printing can overcome it, because the blue-sensitive film layer received virtually no exposure at all. Attempts at darkroom filtering result in a dull pink rendition.

An exception to this rule is Kodacolor 400. Aside from the usual three color-sensitive emulsions, Kodacolor 400 has two special layers, one red-sensitive, the other green-sensitive. When the red-sensitive layer is excited by the red in tungsten light, it produces additional cyan dye in processing. The green-sensitive layer responds to the excess green from unfiltered fluorescent lights, producing extra magenta dye in processing. The result is a film with two "insurance" emulsion layers intended for two common mistakes photographers make—shooting under tungsten or fluorescent lights without correct filtration.

WHAT THE LABS SEE

Color labs are very knowledgeable about what mistakes photographers commit most often. Here are some of the big losers:

Unsharpness. Labs see a lot of careless focusing. When people start ordering big prints, the results can be disastrous. The image of a 35mm frame through the finder of a 35mm SLR is only equivalent to a 5 x 7 print. Just because it looks sharp to casual viewfinder inspection doesn't mean that the image is sharp enough for crisp results in a big print or on a projection screen. Practice focusing. If the camera accepts interchangeable focusing screens, test them all under shooting conditions. Choose the screen that gives the sharpest pictures with the least effort. While many photographic mistakes can

Colors can be worth arranging if you have the opportunity. A rainy day was just right for photographing these bright orange pumpkins in Boston's Dock Square, but a human subject was needed to give the picture some scale. After a cooperative passerby in an appropriate yellow raincoat was posed in the middle of the pumpkin display, the shot was taken from an overhead fire escape with a 135mm lens on high-speed color film.

THE HANDBOOK OF COLOR PHOTOGRAPHY

be corrected at later dates, a fuzzy picture will never be sharp.

Not shooting close enough. Many photographers suffer from a form of tunnel vision: They look only in the middle of their viewfinders and don't make full use of the image area, packing it with unimportant details right to the edges. Labs are often requested to "blow up the image," cropping out the edges of the frame. The result is graininess and lack of sharpness. The more an image is magnified, the more quality is lost.

Fast film used unnecessarily. Many photographers are lazy: They'd rather shoot fast color film with its attendant higher shutter speeds and smaller *f*-stops than work with slower, harder-to-use emulsions. The trouble is that quality goes down as ISO speed goes up. Professionals always use the slowest color film they can in a given shooting situation. They know that the better the quality of a color image, the more money it's likely to earn.

Bad exposure. Photographers trust TTL meters too much, particularly the fully automatic variety found on an increasing number of 35mm SLRs. These reflected-light meters have extremely limited capabilities. Back-lighting, extralight, and extradark subjects fool them. Worse yet, many such errors are on the underexposure side. Underexposed color negatives will never produce good prints. With color slides, exposure tolerance is less than one *f*-stop.

Forgetting to set the correct *f*-stop on automatic-exposure flash units also contributes to many underexposures. So does forgetting to reset meter or camera ISO speeds when switching films.

LIVING WITH A LAB

Color labs are becoming an integral part of color photography. Many successful professionals admit that they'd be lost without the support and objective criticism of their labs. Unfortunately, much of the time, money, and expertise of color labs goes into undoing customers' mistakes. The better a photographer's technique, the better the results that can be expected from a lab. This is a strong argument for dealing with a local, walk-in lab, even if it is more expensive than a mail-order outfit: The criticism and support resulting from such an ongoing relationship can result in better pictures and the pleasure of sharing successes with a sophisticated audience.

Opposite page, top: Two uniformed junior high school students in Portree, Scotland were photographed without filtration on Ektachrome 200 with a 21mm lens. Illumination came from windows on both sides of the classroom. Since the girls' faces were right in the middle of the picture, the center-weighted TTL meter of a Nikon F3 read a correct exposure without compensation.

Bottom: People seldom face bright sun if they can help it, and these girls on their way to school in Willemstad, Curaçao were no exception. Fortunately, the bright yellow wall and their cool-colored dresses formed an effective composition, even though their faces were in shadow.

CHAPTER EIGHT
SLIDE DUPLICATION AND IMAGE PRESERVATION

Duplication can't cure extreme color casts. The overall green of this computer room scene was due to the use of unfiltered daylight color film *(top)*. Compensatory filtering of a dupe slide eliminated most of the green but not its density *(above)*. The result is dull color. Selective color bleaching would have been a better choice.

Opposite page: Slight underexposure can often be cured by duping. This aerial Kodachrome of California's Sacramento River Delta turned out to be about two-thirds *f*-stop underexposed. By duplication with the necessary exposure increase on Ektachrome SO 366, a correctly exposed slide results.

While thousands of slides are duplicated every day by custom color labs, the procedure was only touched on in chapter 7 because "duping" can also be done at home, using simple equipment. Duping doesn't just provide extra slides; it offers a chance to improve many poor-quality pictures. Corrective duping can result in slides that are superior to the originals.

☐ Minor underexposure (about 1 to 1½ *f*-stops) can often be corrected.
☐ Minor color inaccuracies can be corrected with appropriate filters.
☐ By copying on different films, such as Ektachrome Infrared, original color rendition can be completely altered.
☐ Slide images can be cropped.

DUPLICATION AND CONTRAST

Slide duplicating is essentially straightforward. The original is photographed on transparency film. While precise duplicates are rare, most come close enough to the original to be acceptable. This is the "reproduction quality duplicate," or "repro dupe" that is churned out by most commercial labs.

Low-volume standardized duping is best left to professionals. Most color labs (including Kodak) produce acceptable dupes for under a dollar each (less in bulk quantities). Home duping is only worthwhile for customized or high-volume work.

The traditional bugbear in slide duping has been excess image contrast. Going from positive to negative, negative to positive, or positive to positive invariably produces a result with higher contrast than the original. To deal with this problem, Kodak's two 35mm duplicating films, SO-366 (for electronic flash) and 5071 (for 3200 K incandescents), are available. They make high-quality slide duping easy due to specially designed low contrast that keeps dupe quality close to original quality. E-6 processing-compatible, both films are available in 36-exposure cassettes and long rolls.

DUPLICATING EQUIPMENT

While simply photographing a slide sounds easy, successful slide duplication still has its problems.

Most camera lenses run into optical problems when same-size dupes (or 1:1 magnification ratio) are made, since distance from the subject to the front of the lens is less than distance from the back of the lens to the film. To deal with this problem, some lens manufacturers supply "reverse adapters," allowing lenses to be mounted backward. A better idea is a lens designed for close-up work. There are many specially designed "macro" lenses available, but an enlarging lens is just as good and cheaper.

Both Kodak duplicating films vary greatly in rendition from one emulsion batch to another, and different originals often need customized filtration as well. Since heavy filter packs are routinely used, flexible filter capability is essential.

Slides can be duplicated with an inexpensive tubular copier like the Ohnar *(right)* that features variable magnification, or with expensive "dupers" like the Bowens Illumitran *(below)*. However, assuming that Ektachrome duplicating film is used in both cases and illumination is correctly filtered, results should be comparable. Expensive duplication setups are just more convenient.

Effective slide duplication requires equipment capable of measurable, repeatable results.

Slide duplicating equipment can be simple or complicated. While the expensive "dupers" are easier to use, all of the following can produce comparable results at cheaper prices.

Tubular copier. Mounting like interchangeable lenses, these are available from many manufacturers. A built-in lens with a fixed *f*-stop forms the image. In the front is a slip-in mount to hold a 35mm slide. The light source is provided by the photographer. TTL meter systems make accurate exposure easy, but a controllable light source may be a problem. These copiers are available in fixed-focus versions, allowing only a 1:1 dupe, and variable-focus models that allow some cropping. For occasional simple duping, an inexpensive tubular copier is all most photographers need.

Bellows slide copier. More expensive than tubular copiers, this device actually offers few advantages. Many interchangeable-lens 35mm SLRs offer a close-up bellows as an accessory; the slide copier attaches to it. The copier consists of a second bellows, fitting over the lens to hold a slide in copying position. Slide-to-lens and lens-to-film distances are adjustable, making cropping easy. Light source is still supplied by the photographer, as with the tubular copier.

Light box illuminator. The Kingdon/Testrite SC Illuminated Slide Copier (Testrite Instrument Co., Newark, NJ) and the Multiblitz Color Dia-Duplicator (HP Marketing Co., Cedar Grove, NJ) are examples of controllable duping light sources.

The Testrite is basically a metal box topped by a slide mounting stage. Inside is a 3200 K incandescent bulb for making exposures. There's also a mounting for a small electronic flash unit. The Multiblitz Dia-Duplicator combines 3200 K incandescent and electronic flash light sources, allowing the use of either at the touch of a switch. Both units can be used for illuminating tubular and bellows slide copiers by removing their slide stages.

An alternative light source for tubular and bellows slide copiers is the dichroic head of a color enlarger. Removed from its chassis and placed upside down, it becomes a convenient light source with continuously adjustable filtration. Just mount the slide copier above the head's illuminating area.

Special slide copier. Designed for mass production, these expensive devices make duping easy. They consist of a light source and a vertically mounted camera/bellows assembly.

The Bowens Illumitran (Bogen Photo Corp., Englewood, NJ) uses variable-intensity electronic flash illumination, handling exposure control with a photoelectric cell that meters the density of the original. Two configurations are available, the Model 3 and the Model 3C. The 3C differs from the 3 in offering contrast control via an angled glass plate reflecting illumination of a

Slide cropping is often done in duplication. This comfortable-looking seal was originally only a small section of a Kodachrome. By duping and blowing up just that part of the image on Ektachrome SO 366, a tightly composed portrait results.

Duplication of delicate tones like the mist in this telephoto shot in New Hampshire's White Mountains can be difficult without special dupe films or a contrast control duplicator like the Illumitran 3C. When taking such pictures, it's wise to shoot extra slides. It's a rare dupe that can equal such an original.

THE HANDBOOK OF COLOR PHOTOGRAPHY

supplementary flash unit to reduce contrast of the original, allowing low-contrast dupes to be made on regular color films. Since present low-contrast duping films are available only in 35mm, this feature allows low-contrast dupes on formats larger than 35mm. Similar contrast control is available for a higher price on the Matrix Reprobox (Karl Heitz Inc., New York, NY), using a fibre optic. The Reprobox lacks the Illumitran's adjustable exposure control. The Reprobox 2 (Leedal, Inc., Chicago, IL) offers electronic flash illumination similar to the Illumitran without exposure or contrast control. It is intended for use with SO-366 duplicating film.

The Sickles Chromapro (Mangum Sickles Industries, Inc., Tempe, AZ) utilizes 5071 incandescent-light duplicating film. The Chromapro incorporates continuously adjustable dichroic filtration similar to that of a color enlarger.

Copiers without the Chromapro's built-in color control require the use of separate filters, usually mounted below the slide. Such positioning does not interfere with lens sharpness and allows using inexpensive acetate filters, available from Kodak (as Color Printing, or CP filters) and several enlarger manufacturers in a range of yellow, magenta, and cyan densities.

For really unusual effects, try using an electronic flash slide copier with Ektachrome Infrared for a duping film. Color rendition can shift from red/magenta, green/white by the use of an infrared cutoff filter such as the #HA 11 filter from Fish-Schurman Corp. (New Rochelle, NY). A Wratten #11 deep yellow filter will give further color variations.

While testing will be necessary before color effects and standardized exposures are arrived at, an attractive aspect of infrared slide duplicating is that a given slide copier will produce predictable results once its exposure characteristics are determined.

DUPLICATION LIMITATIONS

Duplication gives considerable technical and creative control, but it has its limitations. Duplication does not offer the manipulation available in color printing and is often a partial solution rather than a real cure for many color problems. Overexposed slides with washed-out color, for example, cannot be saved by duplication, though overexposed color *negatives* can often be printed successfully. Duplication cannot remove heavy color casts without degrading the overall image (see chapter 7).

An alternative to slide duplication is color bleaching of the original, allowing chemical reduction of each dye layer or simultaneous reduction of all three. Color casts can be removed and underexposure up to about 1½ f-stops can be cured. The following bleaches are all recommended for use with E-6 films, though they will also work with Kodachrome.

☐ Colorbrite Reducers (Special Products Lab, Chicago, IL) are available for bleaching yellow, magenta, or cyan dye layers, plus an overall reducer for general un-

derexposure. A chemical regenerator is also available to restore up to 90 percent of the original color in case of inadvertent overbleaching.

☐ Similar in application are the Sav-A-Chrome reducers (Sav-A-Tran, New Orleans, LA).

☐ The Pebeo Retouching System is imported by Calumet Photographic (Bensenville, IL). Three selective color reducers plus one overall are available for both color slides and color prints.

Color bleaches should be used carefully. Since slides must be bleached while wet, and wet Ektachrome is semiopaque, judging the extent of bleaching requires experience. While instructions specify bleaching times depending on the effect desired, solutions often become diluted during use, making such times inapplicable. Wet film is also extremely vulnerable to abrasion and should be handled with care.

Color bleaches work directly on complementary colors, but they can be used to reduce primary color casts by treatment in two separate bleaches. To reduce a red color cast, bleach in magenta and yellow; to reduce a green color cast, bleach in cyan and yellow; to reduce a blue cast, bleach in cyan and magenta.

Careful use of color reducers allows controls unavailable in duplication. While a heavy color cast cannot be effectively filtered out of a slide in duping, for example, the density of the undesired color can be physically reduced by bleaching. Since inexpert bleaching can result in the loss of a color slide, however, it's wise to bleach only duplicate slides, saving the original for extra copies if necessary.

COLOR IMAGE PERMANENCE

All color film and print materials routinely carry the warning that image-forming dyes may deteriorate with time and that the manufacturer is not responsible for the consequences of such deterioration. Since dyes don't deteriorate evenly (cyan fades first, then yellow, and finally magenta), the result is color changes in the original, followed eventually by the complete loss of the image.

This impermanence has become particularly significant due to the growth of photo galleries and museums handling fine-art color photographs. With acquisition prices climbing into four and five figures, purchasers understandably want lasting images for their money. Unfortunately, compared to black-and-white photographs (which can last for centuries), color images are so delicate that everyday environmental components can destroy them in a surprisingly short time.

The worst enemy of color dye images is ultraviolet light (UV), particularly that found in sunlight. Color prints displayed in sunlit areas will fade noticeably in a few months or less. A high UV content is also present in fluorescent lights illuminating millions of rooms. Color prints should be displayed as little as possible and illuminated by incandescent light when they are.

Opposite page: This Ektachrome slide of a U.S. congressman in his office could be difficult to duplicate. The deep shadow under the table and the dim rendition of the figure at the left could result in serious detail loss unless the dupe film contrast is kept extremely low. For this picture, Ektachrome SO 366 *plus* the contrast control of an Illumitran 3C duplicator were used.

Above: Boston professional photographer Steve Grohe stores sealed boxes of sheet color film in his crowded studio refrigerator. If film is to be kept for long periods, it's a good idea to freeze it. Frozen film will keep almost indefinitely.

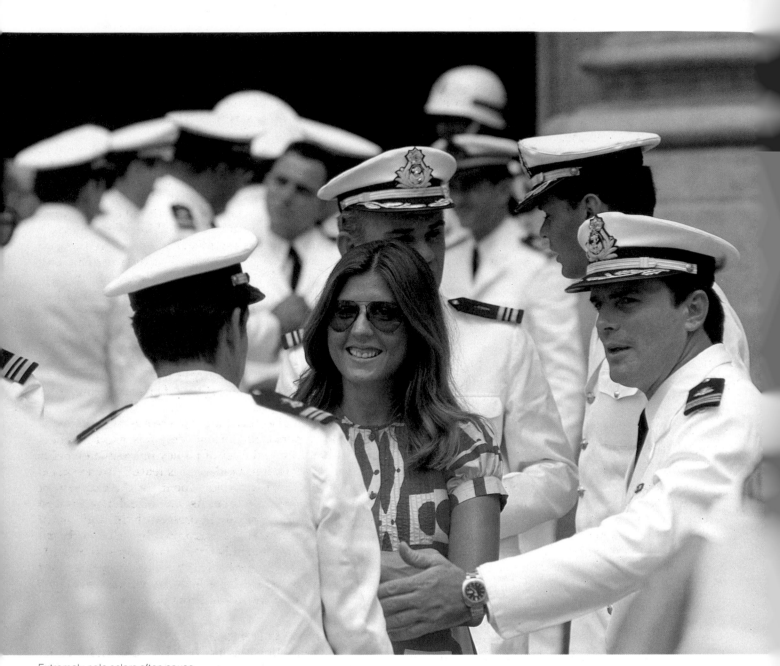

Extremely pale colors often cause problems in duplication. They frequently reproduce as gray or pale cyan. The original quality of this Kodachrome of Brazilian navy officers in Rio de Janeiro would be almost impossible to maintain in a dupe.

Heat and humidity also damage color images. Above 60 percent relative humidity and 75 F, dyes deteriorate seriously. To give some idea of how much difference heat and humidity make in the stability of color images, Kodak claims that storage in darkness at 45 F with 40 percent relative humidity will extend the life of color images ten times, while storage under these conditions below 14 F will extend their life a hundred times.

Achieving such storage conditions is easier than it may seem. Frost-free refrigerators, common in many homes, will supply low temperature and low humidity. For physical protection plus dark storage, special Kodak Storage Envelopes (catalog # 148-6398) are available in 4 x 5 and 8 x 10 sizes.

Ironically, most effective methods for preserving color images require keeping them hidden away in dark, cool, low-humidity environments. While this unfortunate shortcoming is necessary for maintaining quality, here is a list of expedients for keeping color images both safe and accessible.

Project duplicate slides. The heat of slide projectors fades dye images quickly. Keeping originals in dark storage and projecting duplicates will safeguard the originals' color and contribute to their physical safety as well. While Kodachrome outlasts Ektachrome for storage longevity, exactly the opposite is true for ability to tolerate slide projector heat.

Make two or more of everything. Some photographers who sell color prints for display purposes include a second print in the sale price. The first print is displayed while the other is kept in approved dark storage. From time to time, the two prints are compared. When fading of the display print becomes apparent, a new one is ordered.

Convert to black-and-white separations. It costs about $50 per picture as of this writing to have a color image broken up into a trio of black-and-white separations. These stable silver images can be converted back into a color image at a later date.

Investigate color restoration. A complex, expensive procedure is currently being researched by Kodak to restore faded color transparencies using a tricolor duplication technique. The degree of fading in each dye layer is scientifically determined and a suitably color image mask is created to restore original color density. PEC LaserColor Laboratories (West Palm Beach, FL) are investigating the possibility of computer-controlled color restoration using laser beams.

DIFFERENT PROCESSES, DIFFERENT STABILITIES

As far as image stability is concerned, all color photographic processes are not created equal. Some last longer than others.

At the top of the list is the carbro print. Using pigments instead of dyes, such prints last almost indefinitely. Drawbacks are extremely high prices (around $700 for an 8 x 10 as of this writing) and the fact that only one lab (Stewart Color Labs, New York, NY) currently produces carbros.

Cibachrome incorporates extremely stable dyes, with Dye Transfer running a close second, because neither of these processes uses what are called *chromogenic* dyes to form an image.

Print processes like Ektacolor 74 and Ektachrome 14 do not incorporate dyes in their emulsions. They incorporate color couplers that produce so-called chromogenic dyes in processing, dyes that don't have the stability of those used in Cibachrome and Dye Transfer. Cibachrome dyes are incorporated into the material's three emulsion layers and bleached out where they are not needed to form an image. The dyes used in Dye Transfer are added late in the process. Such nonchromogenic dyes outlast those in Ektacolor and Ektachrome images.

Among color films, the longevity winner is Kodachrome, with a claimed image life of one hundred years under proper storage conditions. While E-6 Ektachromes clock in at about fifty years, Kodak claims only a ten-year life for color negative films and prints (plus Ektachrome 14 paper).

How much does this matter to the average photographer? It's a personal decision. Very few photographers are willing to spend a lot of money or trouble on color image preservation, and sophisticated preservation may not be worth worrying about for the majority of pictures most people take. As long as color prints and slides are kept out of sun, fluorescent light, and humid cellars, further preservation probably isn't worth the trouble. Preservation only becomes a more serious matter when a lot of money is involved. Some portrait and school photographers have lost enough business to go bankrupt after color print-fading fiascoes.

TAKING CARE OF COLOR FILM

Image preservation may not be a big concern for many photographers, but taking care of film, before and after exposure, is one of the elementary precautions every color photographer should practice. Aside from the postprocessing problems already described, there are four areas where color film abuse invites trouble:

Before the factory-sealed package is opened. The package is proof against high humidity, but heat can do serious damage all the same. The classic trouble spot is the glove compartment of a car on a hot day. Temperature in this mini-oven can easily hit 160 F, resulting in more damage than letting film run months over the expiration date. The same goes for the trunk of a car. When traveling under hot and/or humid conditions, keep film in a Styrofoam-insulated picnic chest on the floor of a car's back seat, away from the hot exhaust pipe. If this case is filled in the early morning, it will stay reasonably cool during the day, as long as it isn't opened in the blazing sun. If very hot weather is anticipated, dry ice

Once color film is removed from sealed manufacturer packaging, it cannot be safely refrigerated unless it is sealed in a plastic bag along with a dehumidifying agent. The moisture in many refrigerators can seriously damage film.

or sealed refreezable ice packs should help keep the chest cool. Avoid regular ice; it will increase humidity inside the chest.

If factory-sealed, unexposed film is to be stored for any length of time, it's wise to freeze it. Film stored at 0 degrees will keep almost indefinitely, but it must be thawed carefully before use. Cold film is stiff and brittle, and moisture in the air will condense on the color film, softening the emulsion, hastening its deterioration, and possibly causing a slight fog. Kodak recommends giving 35mm films one hour to warm up 20 F from a colder temperature, 1½ hours to rise 75 F.

When the package has been opened but the film is still unexposed. The moment real-world air with its potential humidity touches film, troubles increase. Since humidity is a deadly enemy of color film, unseal *only* as much film as will be used at any one time, exposing and processing as soon as possible.

Don't put color film back into a refrigerator after its seal has been broken (unless it's a frost-free type); humidity will damage the emulsion. When stuck with unsealed, unexposed film that must be stored (such as an opened box of sheet film), seal it into a plastic bag along with a dehumidifying agent (or *desiccant*) such as silica gel, available in bulk from a number of chemical supply companies. Try the Davison Silica Gel Air Dryers (from Davison Chemical Division, W. R. Grace and Co., Baltimore, MD). Containing 1½ ounces of silica gel, these small metal devices can be reactivated according to instructions by heating them in an oven after they have absorbed their fill of moisture (at which point the pink filling turns blue). Use one ounce for 20 rolls of 35mm film for a two-week period (assuming that there is not a lot of extra air in the sealed bag) and five ounces for two weeks for 20 rolls of 120 color film.

After the film is exposed but before it is processed. Latent image decay, the degradation of an exposed but unprocessed color film image, now becomes a problem. Exposed, unprocessed film is far more vulnerable to such deterioration than before it is exposed. Pictures taken at the end of a long trip may be of better quality than ones taken at the beginning. Due to latent image decay, the earlier pictures had more time for color to become degraded. Professionals who travel a lot either store exposed film with a desiccant in a sealed bag or air-freight the bag to a color lab for immediate processing.

During processing. Color processing can have a far-reaching effect on how quality will stand up over the years. Manufacturer processing is the wisest idea, but it's not always possible. When choosing a local lab, try out a couple of them and see how results compare. Run some simple tests of a color chart like the Macbeth Color Checker, shot on different rolls of the same film (be sure they're all the same emulsion number). Send a roll to each lab and compare the results. The color variations may be surprising. Compare them to the color

chart. Whose processing comes closest to the original color? The closest color reproduction indicates a lab that maintains its processing solutions carefully. Such details can make the difference between a long-lived and a short-lived color image.

Processed slides can be sealed against fungus and routine abrasions by a process called Vacuumating (Vacuumate Corp., New York, NY). The per-slide price is low (even less in bulk), and resulting transparencies should be proof against at least some of the dangers of humidity. An alternative is Edwal Perma-Film (Edwal Scientific Products Corp., Chicago, IL). Edwal also makes a useful liquid called No-Scratch. Brushed over a slide or negative, No-Scratch has the same refractive index as the film itself, hiding base-side scratches. A scratched original slide treated with No-Scratch can result in an unscratched dupe.

Flexible plastic file pages are a convenient way to store color slides, but all but one brand of these files are made of PVC (polyvinylchloride), which can damage slides. The only exception is the #8400 polyethyline file pages from RNI Photo Marketing. (Ocala, FL). Light Impressions Corp. (Rochester, NY) manufactures similar pages. Alternatives include the rigid plastic VPD Slide-Sho (Joshua Meier Corp., No. Bergen, NJ), Franklin Safe-T-Stor pages (Franklin Dist., Denville, NJ), and the cardboard Vue-File (Vue-File Corp., Franklin, OH). Since none of these storage pages protects the front of the slides, individual Kimac (The Kimac Co., Guilford, CT) or Franklin X-22 (Franklin Dist., above) slide sleeves should be used.

Cold-Weather Photography. While new camera designs and improved lubricants have resulted in greatly improved cold-weather camera performance, film remains the most cold-vulnerable photographic component.

The most serious cold-weather film problem is static electricity marks, particularly on 35mm film. The plush lip on the film cassette is the problem area: As film rubs against it, static electricity is produced. Since dry winter air is a poor electrical conductor, the static cannot dissipate. Having nowhere else to go, it winds up on the film as photographically recorded arcs of blue light resembling lightning flashes.

Static marks are most prevalent when film is too quickly advanced or rewound, particularly with motor drives and motor rewinds. The cure is simple. Wind and rewind film slowly and carefully when working under cold, low-humidity conditions. It's always that spectacular frame that winds up with a static mark right across it!

Cold, brittle film can also break if wound too fast, or when twisted too violently during camera loading. Make it a habit to keep film in a warm inside pocket where it will remain supple and easy to thread into a camera. Keep some extra camera batteries in that pocket. Batteries often die in cold weather (warming often rejuvenates them). Finally, cold film can be dam-

These jagged marks are static electricity flashes on a roll of film that was wound too quickly on a cold, dry day. Wind and rewind slowly in the winter, or marks like this may ruin your pictures.

Above: X-ray inspections of carry-on airline luggage are standard nowadays. Be careful not to let film pass through one of these machines because X-rays can fog film.

Opposite page, top: The sunset behind the Boston skyline was less than spectacular, so an orange filter intended for black-and-white photography was used to turn the bland color into a visual spectacular. The giveaway is the color of the fluorescent lights in the building windows. On un-filtered daylight Kodachrome, they would photograph green instead of yellow.

Opposite page, bottom: Twilight in Boston, reflected in the Charles River. Such a picture can only be shot during the relatively brief time when sky brightness silhou-ettes the buildings without over-whelming the lights in the windows. This picture was taken at 4:40 P.M. on a winter afternoon on Koda-chrome 25 with a 200mm lens.

aged by moisture if it is brought directly from the cold outdoors into a warm, moist interior.

Airport X-Ray Fogging. Almost every commercial airport in the world obliges passengers to pass their carry-on baggage through inspection machines that "see" inside. Security personnel are very reassuring when asked if these machines can damage film. Are these inspection machines safe?

The answer is probably not. Such machines all use X-rays, and X-rays are a known fogger of both color and black and white films. Dangers range from inconsequential to catastrophic, and high-speed films are more vulnerable to X-ray fogging than slower films.

Two different X-ray inspection machines are used: "high-dose" and "low-dose." U.S. and many other airports use low-dose machines. At their worst, low-dose machines can cause slight noticeable film fogging. At their best, they will cause almost no damage at all. This is because maintenance of inspection machines is done on a haphazard basis. Film might be run through a low-dose machine in such poor condition that its X-ray output will not cause noticeable film fogging. On the other hand, it might be a recently serviced machine that would definitely cause trouble. There's no guarantee.

While a single X-ray exposure may not cause visible damage to film, X-ray exposure is cumulative. This means that each successive exposure increases the chance that the *combined* exposures will result in visible damage.

X-ray fogging seldom results in total destruction of film images (except for high-dose machines, see below). There will often be only a bit of blue fog that might be passed off as improperly filtered atmospheric haze. The result is that much X-ray fogging is never recognized for what it is.

But even subtle fogging can cause unexpected trouble. The story is told of a travel slide lecturer/photographer who flew to Athens to supplement his inventory of pictures of the Parthenon. On the way home, his film ran afoul of an X-ray inspection machine. The resulting slides had a slightly different color cast to them, just enough to make them unusable side by side with his earlier Parthenon pictures. One trip wasted.

High-dose X-ray machines, on the other hand, will completely ruin film. These relatively rare devices are used by the following airlines: British Airways, Cathay Pacific, Philippine Airlines, and Singapore Airlines. They are also used in these countries: Great Britain, Hong Kong, Philippines, Singapore, Bahrain, and the USSR. Concorde transatlantic flights also use high-dose X-ray machines. They are occasionally used in Swiss airports. No law requires the dangers of these machines to be posted. The only way to protect film from the destructive output of high-doze X-ray machines is to be sure that no film passes through one. Horror stories have been told of photographers finding the outline of their camera-bag zippers photographically stenciled on their film by the blast of high-dose machines.

While high-dose machines should be avoided at all costs, it makes sense to avoid all X-ray inspection machines, be they high-dose or low. Explain to security personnel that luggage contains photographic film and request hand inspection. Most airport security checkpoints are willing to grant hand inspection, but they are under no obligation to do so. In many French and German airports, hand inspection is simply not given.

While laziness may play a part in some officials' refusal to grant hand inspections, another reason is money. All air tickets include an inspection fee based on the projected cost of hand inspection. But large-volume X-ray inspection machines speed up the process, allowing fewer security personnel and letting the airlines turn a profit on inspections. Asking for hand inspection means asking for your money's worth of inspection. Airlines would rather run baggage through X-ray machines and pocket the difference. It's not *their* film they may be ruining!

Airports equipped with high-dose inspection machines are usually willing to grant hand inspection, except for the USSR, where cooperation is uneven. Russia-bound travelers should check with their airline for special film safety instructions.

Is booked luggage X-rayed? Sometimes, sometimes not. Most booked luggage is X-rayed on a spot-check basis, though if there's been a recent hijacking scare, *all* the booked luggage may be X-rayed on any given flight. There is no guarantee that film will avoid X-rays if it's shipped in an airplane's cargo hold.

The easiest provision for film X-ray protection is to place film in X-ray–proof packaging. FilmShield bags (Sima Products Co., Chicago, IL) are specially designed for this task. Made of lead foil and barium with a white plastic covering, FilmShield bags protect film from low-dose X-ray machines. Sima also maintains worldwide files on X-ray inspection machines and can advise travelers with up-to-date information.

Canadian airports now use the lowest low-dose inspection machines anywhere. While these machines will probably cause no harm to film, the danger is stated in writing at the machines and hand inspections are routinely granted.

Don't take chances with X-ray fogging. It may not even be noticed, but when it is, the damage is already done.

Opposite page: These skydivers, 5,000 feet over Orange, Massachusetts, were photographed with a 16mm full-frame fisheye lens. The remote-control motorized camera was mounted on the wing of the plane, preset and prefocused to show both the exit door and the round target on the ground a mile below. The bright-colored jumpsuits contrast with the blue-green surroundings.

CHAPTER NINE
COLOR PHOTOGRAPHY TIPS

Above: The longer the lens being used to shoot a picture, the greater the chance of camera movement. For hand-held photographs, multiply the lens focal length by 2 to determine the minimum shutter speed for sharp pictures of nonmoving subjects.

Opposite page: Luggage being loaded into an old DC-3 on Roatan Island, Honduras, was shot at 7:00 A.M. with a 21mm lens. A problem with low-angle lighting is that the photographer cannot always avoid throwing a shadow onto the foreground of the picture — as was the case here.

☐ When metering sunsets with a TTL meter, open up one *f*-stop if the sun is fully visible above the horizon to avoid underexposure, especially with center-weighted meters.

☐ Save outdated or questionably stored color film for abstracts, sunsets, and other subjects where precise color rendition is not important.

☐ Try a roll of 35mm Kodak Photomicrography Color Film 2483. This film is slow (ISO 16/13°) and extremely contrasty. Its daylight color balance sometimes picks up a magenta color cast, and a CC 20 Green filter may improve results. For "snapping up" dull colors on a gray day, this can be a useful film. Like Ektachrome Infrared, the film is only available in an E-4 emulsion.

☐ Try shooting an extremely bright-colored subject (like a person in red clothing) on an extremely dull, gray day. While other colors will be muted, the bright color should look even brighter.

☐ A variation on this idea is to shoot vivid colors outdoors on Type B film. Backgrounds will come out deep blue, but bright colors will still shine.

☐ Too much color in a picture can be as bad as too little. Professional photographers' work often shows a relatively limited number of carefully chosen (or carefully controlled) colors. Such selections make the presence of each more meaningful.

☐ Be careful of metering exposure for shiny subjects (e.g., polished metal) with an incident-light meter. High reflectivity will result in overexposure. Try taking a reflected light reading and overexposing one or two *f*-stops.

☐ When illuminated by the "black lights" available in many hardware stores (such as General Electric's BLB), fluorescent minerals will glow with intriguing colors that make for interesting photographs. Use a 2B UV-absorbing filter and a solid tripod, and be prepared for some long exposures (15 *minutes* at *f*/16 with Ektachrome 64 film isn't unusual). Either daylight or tungsten film can be used.

☐ After using a filter, remember to take it off the lens. It's all too easy to forget that the filter is there, and it may not be appropriate for subsequent pictures.

☐ Autumn colors (and other varicolored subjects) can merge in the eye into a variety of additive color when photographed from a great distance, especially through haze. The result may be different from the colors that were actually present.

☐ When testing out a new purchase of film, don't use too fast or too slow a shutter speed. Stick to 1/30 or 1/60 sec. unless the film has specifically stated limitations. Most films actually give their best results at a specific exposure, and it's usually in this average-speed range.

☐ Check out lenses to see if their colors vary. Lay them out on a sheet of white paper for side-by-side inspection. If any lens has a notable color cast, it may be worthwhile to have a repair shop incorporate a CC gel filter inside the lens.

☐ Store filters in a dark case. They can be faded by ultraviolet light. Gels are particularly vulnerable.

☐ Placement of a thick glass filter can affect the focal length of a lens. In front of the lens, the filter shortens focal length slightly. In back of the lens (a common view-camera expedient), it increases focal length slightly. This distortion is the reason why some very long lenses focus past infinity.

☐ If glass filters are not mounted parallel to the lens, distortion will degrade sharpness. Such mounting can be due to careless "cross-threading" of filter mounts.

☐ Glass filters lose about 4 percent in light transmission due to surface reflections.

☐ Kodak labs have strict rules about processing nude photographs and other subjects that they consider "obscene." If subject matter is at all questionable, pictures will not be returned. Kodak's right to do so was upheld in a recent court case.

☐ While some color casts in slides can be cured in duplication, a permanently mounted compensating filter can also do the job. As long as the filter is mounted behind the slide, inexpensive acetate filters can be used. Investigate the wide variety of shades available as Bourges Color Sheets at commercial art-supply stores.

☐ Entire transparencies can be colored with transparent Webster Photo Colors (Webster Bros. Laboratory, Grayslake, IL).

☐ Transparent dye kits are available for hand-coloring transparencies. Gray skies can be turned blue and busy backgrounds can be subordinated. Experience is crucial here. Practice on dupes and rejects to get the hang of this painstaking procedure. Try Marshall's Photo Colors. Other kits are available from Berg Color-Tone, Inc. (East Amherst, NY) and Calumet Photographic (Bensenville, IL).

☐ The light from an entire window can be filtered with special roll-size filters available from Rosco Laboratories, Inc. (Port Chester, NY). These giant-size filters are available in various light balancing filter shades plus neutral density.

☐ Sharp pictures always look less grainy than unsharp ones because the viewer's eyes naturally seek out the sharpest detail. If the image is not sharp, the grain will get the most attention.

☐ For sharper hand-held shooting, try this formula. The slowest safe shutter speed (for nonmoving subjects) is *double* the focal length of the lens. For example, the slowest safe shutter speed for a 100mm lens would be $100 \times 2 = 200$, or 1/200 sec.

☐ If there are a few frames left on a roll of film, use them for experiments. Try mixing light sources, or a way-off exposure. More experimentation means more knowledge and more control over color photography.

☐ When "double shooting," with color in one camera body and black and white in the other, avoid inevitable exposure mistakes by using films with similar speeds.

☐ Color photography doesn't have to be done under ideal conditions. Lots of "photographically incorrect" situations can result in visually satisfying results. By itself, technical perfection is meaningless.

☐ When working under fluorescent lights that correct with a CC 30 Magenta filter, a #2½ Kodak Polycontrast black-and-white printing filter will give about the same filtration.

☐ People who wear glasses usually prefer to wear them when sitting for portraits, even though reflections from the glass are a problem for the photographer. Because of this, portrait photographers often carry eyeglass frames with no glass in them. This simple expedient can make portrait lighting much easier.

☐ Some women's liquid makeup gives the skin a glistening look that photographs badly (it also reflects ultraviolet). When shooting such portraits, request dull powder makeup.

☐ When photographing people around a campfire at night, the color of the fire can be changed with the chemicals listed, available from most chemical supply houses. Mix about two tablespoons into a cup of water (or about one pound per gallon) and soak some wood chips in the solution for about ten minutes. Let the chips dry. When the fire is burning brightly, add the chips and be prepared for a colorful result.

 Orange: calcium chloride
 Blue: copper chloride or barium nitrate
 Purple: potassium chloride
 Red: strontium nitrate
 Carmine: lithium chloride
 Emerald Green: copper sulfate

☐ Filters available only in gel form can be cemented between sheets of glass for durability. Tiffen Mfg. Co. (Hauppauge, NY) offers such a service.

☐ Certain TTL meters use polarization in their optical systems and thus cannot read exposures through polarizers. Among others, the Leicaflex has suffered from this problem. Its manufacturer supplies a specially designed double polarizer to allow the meter system to operate correctly when reading a polarized scene (expensive). A make-do solution involves taking a reflected-light reading through the polarizer with a hand-

held meter. Be careful to maintain identical filter axis orientation on the camera and in front of the meter.

☐ Another useful polarizer application is copying shiny oil paintings with polarized light. Use a pair of reflector lights oriented at 45 degrees to the camera, one on each side (making a 90-degree angle from the light source to the camera) and equipped with polarizing screens (big cardboard-mounted plastic polarizers, available at camera stores for about $15 each). Use a polarizer on the camera lens with the axis oriented at right angles to the axes of the polarizing screens on the lights. Surface reflections disappear and colors seem to jump right out.

☐ Many TTL meters won't give accurate filter density compensation if the meter's light-sensitive cell is insufficiently "tuned" to the color of the filter it's reading through. Very few meters have equal sensitivity to all colors, and when certain filters are used on the lens, the TTL meter will not yield an exposure that includes correct exposure compensation. Precise color sensitivity varies from camera to camera. These relatively slight exposure errors (usually ½ *f*-stop or less) are not a serious problem with color negative films, but they can produce noticeable underexposures in slides. The easiest way to ensure accurate exposures with unfamiliar filters is by bracketing in the direction of more exposure. Usually ½ stop over the meter's recommendation is enough. The new Cokin line of plastic filters lists necessary exposure increases on each filter's case, a very helpful feature.

☐ Using an 85B LB filter to convert Type B film to daylight use gives a slightly warmer result than regular daylight color film. Aerial photographers, who are accustomed to high-UV lighting conditions (UV increases with altitude), often use this film/filter combination even when daylight-balanced color film is available.

☐ A novel meter accessory is the "Expo-SURE" (Bild Enterprises, San Jose, CA). In effect, it's the light-collection hemisphere of an incident-light meter in a size to fit over the lens of a TTL meter-equipped 35mm SLR, turning the camera's reflected-light meter into an incident-light meter.

☐ Can Vericolor II films be used interchangeably? Outdoors with Type L, an 85B conversion filter will give acceptable results if exposures are kept 1/10 sec. or longer. Don't try the reverse. Long exposures on Type S result in serious color crossover. Under such questionable circumstances, stick to Kodacolor. This film is designed to tolerate more abuse than Vericolor and still produce printable negatives.

☐ A homemade device called the "Harris Shutter" makes tricolor photographs easier. It even allows photographing living subjects if they can hold still momentarily in the midst of surrounding motion. For example, if a subject can hold still while seated in front of a waterfall, the result will be a normal-looking subject and

A highlight exposure for this telephoto Kodachrome of a Brazilian oxcart would have resulted in total loss of crucial shadow detail. Since highlights were a relatively minor part of this picture, a spot-meter shadow reading was taken instead.

THE HARRIS SHUTTER

Materials:
Red, green, and blue filters
Adapter ring to fit lens
Black cardboard
Black masking tape

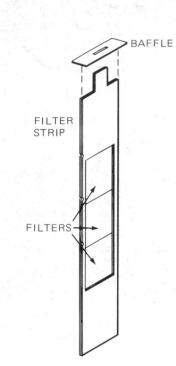

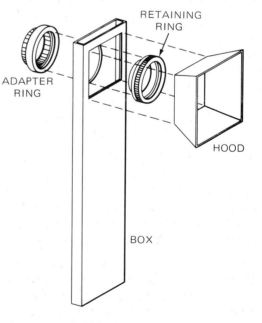

1. Cut out two identical strips of cardboard, large enough to accommodate the three square filters, in the shape shown. Sandwich the filters between the two strips. Fit the baffle over the tab at top and attach with tape.

Note: No dimensions are given here, because the size of the Harris Shutter depends on the size of the filters used. The filters should completely cover your lens. Determine other dimensions accordingly.

2. Make the box large enough to allow the filter strip to drop freely. Use black cardboard, cutting on the solid lines and folding on the broken lines shown in the diagram. Tape the flaps together with black masking tape. Be sure to cut out a round hole for the adapter ring and a square hole for the hood.

3. Make the hood to fit over the square opening in the box. Attach the adapter ring to the lens. Fit the retaining ring, through the round hole in the box, into the adapter ring. Attach the hood to the box with tape. You are now ready to drop the filter strip into the box as you make your exposure.

THE HANDBOOK OF COLOR PHOTOGRAPHY

multicolored moving water. Panning the camera with a moving racing car can show a normal-looking race car with a blurred background in three colors!

The shutter consists of three sharp-cutting filters mounted one above the other row on a panel that is designed to slide down a channel mounted over a camera lens (see illustration). Exposures are made with the shutter open while the tricolor filters are dropped down the channel, passing quickly in front of the lens. Since there's no guarantee that the filter panel will fall at the same speed each time, exposures are difficult to calculate. Try f/22 on Kodacolor II (with its wide exposure latitude) as a starting point. A description of the Harris shutter is included in Kodak publication AE-90: "The Seventh Here's How."

□ When using many special-effect lens attachments, apertures smaller than f/5.6 will result in so much depth of field that the patterns or designs of the lens accessories will become noticeable.

□ A cheap method of obtaining variable diffusion involves the Arkay Pic-Trol (Arkay Corp., Milwaukee, WI), originally intended for creating diffusion effects on an enlarger. Resembling a plastic lens diaphragm with transparent blades, it can be adapted for camera use by glueing a Series 7 adapter ring onto the back. By rotating the Pic-Trol's outer rim, the degree of intrusion of these blades into the picture area can be controlled, and with it the amount of diffusion. Due to its construction, only lenses of 85mm and up can be used.

□ Since a green phosphor is nearly universal in fluorescent lights, almost every fluorescent requires magenta filtration. If for any reason the color type of a fluorescent cannot be determined, a CC 30 Magenta filter will probably be at least a step in the right direction. Check to see if the designation includes either "cool" or "warm." If it's warm, additional cyan filtration will be necessary; if cool, additional yellow.

□ While neutral density filters are supposed to be colorless, some impart a touch of undesirable color. Before carrying any ND filters as a matter of course, run some tests with them. Photograph the same subject both with and without the filters. If the results show any color differences, try another brand of ND filter.

□ The darker ND filters are useful for photographing such ultrabright subjects as solar eclipses, but *don't* look at an eclipse through an ND filter! These filters do not screen out the rays that can burn the retina of the eye. A safe eclipse viewing filter is *two* sheets of fully fogged and processed black-and-white film.

□ ND filter effects can be calculated by percentages as well as filter factors. For example, a common use that photographers make of ND filters is to drop the ISO 3200 speed of Polaroid Type 107/667 down to ISO 64/19°, allowing Polaroid exposure checks for Ektachrome 64.

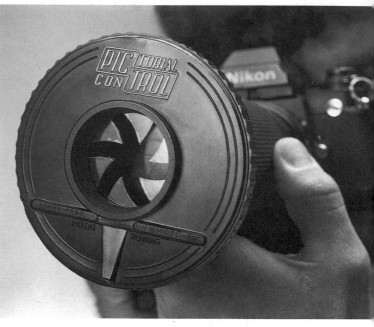

Originally intended for use on an enlarger, the Arkay Pic-Trol offers inexpensive variable diffusion.

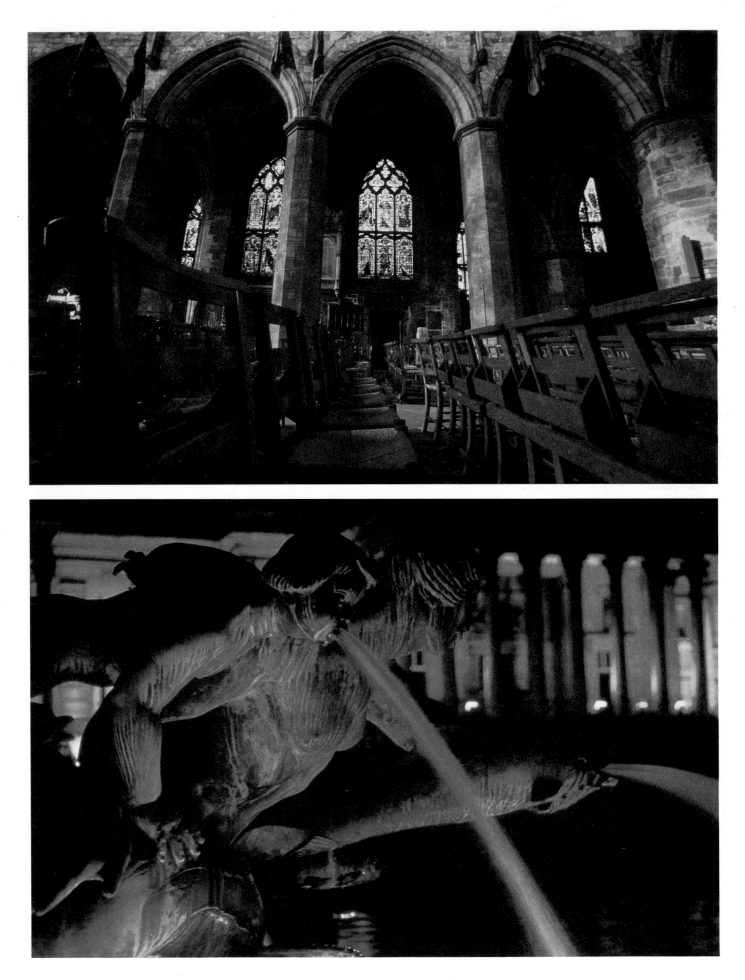

THE HANDBOOK OF COLOR PHOTOGRAPHY

The fraction of 64 over 3200 shows that the slower film is one-fiftieth as fast as the fast film. Figuring that one-fiftieth can also be expressed as 2 percent, it follows that an ND filter that transmits 2 percent of the light going through it will turn that ISO 3200 film into ISO 64/19°. Kodak's chart of ND filter densities shows a filter that will transmit 20 percent of the light (the 0.7 density), and another that will transmit 10 percent (the 1.0 density). Since 10 percent of 20 percent is 2 percent, this combination of filters will shrink ISO 3200 to ISO 64/19°. Any other ND filter combination that will add up to the same density can be used (such as the 0.9 and the 0.8). With a set of five ND filters—0.1, 0.2, 0.4, and two 0.8s—almost any density can be achieved.

□ The smaller the dimensions of a lens, the less stopping down it will tolerate before image quality begins to suffer unacceptable loss. That's why the big long-focus lenses used on view cameras can stop down to very small apertures, $f/90$ or $f/128$. The lens is so big that a small f-stop is still physically large, and light refraction is not serious.

□ A #47 blue sharp-cutting filter can be combined with underexposure (about one f-stop) to give "moonlight" effects in bright sunlight.

□ A CC 30 Red filter can improve pictures shot through the green-tinted windows of tour buses.

□ The Kodak Wratten #90 filter serves as a "viewing filter." If both highlight and shadow details of a subject are visible when viewed through the #90 filter, the subject contrast range is within the capability of color film. If only highlight detail is visible, the light is too contrasty for both shadow and highlight rendition. Zone VI, Inc. (Newfane, VT) supplies a #90 filter in a handy cardboard mount.

□ Several filter manufacturers (including Tiffen, Kodak, and B/W) offer two different capabilities in a single filter. Such filter combinations often mate conversion filters (usually 85Bs) with neutral density filters or polarizers for outdoor work.

□ When shooting color negative outdoors on a dull day, image contrast can be increased by overexposing about two f-stops.

□ The color temperature of 3400 K photofloods can be dropped to 3200 K by attaching a fifty-foot extension cord to the light. This is helpful when shooting Type B Ektachrome when only 3400 K bulbs are available.

□ Since Panalure paper is panchromatic, it will respond to the filters commonly used for outdoor black-and-white photography. Thus, the clouds in the blue sky of a color negative being printed on Panalure can be emphasized with a red #25 or a yellow K2 filter as though the picture were being shot outdoors on black-and-white film.

□ Although Kodachrome II, the predecessor of Kodachrome 25, is no longer manufactured, Kodak still offers processing service for it.

□ Wearing rubber-soled shoes in low-humidity surroundings can increase static electricity problems, since static cannot drain into the ground (some surgeons loop a metal chain around their legs, letting it drag on the floor to dissipate static).

□ For cold-weather photography, a special Photo Coat with big pockets both inside and out is available from Outlast Uniforms, Inc. (Chelsea, MA).

Opposite page, top: Low-light situations are often contrasty lighting situations as well. This interior of St. Giles Cathedral in Edinburgh, Scotland was shot for 8 seconds at $f/5.6$ on Kodachrome 64, using a 15mm lens. The foreground is rendered undesirably dark, but this off-the-cuff picture opportunity gave no chance to use fill-in lighting.

Bottom: The water-spouting fountains of London's Trafalgar Square were given a tripod-supported 30-second time exposure on Kodachrome 25 with a 200mm lens. Rendition on this daylight-balanced emulsion may be too warm for some tastes. A better idea would have been to take the picture on both daylight and Type B emulsions, allowing a choice of results.

APPENDICES

This dewy autumn leaf was shot
with a center-sharp special-effect
filter consisting of a ground-glass
diffusion disk with a clear center
spot. This can be a useful tool if
you're photographing a sub-
ject with bright-colored edges that
will diffuse effectively into an
abstract blur. If the edges of this
picture had been dark, there would
have been no color to diffuse and
no point in using the disk.

FILTERS FOR CONVERTING COLOR FILM

	LIGHT SOURCE	WRATTEN FILTER
DAYLIGHT FILM (5500)	Photoflood (3400K)	80B
	Tungsten (3200K)	80A
	Clear flashbulb (3800K)	80C
TYPE A FILM (3400K)	Daylight	85
	Tungsten	82A
	Clear flashbulb	81C
TYPE B FILM (3200K)	Daylight	85B
	Photoflood	81A
	Clear flashbulb	81C

COLOR FILTER NOMOGRAPH

Use a ruler to line up your film type and light source. The point where the ruler crosses the middle column will give you the proper filter.

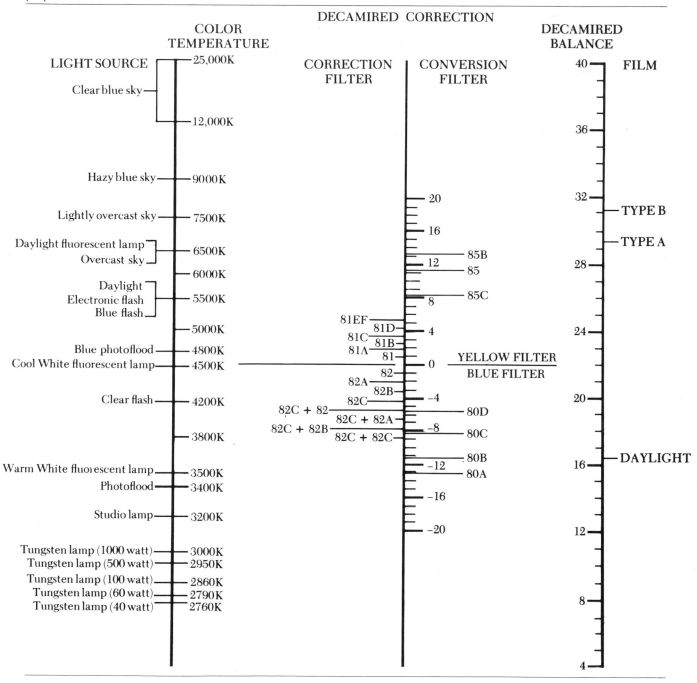

FILTERS TO BALANCE LIGHTING FOR TYPE A AND TYPE B FILM

	WRATTEN FILTER	TO BALANCE FOR TYPE B FILM (3200K) FROM:	TO BALANCE FOR TYPE A FILM (3400K) FROM:	EXPOSURE INCREASE (in f-stops)	MIRED SHIFT VALUE
(CC)	80A	3200-5500K	3200-5500K	2⅓	−131
	80B	3400-5500K	3400-5500K	2	−112
	80C	3800-5500K	3800-5500K	1	− 81
	80D	4200-5500K	4200-5500K	1	− 56
	82	3100K	3290K	⅓	− 10
	82A	3000K	3180K	⅓	− 21
	82B	2900K	3060K	⅔	− 32
	82C	2800K	2950K	⅔	− 45
	82C + 82	2720K	2870K	1	− 55
	82C + 82A	2650K	2780K	1	− 65
	82C + 82B	2570K	2700K	1⅓	− 77
	82C + 82C	2490K	2610K	1⅓	− 89
(LB)	81	3300K	3510K	⅓	9
	81A	3400K	3630K	⅓	18
	81B	3500K	3740K	⅓	27
	81C	3600K	3850K	⅓	35
	81D	3700K	3970K	⅔	42
	81EF	3850K	4140K	⅔	52
	85	5500-3400K	5500-3400K	⅔	112
	85B	5500-3200K	5500-3200K	⅔	131
	85C	5500-3800K	5500-3800K	⅓	81

SHUTTER SPEED (in seconds)

FILM°		1/10,000	1/1000–1/100	1/10	1	10	100
Kodachrome 25	EI	None	None	None	+1	+1½	+2½
	F	None	None	None	CC10M	CC10M	CC10M
Kodachrome 64	EI	None	None	None	+1	NR°°	NR
	F	None	None	None	CC10R		
Ektachrome 64	EI	+½	None	None	+½	+1	NR
	F	None	None	None	CC10B	CC15B	
Ektachrome 200	EI	+½	None	None	+½	NR	NR
	F	None	None	None	CC10R		
Kodacolor II	EI	None	None	None	+½	+1½	+2½
	F	None	None	None	None	CC10C	CC10C + CC10G
Kodacolor 400	EI	None	None	None	+½	+1	+2
	F	None	None	None	None	None	None
Vericolor II Type S	EI	None	None	None	NR	NR	NR
	F	None	None	None			
Vericolor II Type L	EI	NR	NR	None	+⅓	+⅔	+1⅔
	F			None	None	None	None
Ektachrome 50 Professional	EI	—	None	None	None	+½	+1½
	F		CC10C	None	None	None	None
Ektachrome 160 Professional	EI	+½	None	None	+½	+1	NR
	F	None	None	None	CC10R	CC10R	

EI – Exposure Increase in *f*-stops. F = Filter.
*Data are based on using light source for which film is balanced.
**Not Recommended.

DECAMIRED VALUES

FILM TYPE	DECAMIRED VALUE
Daylight (5500K)	18
Type A (3400K)	29
Type B (3200K)	31

LIGHT SOURCE	
Average sunlight (5500K)	18
Late afternoon sun (5000K)	20
Hazy blue sky (9000K)	11
Electronic flash (6500K)	15
Photofloods (3400K)	29
Clear flash (3800K)	26
Blue flashbulbs (6000K)	16
3200K lamps	31

WRATTEN FILTER	
82	$-1°$
82A	-2
82B	-3
82C	$-4\frac{1}{2}$
82C + 82A	-6
82C + 82C	-9
80B	-11
80A	-13
81	$+1°°$
81A	$+2$
81B	$+3$
81C	$+3\frac{1}{2}$
81D	$+4$
81EF	$+5$
85C	$+8$
85	$+11$
85B	$+13$

*Minus sign designates a blue filter.

**Plus sign designates a red filter.

WRATTEN NEUTRAL DENSITY (ND) FILTERS

NEUTRAL DENSITY	LIGHT TRANSMITTED	FILTER FACTOR	EXPOSURE INCREASE (no. of stops)
0.1	80%	1¼	⅓
0.2	63%	1½	⅔
0.3	50%	2	1
0.4	40%	2½	1⅓
0.5	32%	3	1⅔
0.6	25%	4	2
0.7	20%	5	2⅓
0.8	16%	6	2⅔
0.9	13%	8	3
1.0	10%	10	3⅓
2.0	1%	100	6⅔
3.0	0.1%	1000	10
4.0	0.01%	10,000	13⅓

YOUR SMALLEST STOP	STOP YOU WANT	ND FILTER TO USE
$f/16$	$f/22$	0.3
	$f/32$	0.6
	$f/45$	0.9
	$f/64$	1.2
	$f/90$	1.5
	$f/128$	1.8
	$f/180$	2.1
	$f/256$	2.4
$f/22$	$f/32$	0.3
	$f/45$	0.6
	$f/64$	0.9
	$f/90$	1.2
	$f/128$	1.5
	$f/180$	1.8
	$f/256$	2.1
$f/32$	$f/45$	0.3
	$f/64$	0.6
	$f/90$	0.9
	$f/128$	1.2
	$f/180$	1.5
	$f/256$	1.8

PHOTOFLOOD LAMPS

	ANSI LAMP CODE	DESCRIPTION/BEAM SPREAD	WATTAGE	LIFE IN HOURS	COLOR TEMP (K)
REFLECTOR	BEP	Medium beam / 30 x 20 deg.	300	4	3400
	BFA	Medium beam / 30 x 20 deg.	375	4	3400
	DXB	RSP-20 / 20 deg.	500	6	3400
	DXC	RFL-20 / 90 deg.	500	6	3400
	DXE	Flood beam / 90 deg.	500	6	3400
	EAL	Reflector lamp	500	15	3200
	EBR	Medium beam / 40 deg.	375	4	3400
STANDARD	BBA	No. 1	250	3	3400
	BCA	No. 1B (blue)	250	3	4800
	DMS	Clear	500	50	3200
	EBV	No. 2	500	6	3400
	EBW	No. 2B (blue)	500	6	4800
	ECA	Frost	250	20	3200
	ECT	Frost	500	60	3200

LIFE EXPECTANCY OF COLOR PRODUCTS*

FILMS

Agfachrome	50 years
Kodachrome	100 + years
Ektachrome E-6	50 + years
Fujichrome 100 and 400	45–90 years
Fujicolor FII 100 and 400	10–20 years

NEGATIVES

Agfacolor	20 years
Kodacolor II	10 + years
Vericolor	10 + years

PAPER PRINTS

Agfacolor	10 years
Cibachromes	100 + years
Ektacolor	10 + years
Ektachrome 2203	10 + years
Ektaflex	10 + years
Fujichrome	10–20 years

*Figures are based on dark storage at room temperature with 40 percent relative humidity.

LIST OF MANUFACTURERS

Acme-Lite Mfg. Co.
3401 W. Madison St.
Skokie, IL 60076

Ambico, Inc.
101 Horton Ave.
Lynbrook, NY 11563

Berg Color-Tone, Inc.
P.O. Box 16
East Amherst, NY 14051

Berkey Marketing Co.
25-20 Brooklyn-Queens
Expressway
Woodside, NY 11377

Bild Enterprises, Inc.
Box 32754
San Jose, CA 95152

Bogen Photo Corp.
100 S. Van Brunt St.
Englewood, NJ 07631

Calumet Photographic
890 Supreme Dr.
Bensenville, IL 60106

Chemplast Corp.
150 Dey Rd.
Wayne, NJ 07470

Copal Corporation
of America
58-25 Queens Blvd.
Woodside, NY 11377

Davison Chemical Div.
W.R. Grace Co.
10E Baltimore St.
Baltimore, MD 21203

Dynacolor Lab
11915 West Olympic Blvd.
Los Angeles, CA 90064

Eastman Kodak Co.
343 State St.
Rochester, NY 14650

Edwal Scientific Corp.
12120 So. Peoria St.
Chicago, IL 60643

Fish-Schurman Corp.
70 Portman Rd.
New Rochelle, NY 10802

Franklin Distributors Corp.
Denville, NJ 07884

Freestyle Sales Co.
5124 Sunset Blvd.
Los Angeles, CA 90027

Fuji Photo Film U.S.A., Inc.
350 Fifth Ave.
New York, NY 10001

Fujinon Optical, Inc.
672 White Plains Rd.
Scarsdale, NY 10583

Harrison and Harrison
6363 Santa Monica Blvd.
Hollywood, CA 90038

HP Marketing Corp.
216 Little Falls Rd.
Cedar Grove, NJ 07009

Joshua Meier Corp.
No. Bergen, NJ 07047

Kalt Corp.
2036 Broadway
Santa Monica, CA 90404

Karl Heitz, Inc.
979 Third Ave.
New York, NY 10022

Keystone Ferrule and
 Nut Corp. (Kenko)
909 Milwaukee Ave.
Burlington, WI 53105

Kollmorgen Corp.
 Photo Research Div.
3000 N. Hollywood Way
Burbank, CA 91505

Laskey Studio
2222 Shawnee S.E.
Grand Rapids, MI 49506

Leedal, Inc.
1918 So. Prairie Ave.
Chicago, IL 60616

Light Impressions Corp.
Box 3012
Rochester, NY 15614

Lowel-Light Mfg. Co.
421 W. 54 St.
New York, NY 10019

Meisel Photochrome Corp.
Box 226067
Dallas, TX 75281

Minolta Corp.
101 Williams Dr.
Ramsey, NJ 07446

New York Color Works, Inc.
928 Broadway
New York, NY 10010

Nikon, Inc.
623 Stewart Ave.
Garden City, NY 11530

Outlast Uniform
6 Hancock St.
Chelsea, MA 02150

PEC LaserColor
 Laboratories, Inc.
Fairfield Dr.
W. Palm Beach, FL 33407

Polaroid Corp.
549 Technology Sq.
Cambridge, MA 02139

Quantum Instruments, Inc.
1075 Stewart Ave.
Garden City, NY 11530

RNI Photo Marketing
P.O. Drawer 638
Ocala, FL 32670

Rosco Laboratories, Inc.
36 Bush Ave.
Port Chester, NY 10573

Sav-A-Trans, Inc.
Box 51234
New Orleans, LA 70151

Sima Manufacturing Co.
4001 W. Devon Ave.
Chicago, IL 60646

Smith-Victor Corp.
301 N. Colfax
Griffith, IN 46319

Special Products Lab
5244 W. Madison St.
Chicago, IL 60644

Spiratone, Inc.
135-06 Northern Blvd.
Flushing, NY 11354

Stewart Color Labs
563 11th Ave.
New York, NY 10036

Tekno, Inc.
221 W. Erie St.
Chicago, IL 60610

Testrite Inst. Co., Inc.
135 Monroe St.
Newark, NJ 07105

3M Co. (Photo Products Div.)
3M Center
St. Paul, MN 55101

Tiffen Mfg. Corp.
90 Oser Ave.
Hauppauge, NY 11787

Uniphot-Levit Corp.
Woodside, NY 11377

Vacuumate Corp.
207 W. 25th St.
New York, NY 10001

Vue File Corp.
Box 38
Franklin, OH 45005

Webster Brothers Laboratory
P.O. Box 122
Grayslake, IL 60030

Zone VI Studios, Inc.
Newfane, VT 05345

LABS OFFERING PROCESS E-4

Kolor Print, Inc.
2121 Thayer St.
Little Rock, AK 72202

Dynacolor Corporation
1407 West Fifth St.
Northfield, MN 55057

Columbus Photo Service, Inc.
2716 Lumpkin Rd.
Columbus, GA 31903

Dynacolor Corporation
2043 Lawrence Ave.
East Point, GA 30344

Dynacolor Corporation
P.O. Box 225004
Dallas, TX 75265

Multimedia Film Labs
333 K, SW Ninth St.
Des Moines, IA 50309

Eastman Kodak Company
Building 65, Kodak Park
Rochester, NY 14650

Technicolor Inc.
4330 Roseville Rd.
N. Highlands, CA 95660
(916) 485-4422

Precision Photo Lab, Inc.
5758 N. Webster St.
Dayton, OH 45414

WAC Corporation (EA-5)
520 Conger St.
Eugene, OR 97402
(503) 342-5169
($75 min. order—$20/roll)

Rapid Color, Inc. (EA-5)
16661 Milliken Ave.
Irvine, CA 92714
(714) 979-6856
($25 min. order—$1.15/ft.)

Courtesy of Eastman Kodak Company

Edited by Elizabeth Burpee and Judith Royer
Designed by Bob Fillie
Graphic production by Hector Campbell
Text set in 11-point Laurel